R E A L L Y

Useful*

* the origins of everyday things

for Sophie and Josh

REALLY

Useful*

*the origins of everyday things

JOEL LEVY

FIREFLY BOOKS

A FIREFLY BOOK

Published by Firefly Books Ltd. 2002

First printing

National Library of Canada Cataloguing in Publication Data
Levy, Joel
Really Useful: the origins of everyday things / Joel Levy.

ISBN 1-55297-623-8 (bound) ISBN 1-55297-622-X (pbk.)
1. Inventions—History. I. Title.
GN406.L48 2002 609 C2002-901653-3

U. S. Publisher Cataloging-in-Publication Data
Levy, Joel.
Really Useful: the origins of everyday things / Joel Levy. —1st ed.
[240] p. : col. ill. , photos. ; cm.
Includes bibliographic references and index.
Summary: The stories behind the invention and development
of everyday objects in homes and offices.
ISBN 1-55297-623-8
ISBN 1-55297-622-X (pbk.)
1. Inventions. 2. Technological innovations. I. Title.
608 21 CIP T19.L48 2002

Published in Canada in 2002 by
Firefly Books Ltd.
3680 Victoria Park Avenue
Willowdale, Ontario, M2H 3K1

Published in the United States in 2002 by
Firefly Books (U.S.) Inc.
P.O. Box 1338, Ellicott Station
Buffalo, New York 14205

USE

This book was designed and produced by
Quintet Publishing Limited
6 Blundell Street
London N7 9BH

Project Editor: Corinne Masciocchi
Editor: Anna Bennett
Photographers: Juliet Piddington/Jeremy Thomas
Art Director: Sharanjit Dhol
Design: Sharanjit Dhol/DW Design
Creative Director: Richard Dewing
Publisher: Oliver Salzmann

Manufactured in Singapore by Universal Graphic Pte Ltd
Printed in Singapore by Star Standard Pte Ltd

Contents

introduction

Take a look around your house and you'll see that it's a kind of museum. In every room, on every surface, are the exhibits: everyday things that you take for granted, but each of which has its own story. *Really Useful* takes you on a tour of this museum, room by room, from top to bottom, exploring the history and workings of more than one hundred everyday objects.

There's plenty of trivia and fascinating tidbits to uncover along the way—did you know, for instance, that the Frisbee is named after a Connecticut pie-maker, or that the ant is the only animal that can survive being cooked in a microwave oven? Some broad historical themes also emerge. For instance, many everyday objects have surprisingly long histories, dating back to the dawn of civilization and beyond, and their development often follows a pattern: invented by the ancient Egyptians or Babylonians, perfected by the Greeks and Romans, lost in the Dark Ages, and rediscovered in the Middle Ages, mechanized and electrified by the Victorians, and mass-produced in the 20th century.

The histories of everyday objects, however, are not simply tales of scientific breakthrough, technical progress, and inventive genius, although these have their place. The real driving forces behind invention and innovation are social and cultural ones, and this is doubly true for everyday things. Many of them were not always familiar or ubiquitous, and a second theme to emerge from this book is one of social transition. Items that can now be found in almost every household were once so rare and expensive that only the richest and most powerful could afford them, and they became symbols of rank and privilege in feudal societies. In ancient Egypt, for example, the nobility demonstrated their wealth by having pleats ironed into their clothes, while in ancient Assyria only the king might own an umbrella. As the feudal society gave way to the industrial society, such objects became more affordable and widespread, and during the 20th century mass-produced goods became cheap enough to be available to almost everyone. The industrial society has now become the consumer society, and what was once unattainable has become "everyday."

This is a social transformation that affects every aspect of our lives today, and everyday objects have both reflected and been involved in this transformation. In some respects then, your home is a museum of social change, and the everyday things that it contains are the markers of that change. The next time you pick one up stop for a moment and consider the sheer wealth of history that can be embodied by something as ordinary as an umbrella or as simple as the crease in a pair of pants.

Joel Levy

the Inside World

"Have nothing in your house that you do not know to be useful, or believe to be beautiful."

William Morris, 1834–96

KITCHEN*

* the greatest thing since...

Dishwasher

FOR HANDS THAT WON'T DO DISHES

Dishwashing only became an issue with the introduction of porcelain tableware in the 18th century, and remained a minor element of the housework for most people. Breakages were more of a problem than cleaning, particularly for rich people who used a lot of dinnerware and relied on their servants to clean it.

The first patent for a mechanical dishwashing device dates back to 1850, and was granted to Joel Houghton for a wooden machine with a hand-turned wheel that splashed water on to dishes. Frenchman Eugène Daquin invented another version in 1885. Daquin's device employed a set of revolving "hands" that grabbed the dishes and plunged them into soapy water. It evidently looked ferocious enough to warrant the assertion, in a review in *Scientific American*, that it posed "no danger whatsoever to man or dish."

Neither of these machines was especially practical or effective, and it was left to Josephine Cochrane, an Illinois society hostess and inveterate giver of dinner parties, to find her own solution to the vexing problem of breakages. Exasperated by the constant clumsiness of her servants, Cochrane shopped around for a device that could handle dishwashing in bulk but with a gentle touch. Her search was unsuccessful, and according to legend she was prompted to declare, "If nobody else is going to invent a dishwashing machine, I'll do it myself."

She was as good as her word and built her first machine in a garden woodshed. She twisted wire into racks to hold the crockery and arranged the dishes on a wheel that she placed into a large copper boiler. A motor turned the wheel while hot soapy water was squirted up through the bottom of the boiler to drizzle over the plates.

The "Cochrane Dishwasher" quickly caught on amongst those who shared Mrs. Cochrane's concerns over volume washing and breakages. She patented her device in 1886 and sold copies to her wealthy friends and to local hotels and restaurants. It even won an award at the 1893 Chicago World's Fair. But although KitchenAid, the company that grew from Cochrane's dishwasher business, would eventually become a household name, her initial attempts to launch a dishwasher for the domestic market resulted in disappointing sales.

Dishwasher historians attributed the early recalcitrance of the domestic market to a combination of logistical and cultural stumbling blocks. Early domestic models required huge amounts of hot water at a time when it still took hours to heat a single bath-load. In addition, market research showed that for most housewives dishwashing was a trivial chore that they didn't mind doing by hand, in contrast to the widely loathed drudgery of laundry.

The first electrically powered dishwasher appeared in 1922, but it was not until the postwar era, when newfound prosperity, female emancipation, and the cult of labor-saving inaugurated a widespread change in cultural attitudes among American housewives, that the domestic dishwasher finally caught on.

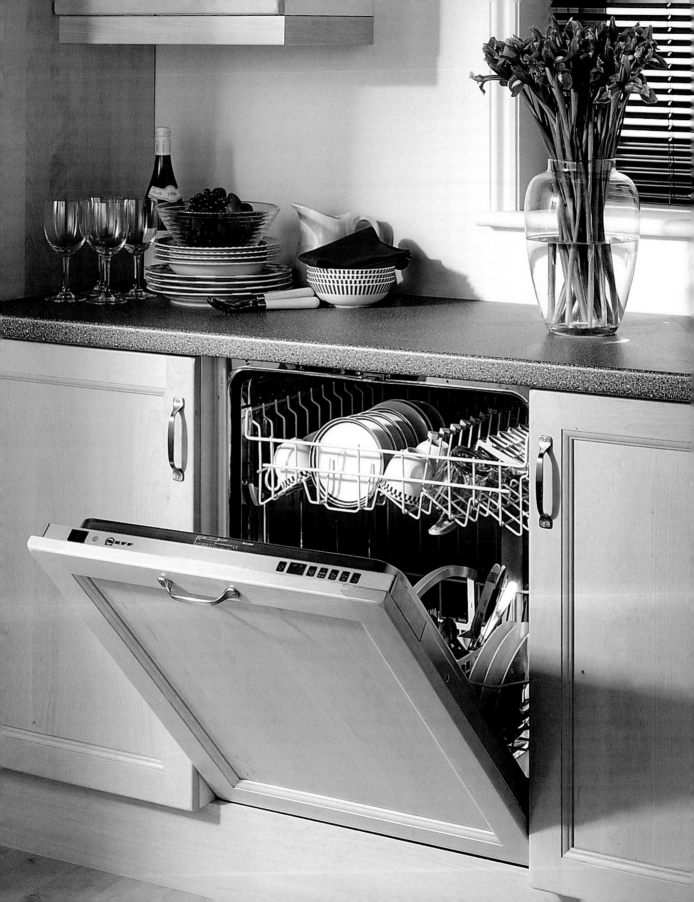

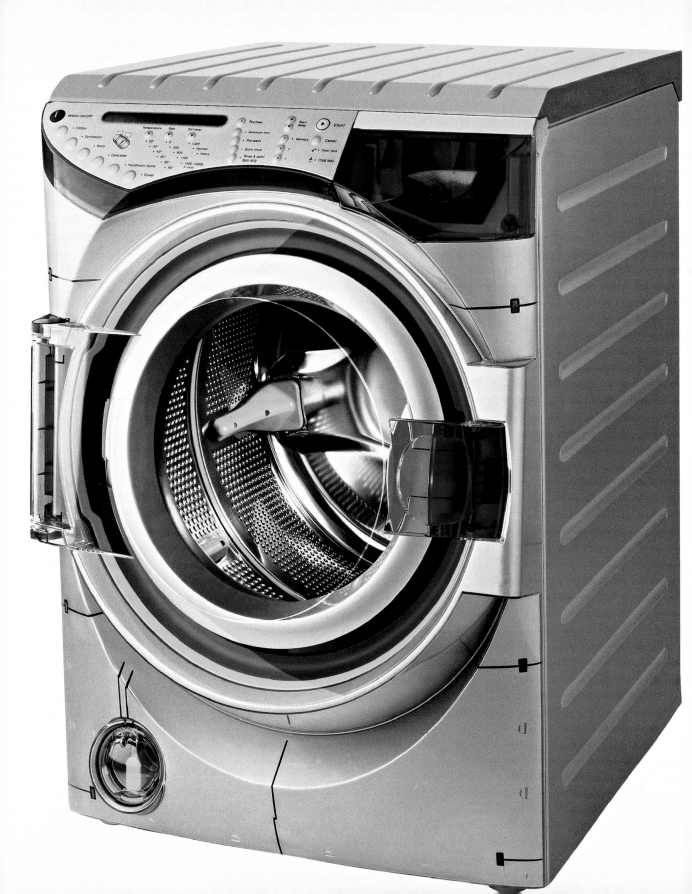

Washing machine and clothes dryer

IN A SPIN

The sheer physical drudgery involved in most household chores before the invention of modern labor-saving devices is difficult for many of us to imagine. Few chores were as tiring and disliked as doing the laundry, which involved exhausting scrubbing and wringing—Caroline Beecher, the 19th century American pioneer of women's education and writer on domestic economy, called laundry "the American housekeeper's hardest problem." By the early 1800s many western European households were already equipped with a rudimentary hand-operated, clothes-tumbling device. This consisted of a wooden box that could be filled with water and soap and turned with a hand-powered crank. Doing laundry was still hard work—to wash, boil, and rinse a single load required up to 50 gallons (190 liters) of water, which had to be transported by hand—and there was obviously room for improvement.

The inventive Victorians devoted much time and effort to devising mechanical solutions to the problem, and by 1875 more than 2,000 patents had been issued for clothes-washing devices. There were washing machines with "stomping" devices, where an instrument like an upturned stool pumped the clothes, machines with clothes wringers attached, machines that dragged clothes back and forth through soapy water with a sort of rake, and even one called "the Locomotive," which ran backward and forward on short rails so that the clothes slammed against the sides of the tub. The most common type used a revolving cage, patented by H. Sidgier of Britain as far back as 1782, or a drum, patented by an American, James King, in 1851.

Nineteenth-century washing machines were mostly powered by hand using handles, wheels, or pumps, although what may have been the world's first laundromat, opened in 1851 in gold-rush California, had machines powered by a donkey. Not until the beginning of the 20th century were electric motors fixed to washing machines and even then they often had to be filled and emptied by hand. The motors themselves were not protected or properly sealed, and water would often splash on to them causing short-circuits, fires, and electrocution (cases for the motors were introduced in the 1930s). Most electric washing machines still relied on an attached wringer to help dry the clothes.

The modern machine finally took shape in the mid 1930s, when John W. Chamberlain of the Bendix Corporation invented a device that could wash, rinse, and drain. This prodigy, first displayed at the Louisiana State Fair in 1937, was clearly the shape of things to come, but at first the expense of the automatic machines made them unpopular. When they reached Britain in the mid 1950s, for instance, automatic washing machines cost as much as a small car. Gradually costs fell, and the introduction of timers, by former jukebox manufacturers Seeburg, boosted sales of the new "autos."

CLOTHES DRYERS

Drying clothes required less effort, so the incentive to mechanize the process was not so great. As early as 1800, however, a Frenchman named Pochon had invented a "ventilator," consisting of a rotating metal drum, pierced with holes, which was turned by hand over an open fire. Although this somewhat self-defeating device did not catch on, the principle of tumble-drying remained, and the first electric clothes dryer appeared in 1915.

Refrigerator

THE BIG FREEZE

Keeping food for long enough to eat before it goes bad has long been a problem for mankind. One way of preserving food is to keep it cold—low temperatures slow down or stop the development of micro-organisms that cause food to decay. As early as 1000 BC, if not before, the ancient Chinese were cutting blocks of ice to use as cooling aids, and this remained the most important form of refrigerator technology for the next 2,800 years. Ice was cut at source in mountainous or snowy areas and transported to warmer areas where it was wrapped in cloth and placed in cellars or straw-insulated icehouses. By Victorian times most homes had an icebox—a metal-lined box insulated with cork, sawdust, or even seaweed, with one compartment for a block of ice and one for the perishables. The iceman was a regular visitor to most homes, and by the late 1800s the United States was exporting 25 million tons of ice a year.

This system was inefficient and inadequate, however, especially for those who lived in warmer climes. One consequence of the Civil War in the United States, for instance, was the interruption of the ice trade between the cold North and the warm South, depriving the Southern states of their cooling capabilities. Successive warm winters in 1889 and 1890 created severe ice shortages throughout the United States, leading to an unprecedented demand for new methods of refrigeration—artificial ones.

The main principle of artificial refrigeration had been exploited as far back as 500 BC, when ancient Egyptians and Indians made ice on cold nights by setting water out in earthenware pots and keeping them wet (the Romans made their slaves fan filled terracotta pots placed in water). In the Middle Ages Chinese scholars observed that objects kept in brine—salty water—were cooled as the brine evaporated. Both these methods rely on the principle that evaporation requires energy. As a liquid evaporates to form a gas it takes heat energy from its surroundings—and as the gas escapes so does the heat. The human body uses the same principle to cool down, through perspiration.

Modern refrigerators also work on this principle, using a coolant substance that normally exists as a gas, even at low temperatures. A compressor

condenses the gas to liquid form, and the liquid is then circulated around the area to be cooled. As it expands and reverts to gaseous form it absorbs heat. Then it travels away from the cool space and is recompressed, releasing its heat as it condenses.

A number of scientists demonstrated the principles of refrigeration before they were used to create practical refrigerators. Probably the earliest to do so was Scottish scientist William Cullen, who demonstrated artificial refrigeration at Glasgow University in 1748. He was followed in the early 1800s by the great British scientist Michael Faraday, who demonstrated the use of liquid ammonia to produce cooling.

An American named Oliver Evans invented the first refrigeration machine in 1805, and although a physician used his design in 1844 to make ice to provide cool air for yellow fever patients, it was not really practical for domestic use.

By the 1870s more practical machines appeared. In 1874 Raoul Pictet of Switzerland designed one that was later used to create the first artificial ice rink, and in 1877 Frenchman Ferdinand Carré successfully designed a system for the world's first refrigerated ship, *The Paraguay*, carrying meat from Argentina to Europe. Ice factories employing the new technology sprang up all over the world, and in 1911 the first home refrigerators appeared in America—by 1920 there were more than 200 models available. Most of these early domestic units used belt-driven compressors run by engines in neighboring rooms.

The very first dual-compartment refrigerators, featuring a cold box 34–35° F (1–2° C) as well as a freezing compartment -0.4° F (-18° C), appeared during the 1920s, at a time when companies relied heavily on both salesmen and demonstrations to sell their appliances. The American manufacturer Maytag, for instance, employed a former ranch hand, known as Cowboy Joe Long, to tour midwestern ranches with a demonstration unit slung on either side of his mule.

These early refrigerators depended on volatile gases, such as ammonia, sulfur dioxide, or ether, as their coolants. Explosions and poisonings were not uncommon. These gases were replaced by freon, a chlorofluorocarbon (CFC), in the 1930s, but this had to be replaced when it proved to be destroying the ozone layer. Innovations like automatic defrost and automatic ice makers first appeared in the 1950s and 1960s. Today the refrigerator is more energy-efficient and environmentally friendly, and is the most common domestic appliance, found in 99.5 percent of American homes.

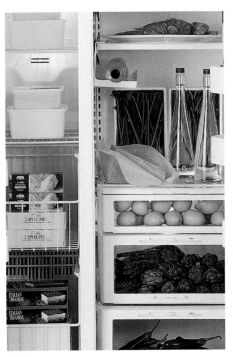

One of the first home refrigerators ever designed was made mainly of wood—a far cry from the modern appliances that adorn our kitchens today. Humidity temperature controlled drawers, interior lights, and automatic defrost are just some of the features that now come as standard.

Microwave oven

THE APPLIANCE OF SCIENCE

Microwaves are a form of electromagnetic energy similar to radio waves (they have a wavelength shorter than radio waves but longer than infrared light), which can be used for cooking and for radar. During World War II Britain's radar defenses used a machine called a magnetron, invented in 1940 by Sir John Randall and Dr. H.A. Boot, to generate microwaves that could be bounced off incoming aircraft.

In 1946 scientist Dr. Percy Spencer of the Raytheon Corporation was carrying out radar-related experiments with a magnetron, when, legend has it, he noticed that a bar of chocolate in his pocket had completely melted, although he himself had felt no heat. Spencer already knew that microwaves could generate heat, and the ruined candy bar set him thinking. He tried placing some uncooked corn kernels in front of the magnetron, and soon had popcorn. Next he tried an egg—its interior heated up so much that it exploded. A new means of cooking had been discovered, but what exactly was going on?

Microwaves can pass through air and materials such as plastic, paper, and glass, and they can penetrate a little into foodstuffs, such as egg, before water molecules absorb them. When this happens the water molecules start to vibrate rapidly—a typical microwave oven makes them vibrate nearly five billion times a second. As they vibrate the water molecules rub up against neighboring molecules, generating heat by friction. So it is not altogether accurate to say that a microwave oven cooks food from the inside out—the heating starts just below the surface and spreads both inward and outward. Microwave energy is converted entirely into heat, so it does not make food radioactive or contaminated.

Another property of microwaves is that they reflect off metal surfaces, a property exploited by Spencer in his design of the first microwave oven— the Radar Range, released in 1947. By firing the microwaves from a magnetron into a metal box he could safely keep the cooking energy in one place while bouncing the microwaves around inside the box to reach all parts of the food.

Unfortunately the magnetron required a bulky water-cooling system, and the Radar Range was the size of a large refrigerator and cost about $5,000. Only the military and a few large catering establishments were interested. Gradually technology advanced, and in 1952 the Tappan Company produced the first domestic microwave oven. For $1,295 the cutting edge consumer got an on-off switch, dual cooking speed, and a 21 minute timer. By 1967 the first countertop domestic microwave oven was released. By 1975 microwave ovens were outselling gas ranges in the United States, and today more than three-quarters of American households own one. They are also popular in industry, with myriad uses from roasting coffee beans, to drying cork and helping shuck oysters.

The modern microwave uses an air-cooled magnetron, and includes numerous safety trips to prevent microwaves from leaking out. Opening the oven door breaks a circuit and instantly turns off the

microwave energy, like turning off a light, so it is impossible to accidentally cook yourself.

One of the few living creatures that can survive a turn in a microwave oven is the ant. As microwaves bounce around inside an oven they can overlap to give a standing wave effect, producing some "hot" zones and some "cold" zones (this is why you need a carousel to turn the food). Ants are small enough to fit on one zone at a time and have a high surface area to volume ratio. This allows them to dissipate heat quickly if they get temporarily caught in a "hot" zone, giving them time to move into a "cold" zone.

Kitchen appliances

MIXING IT UP

The Victorian kitchen included a host of hand-operated devices for whisking, beating, frothing, and even chopping, slicing, and dicing. Once electricity arrived on the scene inventors began to focus on producing electrified labor-saving devices of every description, and it was only a matter of time before they came up with powered versions of the staple kitchen tools.

THE STAND MIXER

One of the earliest such devices was the ancestor of one of today's most famous stand mixer brands, the Kitchen-Aid. Originally an 80-quart industrial dough-mixer developed by engineer Herbert Johnson in 1908, the stand mixer was such a success that a domestic version followed. In 1919, Johnson's Hobart Manufacturing Company produced the H-5, a domestic stand mixer in which the beater rotated with a planetary action (it spun in one direction while moving around the bowl in the other, like a planet going round the sun). A company executive's wife came up with the name Kitchen-Aid, and the machine was advertised with the claim that it could "stir, beat, cut, cream, slice, chop, and strain, by electricity!" Another well-known brand of stand mixer, the Sunbeam, first marketed in 1930, has achieved the distinction of appearing on a postage stamp.

THE BLENDER

Not far behind the stand mixer was the blender, first patented in 1922 by Stephen Poplawski, an inventor from Wisconsin. Poplawski was a fan of malts and milk shakes, and developed a machine with a spinning blade on a long rod that extended down into a cup. He hoped it would be a big success at soda fountains around the country, but the idea of the blender was not particularly popular until it was applied to the mixing of cocktails.

An improved version of Poplawski's blender, patented by inventor Fred Osius in 1933, was brought to the attention of bandleader and invention enthusiast Fred Waring in 1937. Spotting an opportunity, Waring funded development and manufacturing, and used his

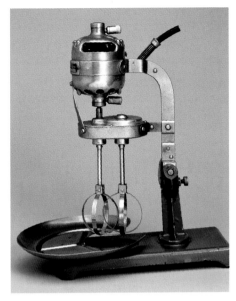

The "Universal" electric food mixer, 1918, produced by the Universal Company of America. This particular model was driven by an electric motor, reducing the amount of time spent on whisking, mixing, and beating.

media and showbiz profile to market the resulting "Miracle Mixer" as a handy tool for making daiquiris. The Miracle Mixer quickly became known as the Waring Blendor®, and soon caught on for liquidizing solid foods to make health drinks and for special diets. It was even used by Jonas Salk during his development of the polio vaccine.

The popularity of Waring's blender quickly brought competition, but, because the basic product was essentially straightforward, rival manufacturers were forced into a sort of arms race known as the "Battle of the Buttons." To appear superior to their predecessors new blenders had more and more speed settings added, until, by 1968, a machine with 15 buttons appeared.

THE FOOD PROCESSOR

By the mid 1970s, however, the heyday of the blender was past, its thunder stolen by a new appliance from Europe—the food processor. First developed in 1947, by British inventor Kenneth Wood, as the Robot Kenwood Chef, and refined in the 1960s by French chef Pierre Verdun as the Robot-Coup (later Magimix), the food processor was a more advanced machine than the blender. When retired American electrical engineer, entrepreneur and keen chef, Carl Sontheimer, introduced the first Cuisinart to America in 1973, it was slow to catch on. Sontheimer had been impressed by an industrial version of the Magimix at a French home goods show in 1971, and had developed a refined, improved version. An intensive marketing campaign slowly won people over and by the late 1970s Cuisinart was selling more than 500,000 machines a year.

Competition and technology have combined to add more and more functions to blenders, stand mixers, and food processors to the point where it is difficult to distinguish between them. For instance, a recent model of blender from Vita-Mix—the Vita-Mix Super 5000!—claims to perform no fewer than 40 different "food feats," including juicing, freezing, whipping, and kneading. The Victorians would have been impressed.

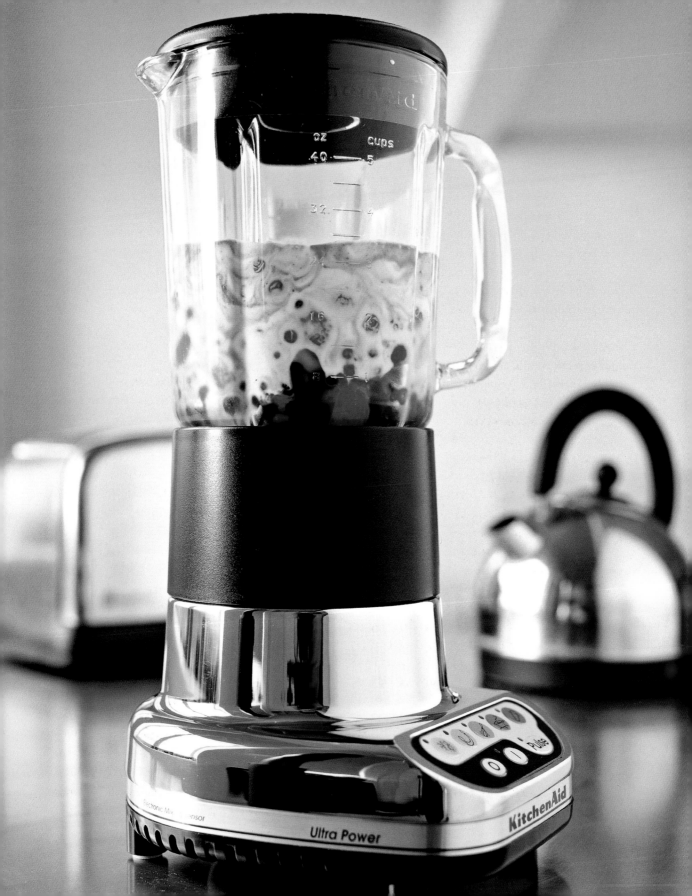

Toaster

AS WARM AS TOAST

Toasting was originally employed as a means of drying and thereby preserving bread, and was practiced by the ancient Egyptians, and later by the Romans. The word "toast" derives from the Latin *tostum*, which means to scorch or burn. Toasting also greatly improved the taste and handling qualities of bread. Exposing bread to heat actually changes its chemical properties. In a process called the Maillard Reaction, the starches and sugars in bread are caramelized, becoming sweeter and turning brown. The resulting toast is also crunchier and harder, and therefore more suited for spreading.

Before the introduction of electricity toast was made by either heating bread on hot stones or, more typically, by exposing it to fire. People used toasting forks and later wire frames that could be flipped over when one side was done. As electricity caught on at the end of the 19th century there was a drive to invent appliances to take advantage of this new power source. Toasters and related heating devices were slow to appear, however, because it was hard to make filaments that could heat up quickly without burning out. Light bulb engineers were grappling with similar problems, but their filaments had the advantage of operating in a vacuum.

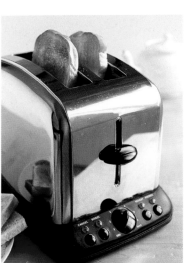

The basic principle for making toast has changed little since it became popular in the first century AD
To begin the Maillard Reaction, heat the bread to 310°F (149°C) but turn the heat off before the sugars and starch turn to carbon.

A suitable filament was not developed until 1905. Made from a mixture of nickel and chromium, this filament formed the basis of the first successful electric toaster, made by General Electric in 1909. Electric toasters subsequently became extremely popular and dozens of manufacturers came up with hundreds of designs, including some magnificent Art Deco masterpieces. Most involved a wire cage to hold slices of bread next to an exposed filament, sprouting from a porcelain base. The bread had to be flipped or turned over in order to cook both sides and had to be carefully watched to avoid burning.

This goal was not always achieved, and in 1919 Minnesota mechanic Charles Strite patented the first pop-up toaster, born out of his frustration at constantly being served burnt toast. The first domestic version was the "Toastmaster," which toasted both sides of the bread at once and featured a color-coded timer-setting dial. Released in 1926, it was advertised with the proud boast, "Makes perfect toast every time! Without watching! Without turning! Without burning!" Unfortunately the timer setting had to be reduced because the toaster heated up with repeated use, and owners were advised to run it once without toast to allow it to warm up.

Coffee makers

BREWING UP A STORM

Making coffee is a complex business—part science, part art. Coffee beans contain desirable substances, such as caffeine and flavorful, aromatic volatile oils. The drink they produce when ground, however, can have a bitter taste. A successful brew extracts as many of volatile oils as possible, and depends on many factors, including the water temperature (which should be hot, but not boiling), and the coarseness and packing density of the grounds.

The Turks were the first to make a drink out of coffee beans in around 575 AD, using a pot called an *ibrik*, designed, according to legend, to be heated in the desert sand. In the *ibrik* the Turks would steep crushed roasted beans in water to make an infusion. This same basic method has been used to make coffee throughout most of the beverage's history, and is still the most widely used method.

When coffee was introduced to Europe in the 16th century it was still made along much the same lines, which meant that coffee drinkers had to contend with boiled or burned coffee and the presence of grounds, both floating and settled, which were irritating and made the coffee taste bitter. During the 16th and 17th centuries numerous pots were designed to help overcome this problem. Some pots had narrow spouts to trap floating grounds, and broad, necked bottoms to trap the settled grounds. Others had the spout set in the middle of the pot, to avoid the grounds at the top and bottom during pouring.

Women played a big part in the development of coffee-making technology. One theory behind this is that coffee was extremely popular in brothels, and that the madams who ran the brothels were the main innovators. Not all women, however, approved of coffee. In England in 1674 a group of concerned wives tried to ban coffee, as their husbands were spending too much time at bawdy coffee houses.

Rudimentary filters, probably of cloth or hemp, must also have been in widespread use long ago, but they would have been individually improvised and no record of them survives. Use of baglike filters (possibly even socks), however, inspired the development in the late 18th century of the biggin— a metal pot with two sections, the upper or inner section of which was pierced with small holes. Hot water was poured over the grounds and percolated through the holes, filtering into the lower chamber. Biggins were extremely popular, but although they successfully separated the grounds from the liquid it was still difficult to avoid under- or overbrewing. If the grounds were too coarse, water would run through too quickly; if they were too fine, they would pack together and water would run down the sides of the filter.

The 19th century saw an explosion of ingenuity in the development of coffee-making devices. The biggin was improved with a water spreader that distributed water evenly over the grounds. The French coffee press, or *cafetière*, was invented in the early 1800s, and was followed in around 1840 by the vacuum pot, or *hydropneumatique*. This device had two sealed glass globes joined by a narrow neck. Water in the bottom globe was heated, generating

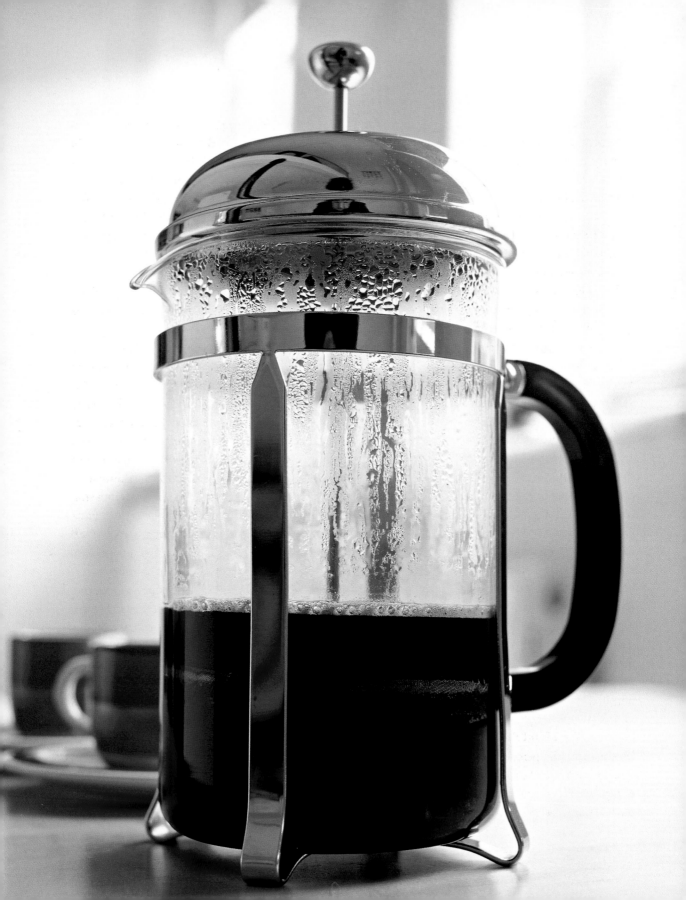

steam, which forced water up into the top globe. When the heat was removed, the steam condensed, forming a vacuum that sucked water back down through the coffee, which was held in place by a filter. Unfortunately glass technology was crude and early vacuum pots had a tendency to explode. The first coffee percolator was invented in 1818, and percolating has been popular ever since, although it breaks several cardinal rules of coffee making—in a percolator, brewed coffee is boiled and repeatedly passed over the grounds.

By the early 20th century several types of coffee maker used metal filters, sometimes with linen or cloth filters on top. These affected the flavor of the coffee, however, and were difficult to clean. In 1907 a German housewife, Melitta Bentz, decided to find an alternative. She experimented with cotton before cutting out a circle from her son's pad of blotting paper. The hard-wearing but porous paper made a perfect filter, and made disposing of the grounds easy. The Melitta Bentz coffee filter company was launched the next year, going on to become one of the biggest names in the world of coffee.

THE PERCOLATOR

By this time the percolator was the most popular type of coffee maker in America, and the first electric versions appeared in 1908. Although they made use of electricity for the hotplate, the real

A mocha is composed of two sections separated by a metal filter holding ground coffee. When placed over a stove, the water from the bottom boils into steam, passing through the coffee into the top where it condenses back into water, now infused with caffeine-rich goodness.

appeal was the development of the automatic cut-off control, which helped to avoid overbrewing. In 1972 Sunbeam developed the Mr. Coffee, with its automatic drip process. It quickly became the leading model of coffee percolator in the United States, and remains so to this day.

THE ESPRESSO MAKER

All these methods depend on infusion, but the best coffee is produced by the espresso method, in which hot water is driven through finely ground coffee at high pressure. This extracts more of the fatty substances in the coffee grounds than infusion. Fatty substances, which include the volatile oils that give flavor and aroma to coffee, do not dissolve in water, which is why they are resistant to infusion, but under high pressure they emulsify, forming a suspension of tiny droplets of oil. The resulting coffee has a strong aroma and velvety texture, and penetrates deeper into the taste buds of the tongue, giving a more intense flavor, while simultaneously inhibiting the bitter receptors.

The first machine to produce coffee in this way was invented in 1822 by Louis Bernard Babut, and refined by Edward Loysel de Santais. At the Paris Exposition in 1855, one of de Santais's machines was said to produce 1,000 cups an hour. Unfortunately these early machines relied on steam to provide the pressure they needed, and frequently overheated, scalding the coffee and risking explosions. In 1935 Francesco Illy built an espresso

machine that used compressed air to provide pressure, while in 1945 Achille Gaggia invented an even better version using a piston to provide pressure. Espresso machines have now been simplified and automated to the point where practically anyone can make a decent espresso.

The derivation of the word espresso is the subject of much debate, but it is generally held to mean a cup of coffee made to order, as opposed to one that is prebrewed. Another possible derivation is from the word "express," as in "fast," or perhaps because the coffee is "expressed" under high pressure.

Kettle

STEAM POWER

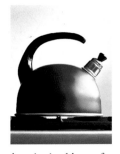

In its earliest form the kettle was simply a metal pot for boiling water, but the form that we associate with kettles today was already known in ancient Mesopotamia. A bronze vessel, almost identical in appearance to a modern kettle, had been found there from the period around 3000 BC, although this early implement is thought to have been used for straining rather than boiling water. After the Bronze Age most kettles were made of iron and, by the 19th century, copper, which is durable, rustproof, and an excellent conductor of heat. Unfortunately copper tarnishes easily, and since kettles were heated over a fire or on a stovetop, copper kettles had to be cleaned after every use.

THE ELECTRIC KETTLE

The first electric kettle appeared in 1891, although there is a dispute over where. Both Crompton and Co. of Britain and the Carpenter Electric Company of Chicago claim the honor of having introduced it. Traditionally, the United Kingdom has been more interested in tea drinking and making, and has therefore been the leader in the field of kettle technology, so perhaps the British claim is more probable.

Early electric kettles copied the principles of nonelectric ones, and were heated by an element housed in a separate compartment underneath the water. This made them inefficient and slow—it took up to 12 minutes to boil the water. This all changed in 1922 when Swan introduced the first element inside the kettle. By encasing the heating element inside a metal tube he could heat the water directly, speeding up the process. The sizzling noise heard when a kettle is first switched on is caused by the rapid heating of this element and the water in immediate contact with it, while the rest of the water is still cool. The heat causes microscopic bubbles of steam to appear, which quickly, and noisily, collapse. As the heat spreads more evenly through the water the bubbles stop forming and the hiss dies away.

Together with other British manufacturers such as Hotpoint, Swan also introduced safety mechanisms that would turn the kettle off if it

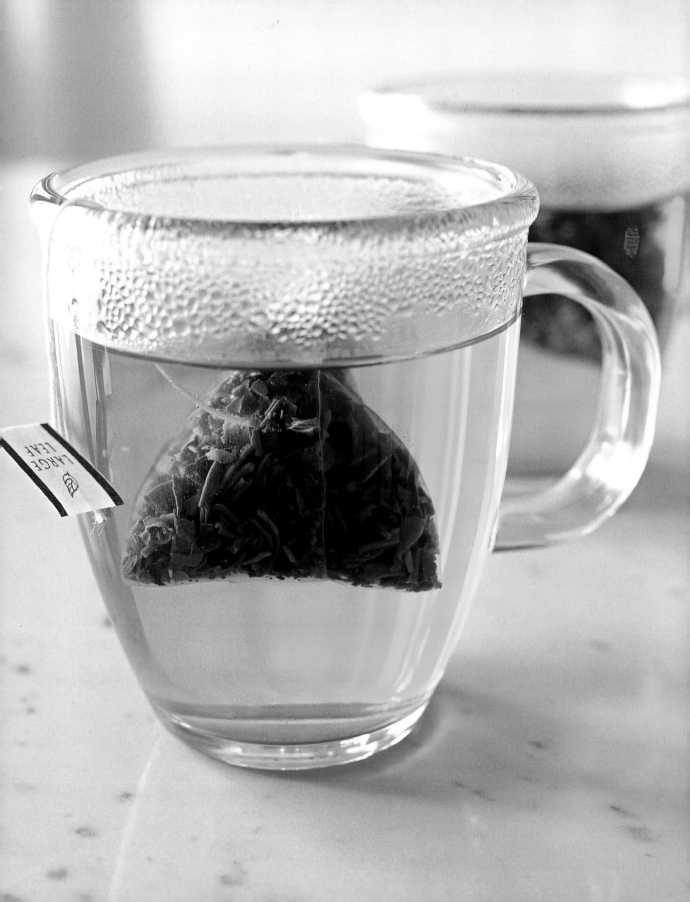

boiled dry or was switched on without being filled. The kettle was not yet fully automatic, however, and had to be watched until it boiled (or, in the case of the whistling tea kettle, invented in 1921, listened out for).

The kettle changed very slowly in the following decades. Most, like their pre-electric predecessors, were still made of copper, sometimes with a nickel-plate or vitreous enamel finishing. Chrome-plating and Bakelite handles appeared in the 1930s. Most of these advances happened in Britain, where the kettle was most popular. During World War II, for instance, when the manufacture of many domestic appliances was interrupted as materials and factories were turned over to the war effort, the kettle was produced as normal—a mark of its central role in the British household.

In 1956 the kettle became fully automatic with the introduction, by Russell Hobbs, of a device to cut the power when the water boiled. Cut-outs on modern kettles still work on the same principle. A strip composed of two or three different types of metal, known as a bimetallic or trimetallic strip, sits in a switch chamber at the back of the kettle. Steam from the boiling water enters the chamber and heats up the strip. Because the different metals expand at different rates in response to heat, the strip buckles and bends, pulling an attached bar out of a circuit. Breaking this circuit cuts power to the element, turning the kettle off. Today's kettles are essentially identical to those of the 1950s, although plastic kettles were introduced in the 1970s, paving the way for a greater range of colors and shapes.

Tea bags and instant coffee

GOING TO POT

After plain water, tea is the most popular beverage in the world, with coffee not far behind. Making tea or coffee properly can be a time-consuming business, requiring a variety of implements such as pots, strainers, and filters, and with consumers drinking several cups a day there has been an inevitable demand for more convenient preparation methods.

THE TEA BAG

When New York tea and coffee merchant Thomas Sullivan started handing out samples of loose-leaf tea in small, hand-sewn silk bags in 1904, he should not, perhaps, have been surprised that customers didn't bother to undo the bags before making their tea. Instead they simply plunged the bags directly into the hot water—the tea bag was born. In the summer of the same year iced tea was invented when Richard Blechynden, a tea seller at the St. Louis World's Fair, having failed to sell his wares to

the overheated crowds, poured his stock over ice. The new drink was an instant sensation and iced tea now accounts for 80 percent of the 136 million cups of tea quaffed by Americans each year.

Early tea bags tended to impart too much of their own flavor to the brew, and they were not commercially released in America until the 1920s. They took even longer to reach Britain, finally making it over in 1953 when Tetley released perforated tea bags "for immediate use in the pot." Manufacturers used various materials for their bags, including hemp, rayon, and woodpulp, eventually settling on a flavorless type of tissue paper. Tea bag sales took off in the 1960s, and in Britain they rose more than tenfold from 1960 to 1968. Subsequent developments in the tea bag, including Lipton's four-sided Flo-Thru bag, Tetley's round and drawstring bags, and PG Tips' pyramid bags are considered to be largely cosmetic, making little difference to the taste or speed of brewing.

Whether using loose tea leaves or bags the rules of proper tea making are the same—warm the pot first, use freshly drawn cold water and add it to the pot straight off the boil, leave it to brew for a few minutes and always add the milk to the cup first.

INSTANT COFFEE

The first attempts at instant coffee made an appearance even before tea bags. In 1901 a Chicago chemist named Satori Kato invented a soluble instant coffee, and in 1906 George Constant Washington, an English chemist living in Guatemala, created the first mass-produced instant brand, Red E Coffee. Instant coffee only became a success, however, with the introduction of freeze-drying. Freezing and drying are two different ways to preserve food but both have their drawbacks. Drying tends to diminish the flavor and quality of the food, while frozen food is difficult and expensive to keep cold. Freeze-drying, technically known as lyophilization, combines the advantages of both.

The principle of freeze-drying was known and exploited by the Incas, who stored potatoes and other crops high on the slopes above Machu Picchu. The food would freeze and the icy winds and low air pressure at high altitudes evaporated their water content by a process called sublimation. When the freeze-dried produce was heated in water it regained its full flavor and texture. Nestlé brought the process to coffee beans in the 1930s, when the Brazilian government asked them to devise a way to preserve and market their massive coffee surplus. The result was Nescafé, introduced in 1938. The powdered drink was a huge success during World War II when it became a staple part of the GI's diet, and sales rose astronomically in the postwar years. Nescafé remains the world's leading brand of instant coffee, with more than 3,000 cups consumed every second.

Why hasn't instant tea caught on in the same way? After all, Nestlé introduced Nestea as far back as the early 1940s. The answer is probably that the tea bag offers enough convenience for the average tea drinker, without sacrificing the taste benefits of using real leaf tea. If coffee bags could be made to work as well as tea bags, instant coffee might also become redundant.

Cans, openers, and ring pulls

CAN-TASTIC

In 1795 a newly appointed General in the French Army, Napoleon Bonaparte, was desperately trying to find an answer to the Army's problems with long supply lines. His troops were defending the Mediterranean coast and the food that reached them was invariably spoiled. As encouragement he offered a 12,000-franc prize for a practical method of preserving food, but it was not to be claimed for another 15 years. In 1810 a French confectioner, Nicolas Appert, devised a process whereby food could be sterilized then stored in airtight containers for long periods without spoiling. Food or milk was put into glass jars, heated in boiling water to kill bacteria, then sealed. This process proved effective, but expensive.

CANS

The first tin can (actually tin-plated iron) was patented that same year by Englishman Peter Durant, who had read Appert's published work on the subject, *L'Art de Conserve*. Again, the process was successful, but the cans were unwieldy and heavy. Using Durant's invention, however, the firm of Donkin and Hall set up a "preservatory" to supply tin cans to the armed forces.

The cans were also popular with explorers—one of the oldest surviving instances was a can of roast veal taken by Captain William Parry on his 1824 Arctic exploration. It came complete with the instructions, "Cut round on the top with a chisel and hammer." At that time, methods of opening cans included using knives, bayonets (which some claim were invented for the purpose), and even bullets. The problem was that in order to maintain their shape, early cans were made of thick iron—Parry's can of veal weighed nearly one pound (0.45 kg) even when empty, and had walls $\frac{1}{5}$ inch (0.5 cm) thick (modern cans have walls just $\frac{1}{5000}$ inch [0.0005 cm] thick—roughly the thickness of a magazine cover). Can-opening devices capable of piercing this sort of armor would have been impractical and the first specially designed can opener was not invented until 1858.

In the mid 19th century steel cans were introduced—these were stronger than their iron predecessors and could therefore have thinner walls. The first cans were individually handmade and even the best worker could produce no more than 60 a day, but in 1846 Henry Evans invented a die-stamping device that could produce a can body in one step. Production rates shot up to 60 per hour, although the tops and bottoms of cans continued to be soldered on by hand for a further 50 years. Inevitably, as speed of production increased, the use of cans became more widespread.

THE CAN OPENER

The first can opener patent was granted in 1858 to Ezra Warner of Connecticut—it was an unwieldy device involving a short blade to punch a hole in the lid and a longer blade to saw round the top.

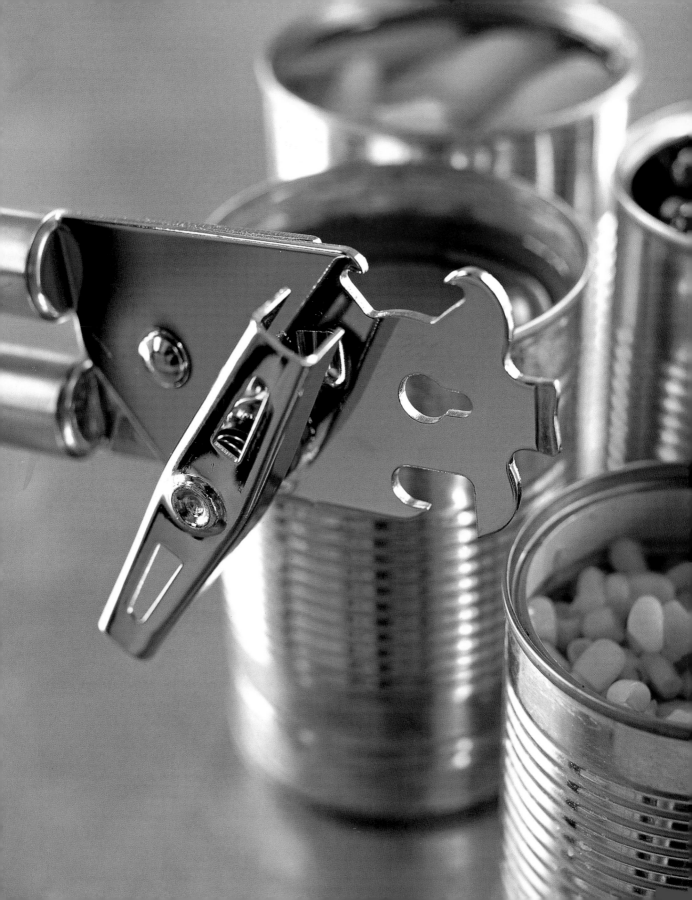

Although soldiers in the Civil War used it, it failed to catch on with the general public, suggesting that they were satisfied with whatever makeshift methods they used for can opening.

In 1870 American William Lyman patented the much more advanced "wheeled" can opener. This device had a metal point that pierced the center of the can's lid and acted as a pivot around which the cutting wheel, powered by the handle, revolved. In order to open a can successfully, the user had to pierce the exact center of the can and the opener had to be adjusted to match the size of the can. This device didn't catch on either—in fact the first popular domestic can opener was probably the 1907 Bull's Head opener, which worked on similar principles to Warner's original invention. In 1925 the Star Can Opener Company of San Francisco modified Lyman's design by adding a toothed gripping wheel to replace the central pivot-arm. This device was much more practical and, apart from an electrified version that appeared in 1931, has remained essentially unchanged to the present day.

Although condensed milk was canned as early as 1885, tin cans were mostly used for food until the

A rigorous process of pressing, ramming, and ironing goes toward making a drink can. Cans today are made either from aluminum or tin-coated steel, and are constructed from just two pieces—the top, with its integral tab, and the main body.

1930s, when beer was sold for the first time in bottle-shaped cans with a crimped on cork-crown lid. Later these were replaced with flat-topped cans, which were much cheaper to make but once again posed the problem of access for consumers. Cutting the whole lid off was obviously a poor option and stabbing the lid with a typical can-opening device was messy. Until 1963 the standard answer to these problems was the church key—a bottle-opener style device that pivoted on the lid rim and pierced the lid with a wedge-shaped point. Two holes had to be made to allow air in as the liquid left and thus avoid "glugging."

Church keys had a number of disadvantages, however. They were an added cost to the beer companies as they often had to supply the keys with the cans, and that meant that a can of beer could only be enjoyed if you had remembered to bring your church key with you—seriously undermining the convenience that was one of the can's original selling points. Ermal Fraze of Dayton, Ohio, was confronted with this very problem on a family picnic in 1956. Having forgotten his church key, he had to resort to using the bumper of his car and lost most of the beer in the process. This proved a happy accident, for Fraze

owned the Dayton Reliable Tool Company, and became determined to find a solution to the problem.

THE RING PULL

Experienced in the field of metal dies and metal scoring, he soon hit upon the idea of scoring a tear-off strip on the can lid and attaching a tab to one end of the strip. The tab acted as a lever for pulling up the end of the strip and tearing it off, leaving a big enough opening for air to get in as the contents left. This idea had existed in a primitive form as early as 1866, when the makers of canned sardines, in response to the fragility of their product and its tendency to break up when the lid was battered in, soldered a key on to the lid, a design that still exists today. Fraze's "pop-top" can was patented in 1963 and proved to be a huge success, paving the way for the introduction of soft drinks in cans in 1965 (1967 for Coca Cola and Pepsi).

In many ways this invention was too successful, and by the mid 1970s there was widespread concern about the ecological cost of tens of millions of discarded ring-pulls and the sharp-edged tear strips to which they were attached. Dozens of patents were issued to inventors attempting to make an "inseparable tear strip," but not until 1980 did Coors, the brewery, arrive at the solution generally employed today, where a tab acts as a lever to depress a tear strip into the can but remains attached to it.

Corks and corkscrews

PULLING OUT THE STOPS

Until the 17th century glass bottles were too expensive and difficult to make to be used for the routine storage of liquids—usually wine or beer. The ancient Romans and Greeks stored their wine in terracotta amphorae and used cork to stopper the jars, but unfortunately this knowledge of cork was apparently lost after the collapse of the Roman Empire. In medieval times, wine was stored in barrels or skins, which were stoppered with plugs of wood or cloth. These did not form an airtight seal, however, and wine quickly oxidized to vinegar.

By the 17th century glass-blowing technology was sufficiently advanced to produce robust bottles with narrow necks, making airtight storage of their contents possible. The new bottles, which were initially used for medicines and cosmetics rather than alcohol, needed something to provide an airtight stopper and the virtues of cork were rediscovered. Relatively cheap and available in large quantities, lightweight, and easy to work with, cork was ideally suited to the job.

CORKS

Cork comes from the *Quercus suber*, or cork oak, a species of tree native to the Iberian peninsula. The English were the first to use cork to seal wine

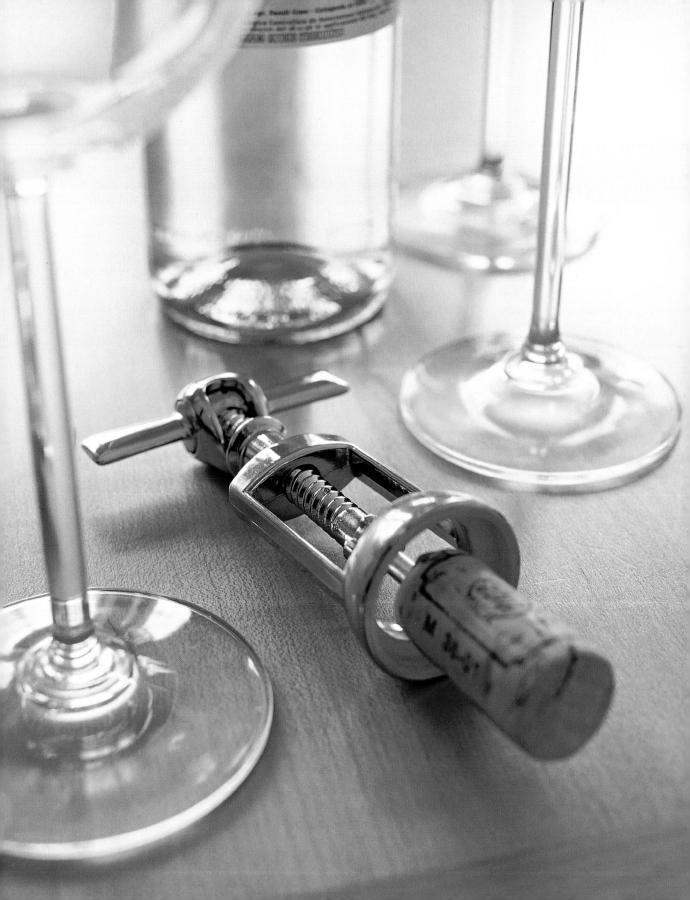

bottles—having imported the cork from Spain and Portugal, still the homes of cork production today. Carefully tended, cork oaks can live for up to 170 years. This is important because the cork is harvested by cutting strips from the bark of the tree, and the older the tree, the thicker the bark. Once cut, the bark strips are dried in the sun for six months, boiled for 90 minutes, dried again for three months, and then corks are cored out of the strips. The process is not very efficient—only 40 percent of the cork strips are used. The first corks were tapered to make them easier to insert, but now that insertion is widely automated they are made with straight sides. You can tell how old a cork is by its shape. The narrower and more misshapen, the older it is. Also, older corks are sometimes encrusted with crystals at the bottom, where tartrates in the wine have come out of solution. The mushroom shape of champagne corks helps them to stay in the neck despite the added pressure of gas in the bottle. They are not solid cork but are made from discs of cork, separated by "cork mash."

Corks do have disadvantages. They are susceptible to mold, which contaminates the wine with a chemical called 2,4,6-trichloranisole—the cause of "corking." They also have to be kept wet, by laying the bottle on its side during storage, or they will dry out and allow air

into the bottle. Modern substitutes such as plastic avoid these drawbacks and do not affect the quality of the wine, but have been slow to catch on, mainly because of consumer inertia.

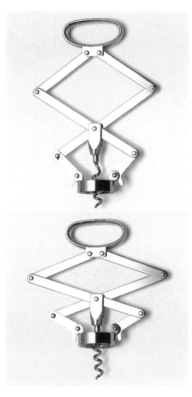

Concertina-style corkscrews, like the one pictured here, make ingenious use of the principles of levers. Winding the screw into the cork compresses the concertina. When you decompress it by pulling the handle, the lever arms allow you to exert less effort than if you were raising the cork directly, but over a greater distance, so that the total amount of work done is the same.

CORKSCREWS

Surprisingly, corkscrews were not invented until some years after corks were rediscovered. Exactly how people gained access to their wine in these years is not certain but they probably adapted an existing tool called a "gun worme" or "bulletscrew." This was a corkscrew-shaped instrument designed for clearing gun barrels. By the early 18th century corkscrews became commonplace. A good corkscrew has a wire spiral (one that is "hollow" down the center) rather than a solid shaft with a screw spiraling around it. A wire spiral enters the cork with minimal resistance and grips it well, whereas a solid-shafted one has to "push" the cork out of the way and is more likely to break or rip it.

Subsequent developments in corkscrew technology included the "waiter's friend" (1882) and the "double-winged lever" (1888) most popular today, also known as the "screwpull." The lever action as the wings are drawn down, or the body of the corkscrew pulled upward against the neck of the bottle, allows for much easier removal of corks.

Milk and juice cartons

CARTON HEROES

Milk, like most other drinks, always used to come in glass bottles. These needed to be heavy enough to be hard-wearing, but also had to be delivered, used, collected, cleaned, and then refilled, in the days when recycling was still a dirty word. It was inevitable that someone would produce a convenient, disposable alternative and, as with cups, straws, and a host of other vessels and containers, paper presented a cheap, lightweight, and easily disposable option. Exactly who developed the concept first is a matter of dispute. Some authorities credit Victor W. Farris, but the best known earlier pioneer of paper cartons was John Van Wormer, owner of a toy factory in Toledo, Ohio. In 1915 he was granted a patent for a paper milk carton called the Pure Pak but struggled for years to devise a machine that could make the cartons. He finally succeeded in the 1920s and became a leading manufacturer of paper milk cartons. Over the next few years the price of glass was to rise considerably, convincing obstinate consumers to give up their milk bottles and "go paper." In 1932 the first plastic-coated-paper milk cartons were introduced commercially, and by 1950 Van Wormer's factories were making 20,000,000 milk cartons a day.

John Van Wormer was supposedly inspired to create the paper milk carton after dropping one milk bottle too many. Today the most familiar carton shape is the gable top of the Tetra Rex and its successors, although screw tops now provide easy access to the contents.

Other paper carton pioneers include Victor W. Farris, and the Swedes Ruben Rausing and Erik Wallenberg, founders of Tetra Pak. Development of the Tetra Pak began in 1943, with the aim of creating a milk carton that used the minimum possible amount of packaging, using a tetrahedral shape. When the Tetra Pak was launched in 1951 it created a media sensation and quickly gained favor in Sweden. Within a few years the cartons were popular all over Europe. In 1963 the company released the Tetra Brik—a brick-shaped carton—and in 1965 the first Tetra Rex, with its familiar "gable" top.

Despite competition from plastic containers for milk and juice, first introduced in 1964, Tetra Pak was enormously successful, increasing production from 10 billion cartons a year in 1971 to 30 billion a year by 1980. Thanks to paper cartons the current owners of Tetra Pak—Ruben Rausing's sons—are two of the world's richest men.

Tupperware

THE HOUSEWIFE'S FAVORITE

 Named after its inventor, Earl Silas Tupper, Tupperware is one of the best-known uses of the plastic polyethylene. Tupper was a New Hampshire tree surgeon and landscape gardener with an interest in inventions and modern materials. Work experience with chemicals giant DuPont introduced him to the world of plastic, and in particular the new synthetic polymer polyethylene, which was commercially introduced in 1942.

Although plastics had been around for several decades, methods of refining and producing them were still somewhat crude. They had a poor reputation with the consuming public, and were widely considered to be unattractive, brittle, greasy, and smelly. Polyethylene could change all that, and Tupper knew it. Unable to afford refined plastic for his early experiments, Tupper instead got hold of a mass of black, unrefined polyethylene slag, a by-product of the oil-refining process. He soon developed a technique for refining polyethylene, turning the slag into a clean, nongreasy, tough, flexible, waterproof, translucent material that he was convinced would make a perfect domestic product.

Tupper's first use of the new plastic was a line of unbreakable bathroom tumblers in a rainbow of colors, released in 1945. The following year the Tupperware Plastics Company brought out a line of polyethylene containers with a revolutionary lid. Modeled on the lid of a paint can (in reverse), the new lid created an airtight, liquidproof seal, which helped to preserve the contents of the container without any spillage or leakage.

Customers found the lid confusing, however, and sales were poor. Only in Florida was the product successful, after an enterprising direct-sales firm specializing in household products added the new Tupperware to their list. Intrigued, Tupper met with Brownie Wise, one of the firm's main sellers, in 1948, and together they perfected the home selling plan that was to make Tupperware a household name. In return for a free sample, a local housewife would agree to host a "Tupperware party" and invite all her friends. Here a demonstrator would extol the virtues of the new product and people could make purchases from the comfort of their living room.

Tupperware parties quickly caught on and seemed to gel perfectly with postwar America. The social aspect of home selling helped the increasingly mobile American housewife to meet and socialize with new people in her new neighborhood. The product itself was also emblematic of the era: plastics represented modernity, progress, style, and convenience, and none more so than Tupperware. The parties were an instant success, and by 1951 Tupper stopped selling his containers in stores altogether. In 1958 Tupper sold his business for millions and retired to a life of quiet seclusion, but his Tupperware still lives on. Today, a Tupperware party begins every two seconds and they are attended by over 118 million people every year, giving the company annual sales of $1.2 billion.

Pepper mill

THE DAILY GRIND

The earliest implements for grinding were the mortar and pestle, which date back to the paleolithic era, before the invention of agriculture (that is, further back than 10,000 BC). For the domestic grinding of salt, pepper, and other foodstuffs the mortar and pestle remained the last word until the 19th century.

From that point on, however, both commercial and industrial technology progressed considerably, resulting in a sophisticated milling apparatus that could crush grains and even metal ores between its grinding wheels. This milling technology was first applied on a smaller scale not to pepper or other spices, but to coffee, which was making a big impact on the European scene in the 1600s. Coffee shops, needing a way to produce ground coffee for brewing fast enough to keep up with demand, started using coffee grinders—small-scale mills that could be turned by hand. Apothecaries and herbalists soon followed suit, using the grinders for their own purposes.

Around 1815 the first domestic grinding devices appeared, again intended for use with coffee beans. British ironworker Archibald Kenrick made a compact mill consisting of a small hopper that fed

Now the most popular spice in the world, pepper used to be a valuable rarity. In medieval times it was given as a reward to victorious Crusaders and used to pay rent, taxes, and even dowries.

beans into a couple of blades, from where the grinds fell into a small drawer for collection. His design was widely copied and similar grinders can still be bought today. Elaborations on this basic design flourished, and more than 150 coffee-grinder patents were granted in the 19th century.

As grinder technology was being perfected, pepper and other exotic spices were becoming much cheaper and more widely available. In the Middle Ages pepper had been literally worth its weight in gold, and was sometimes used as a form of currency. As it became routine to add ground pepper to meals, domestic patience with the mortar and pestle ran out, and the pepper mill became a regular feature of the late-Victorian kitchen.

A close relation of the salt and pepper mill is the cruet set, which also dates back to ancient times, when salt was a highly valued commodity (the word "salary" derives from the fact that Roman legionnaires were paid in salt). The upper classes of many different cultures would demonstrate their wealth by displaying salt on the dining table in ostentatious holders, such as the salt holder in the form of an ornately carved miniature chariot, thought to be the property of a proud Celtic chieftan.

Pyrex

A GLASS ACT

The first "unbreakable"—shatterproof—glass dates back to ancient Rome, during the reign of the Emperor Tiberius (14–37 AD). Both Pliny and Petronius record that an inventive glassmaker demonstrated to the Emperor a remarkable vase made of *vitrum flexile*, "flexible glass," which he was able to throw on the ground and even hit with a hammer. According to the story, Tiberius, fearing that the substance would become more valuable than his own hoards of gold and silver, had the hapless inventor put to death. His secret died with him, not to be resurrected for almost 1,900 years.

The tale of the *vitrum flexile* is probably fanciful, or at least an exaggeration, but it is not impossible that the Roman glassmaker could have stumbled on the secret of borosilicate glass—the basis of today's heat- and shatterproof glass, usually known by its trade name, Pyrex. Ordinary glass is made of fused silicon dioxide (sand), with traces of added ingredients such as sodium and calcium. It is fragile and expands on heating and so cracks and shatters easily with repeated heating and cooling. Adding boron, in the form of boric oxide, dramatically changes the response of the glass to heat—it expands only one third as much and is resistant to chemical and physical attacks.

When American scientist Jesse Littleton originally suggested to his colleagues that they could use borosilicate glass as cookware he was laughed out of the laboratory. Pyrex is indispensable in today's modern kitchen.

It is possible that boric oxide was available in the ancient world. The Romans had extensive trade links with the Indian subcontinent, from where medieval goldsmiths would later import borax (naturally occurring boric oxide). Hot springs and steam vents around Rome also contained naturally occurring boric acid.

Whatever the truth of the story, it was not until 1884 that Germany's Otto Schott produced the first heat- and chemical-proof glass to appear on the modern stage. Schott's glass achieved limited industrial applications, but in 1913 Jesse Littleton, a scientist at the Corning Glass Works in New York, had his wife bake a cake in the sawn-off bottom of a glass battery jar, in an effort to show that "unbreakable" glass could be a useful ovenproof material. By 1915 Eugene Sullivan and William Taylor at Corning had come up with an improved version of borosilicate glass that was given the name Pyrex, supposedly because its first use was to make a 9-inch pie dish for commercial release.

The new material was lightweight as well as resistant to chemical, thermal, and physical attack. Pyrex cookware quickly caught on with the American public—by 1919 they were buying more than 4.5 million Pyrex dishes a year, even

though early versions were often discolored, with internal imperfections and unsightly cracks. There was also a great demand for heat- and chemical-proof glass from laboratories around the world, and Pyrex quickly became the material of choice for test tubes, laboratory flasks, and glassware in hospitals, which must be repeatedly sterilized at high temperatures.

Because Pyrex can also be drawn into fibers and even spun and woven into fabrics, it has become a favorite material for novelty glass-workers and is also used to make giant mirrors for astronomy telescopes.

Teflon

SOLVING A STICKY PROBLEM

Teflon is the trade name for polytetrafluoro-ethylene—a non flammable waxy resin that is impervious to practically anything you can throw at it. Roy Plunkett, an experimental chemist working at DuPont, originally discovered this remarkable compound in 1938. He found that a container of gas stored overnight had congealed to form a waxy dust that could withstand attack by corrosive chemicals, extreme temperatures up to 725° F (385° C), or combinations of the two. He also discovered that it was slippery—in fact, it is the slipperiest solid on earth, according to the *Guinness Book of World Records*. Teflon's remarkable properties make it ideal as a nonstick coating for saucepans, but this never occurred to the chemists at DuPont, who used it exclusively for industrial applications. It was not until 1954 that a French housewife realized its domestic potential. Her husband, Marc Gregoire, had heard about Teflon from an engineer friend and started to use it to coat his fishing tackle and gear to protect them from wear and tear. His wife asked him if he could do the same for her saucepans. By 1958 Gregoire was selling more than 1,000,000 Teflon-coated saucepans a year.

That same year an American journalist named Thomas Hardie was introduced to Teflon cookware by a friend who had recently returned from Paris. He was amazed when the friend cooked him a butter- and oil-free meal without marking the saucepan in any way, and was even more amazed to learn that Teflon cookware was unknown and unavailable in the United States. Spotting a business opportunity, Hardie imported several thousand saucepans from France, expecting them to practically sell themselves, but was dismayed to find that retailers did not believe his extravagant—though accurate—claims for the new material. Eventually he was able to convince a Macy's store in New York to take 200 saucepans—they sold out in two days and within a year Hardie was setting up his own factory to manufacture Teflon-coated cookware.

These days, Teflon has a wide range of applications. It is used to coat spaceships, light bulbs, car brake pads, replacement blood vessels, and even parts of the Statue of Liberty. It is not,

however, the easiest material to use, partly because it is initially produced in powder form and partly for the very nonstick properties that make it so valuable. The first step is to roughen the surface of the item to be coated, using a form of sandblasting. The Teflon powder is then mixed with a fluid to give a sort of slurry. This is used to coat the item, and the liquid medium is then evaporated. The tiny grains of Teflon powder fill up the scratches and notches on the item, and are then heated until each grain sticks to its neighbors—a process known as sintering.

The problem originally was that this layer did not hold up very well under normal household use, and any scratches on the Teflon surface reduced the nonstick quality of the saucepan. The basic nonstick molecule is a polymer, or chain, of fluorine atoms and additives such as carbon and hydrogen. The longer this chain, the tougher it is; but a molecule that is too long gets viscous and hard to handle. To move beyond mere mechanics, skillet engineers added a sticky molecule to the nonstick molecule. Nonstick was now applied in coats, with the bottom coat containing the sticky additive that adhered to both the metal saucepan and the nonstick molecules. A coat of nonsticky nonstick went over that, nonstick and nonstick clinging together lovingly. A final nonstick layer, spiked with minute pieces of ceramic or other tougheners, protected the softer guts.

Thermos flask and cooler

CHILL OUT

James Dewar, one of the leading British scientists of his era, invented the Thermos flask in 1892. Dewar specialized in low-temperature chemistry, and was the first to produce liquid hydrogen. Lacking a container that could store his liquid gases while maintaining their low temperatures, Dewar devised his own, with a design that would interrupt the three processes by which heat moves about—conduction, convection, and radiation.

Even the screws that attach the handle are insulated in plastic in this classic jug-style Thermos flask.

The Dewar flask, as it was then known, consisted of a hollow-walled silvered glass bottle, with a rubber bung. The air was removed from within the walls of the bottle, creating a vacuum. A vacuum is an excellent insulator, preventing heat loss through conduction and convection. The glass walls of the bottle made poor conductors, while their silver covering prevented heat loss through radiation, as silver reflects up to 99 percent of radiation. The

rubber bung, also a poor conductor, again prevented heat loss through both conduction and convection.

As the Dewar flask prevented heat transfer in any direction, it could be used to keep its contents hot as well as cold. Dewar had one made for his son in 1902, but according to legend, his mother-in-law refused to believe the miraculous properties of the ingenious device and knitted a woollen cosy for it.

Dewar did not patent his invention, regarding it as a universal scientific tool, and one of Dewar's assistants, Reinhold Burger, a German glassblower who had helped make the flask, decided to exploit its commercial potential. Improving Dewar's fragile design by encasing the glass bottle in a sturdy metal case, Burger obtained a patent in 1903 and started manufacturing in 1904. To help drum up publicity he held a competition to find a name for the new product, and the winner was "Thermos," based on the Greek *therme* (heat).

As well as inventing the Thermos flask, James Dewar was the first man to produce liquid hydrogen and co-invented cordite. Tea or soup may be the typical contents of today's Thermos but it was originally invented as a tool for storing and transporting liquid gases.

The Thermos was an instant success and a worldwide bestseller, thanks in part to the free publicity it gained from the day's leading explorers and pioneers. Thermos vacuum flasks were carried to the South Pole by Ernest Shackleton, the North Pole by William Parry, the Congo by Colonel Roosevelt and Richard Harding Davis, Everest by Sir Edmund Hillary, and into the skies by both the Wright brothers and Count von Zeppelin.

In addition to holding hot soup and iced tea, the vacuum flask found a range of applications in science and industry. It was used in electrical instruments, altimeters, oil detection, and meteorology, and has carried everything from blood plasma and insulin to rare tropical fish. During World War II British Thermos production was turned over to the military, and between 1941 and 1944, 10,000 to 12,000 Thermos flasks accompanied bomber crews on their nighttime raids over Europe. By 1970 the flask was such a household name that a judge ruled it to be no longer a trademark but a generic term—a part of the English language.

THE COOLER BAG

In 1923 the American manufacturers of Thermos introduced the Jumbo Jug, a gallon-size insulated food jar that may be one of the early forerunners of the cooler bag. Other early versions include the elaborate picnic hampers of the Edwardian era, which included insulated compartments for butter. The development of plastics after World War II made lightweight, waterproof insulating materials widely available—the cool bag was a natural extension of the much less portable icebox.

Sliced bread

THE BEST THING SINCE...

Bread baking dates back thousands of years. Bread was first baked by the ancient Egyptians, but until the 20th century people had to slice it themselves. This suited them very well because a solid loaf of bread could be easily transported from bakery to home whereas a sliced loaf would simply have fallen apart, and would go stale much more quickly than an intact one. It was this very problem that faced Otto Frederick Rohwedder, the inventor of the bread slicer. He made his first machine in 1912, but had great trouble getting the slices to stay together. He tried hatpins at first, but it wasn't until 1928 that he incorporated a wrapping device into his design. By introducing packaging into the equation Rohwedder ensured that his loaves were easy to handle and stayed fresher. By this time the popularity of electric toasters with slots led to greater demand for even-sized slices of bread, which could be difficult to fashion manually, and Wonder Bread successfully exploited pre-slicing as a marketing gimmick. Nowadays airtight plastic packaging and preservatives in the flour help to keep sliced loaves fresher for longer, and slicing is the norm rather than the exception.

Food wrap

CLINGING TO SUCCESS

Wax paper was the staple food packaging of the late-Victorian era but the discovery of new materials led to its gradual replacement. The first plastic substitute was cellophane, invented in 1908 but not perfected until 1927, when it came into widespread use for wrapping cigarette packages. By 1934 the first plastic food wrap, derived from rubber,

When Saran was first developed it was greasy and smelly, a far cry from today's hygienic household staple.

came onto the market under the name Pliofilm.

By this time aluminum foil had appeared in the form of bottle tops for milk, first introduced in Britain in 1929. By 1947 Reynolds Metals of America, a company that had started off using aluminum foil to wrap candy, cigarettes, and loose tobacco, had perfected a means of manufacturing sheets

of aluminum as thin as $\frac{1}{7000}$ inches (0.0004 cm). The new kitchen wrap was an instant success, since it could be used for both cooking and storing, although it did not reach Britain until 1962.

Reynolds' foil soon had a plastic competitor, in the form of Saran Wrap®, discovered accidentally in 1933 by Ralph Wiley, a lab worker at Dow Chemicals. Cleaning up at the end of the day Wiley came across a vial coated with a thin film of plastic he was unable to scrub clean. He initially called it "eonite," after an indestructible substance that appeared in the popular comic strip *Little Orphan Annie*, but researchers soon found that it was actually polyvinylidene chloride—molecules of vinylide chloride bound together in long chains that formed a clinging, impermeable, and chemical-resistant film. Dow dubbed the new product Saran.

At first Saran was greasy and smelly, and was restricted to protecting military fighter planes from sea spray. Further development led to its postwar approval for use as food packaging. Saran Wrap film was released for commercial use in 1949 and for domestic use in 1953. Today most Saran is never seen—it is used as an intermediate layer between layers of cellophane, paper, and plastic packaging to make them more gas- and water-impermeable.

Pedal trash can

PEDAL POWER

Lillian Moller Gilbreth (1878–1972) was one of the most prominent female engineers and businesswomen of the 20th century, combining a groundbreaking career in industrial psychology and management with raising 12 children. One of her fields of expertise was ergonomics—the science of matching form and design to human abilities and functions. She patented numerous inventions, including shelves inside refrigerators and an electric food mixer. She even designed a whole kitchen that could be used easily by both disabled and able-bodied people, but her best-known invention is probably the pedal-operated trash can lid.

Gilbreth's design was based on her observations of the shortcomings of conventional trash cans, which either had no lids, unhygienically exposing their contents to the air with an attendant release of odors, or had lids that had to be clumsily removed with hands full of garbage, picking up dirt in the process. The pedal trash can solves all these problems with one stroke—pressing down with a foot on a pedal operates a simple lever device that raises the lid of the can. The hands are left free and never need to come into contact with the can lid, which falls back into place sealing in germs and keeping odors at bay.

As well as its domestic popularity, the pedal trash can has become an essential appliance in kitchens, hospitals, and laboratories, where hygienic disposal is essential and the hands may not be free.

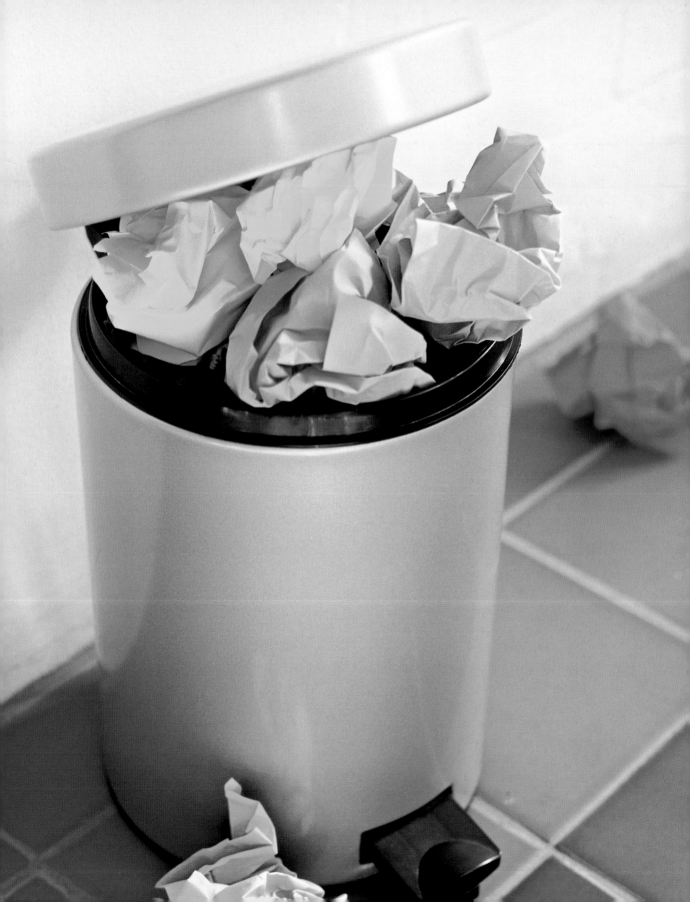

Paper and plastic bags

BAG TO THE FUTURE

Paper production on an industrial scale began in the early 19th century, but even once the raw material was widely available the manufacture of paper bags was slow and far from cost-efficient. Bags were assembled from sheets of paper glued together by hand, and could not therefore be manufactured in any great quantities. In 1883, however, American inventor Charles Stilwell built a machine to mass-produce brown paper bags according to his own ingenious design—with flat bottoms and pleated sides, allowing them to be folded and stacked, shaken open with a snap of the hand, and stand upright unaided, once opened.

The brown paper bag soon became a staple of stores throughout the developed world, and the basic form has hardly changed to this day. In 1912 Minnesota grocer Walter Deubner invented an improved version with an integral cord for added strength and durability—a forerunner of today's "unbreakable" grocery bags. By 1915 he was selling 1,000,000 "Deubner bags" a year. The basic Stilwell version continued to be even more successful with the introduction of the self-service supermarket, and in America today more than 25 billion brown paper bags are used every year.

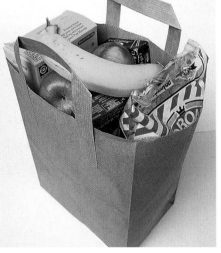

In recent years, the humble paper grocery bag has made a comeback and is celebrated as a standard bearer for environmentalism and sustainability.

THE PLASTIC BAG

This figure would be even higher but for the introduction of plastics in the 1940s. By the late 1950s plastic technology and manufacture had advanced to the point where plastic became the new material of convenience. The plastic garbage bag was invented in 1950 by Harry Wasylyk, but was not widely used until the New York City Sanitation Department's 1969 NYC Experiment proved their effectiveness. In 1977, plastic grocery bags were introduced; by 1996, four out of five grocery bags were made of plastic.

The success of the plastic bag ends here, however. Growing environmental concerns about the use of disposable grocery bags have led to a reverse evolution of bag technology. Before paper bags became a viable alternative, adopted for the sake of convenience, people used cloth or string bags. Then plastic became the progressive choice, replacing paper, which was perceived as old-fashioned, dirty, and reactionary, with a modern, hygienic, and more convenient option. Now we have come full circle—plastics are perceived as environmentally costly, and recycled paper bags are promoted as the eco-friendly option. The most progressive shoppers have reverted to using cloth or string bags.

BATHROOM*

*keeping it clean

The thermometer

TAKING THE HEAT

Anything that changes its physical properties in a constant fashion in response to changes in temperature can be used as the basis for a thermometer. In the case of the classic mercury thermometer the measuring medium is mercury—a highly visible metal that remains in a liquid form over a wide range of temperatures, and expands in a regular fashion as it heats up. The first known thermometers, however, used water. Galileo, for instance, used colored water to make what he called a thermoscope, in 1592. It consisted of a glass bulb with a tube extending downward into a dish of water. A rise in temperature would cause the air in the tube to expand, and the increased pressure would drive down the column of liquid.

Galileo's thermoscope had no scale marked on it, and was also influenced by atmospheric pressure, so it was difficult to take readings of absolute temperature. In the early 18th century Gabriel Fahrenheit, a German instrument maker living in Holland, invented a sealed-glass mercury thermometer and used it to devise a temperature scale. Today the Fahrenheit scale seems frustratingly arbitrary to anyone who has had to convert from Centigrade, but there was method in his madness. For the zero point of his scale Fahrenheit used the lowest temperature he could obtain—using a mix of ice and salt water. He then marked the freezing and boiling points of water on his scale and separated the distance between them into 180 degrees (the

number of degrees in a semicircle). His scale caught on because the fine gradations were useful for scientists and meteorologists. Anders Celsius, on the other hand, proposed to divide the boiling/freezing interval into 100 degrees (hence the term "centigrade"), a slightly more practical system that was adopted by the inventors of the metric system in Napoleonic France.

The classic mercury thermometer is made up of a sealed tube of glass with a narrow bore down the center, a small reservoir of mercury at one end, and a small expansion chamber at the other. This prevents the thermometer from breaking if it is heated beyond its measuring range. In a fever thermometer, the bore constricts as it leaves the reservoir. When the instrument is taken out of the patient's mouth and the column of mercury contracts, the constriction pinches the column off from the reservoir. The column is held in place by capillary action, marking the maximum temperature reached until it is shaken back down with a flick of the wrist.

Expanding liquids are not the only medium used for measuring temperature. Modern digital thermometers use a thermoresistor—a substance in which electrical conductivity changes in response to temperature. Another type of thermometer is the bimetallic strip, used to control temperatures and cooking times in many kitchen appliances, such as the toaster or kettle. A bimetallic strip consists of strips of different metals, which expand at different rates as they heat up. This causes the strip to bend, tripping a circuit breaker that cuts off electricity to the heating elements.

Toilets and toilet paper

FLUSHED WITH PRIDE

It has been argued that the sophistication of a civilization can be measured by the sophistication of its sanitary arrangements, and the history of the toilet seems to bear this out. The first evidence of advanced toilet/drainage systems comes from the Indus Valley civilization, where, in around 2500 BC, wealthy residents from the cities of Mohenjo-Daro and Harappa enjoyed the use of individual toilets. These early toilets were equipped with wooden seats, and drained by way of fired-brick sewage channels complete with ancient manhole covers. About five centuries later, the headquarters of the Minoan civilization, the Palace of Knossos, was equipped with a toilet featuring an overhead reservoir for flushing—the first flush toilet. At about the same time, the neolithic residents of windswept Skara Brae in the Orkney Islands, off northwest Scotland, were building drainage channels from indoor toilets to the sea, possibly so that they would not have to brave the weather while visiting the outhouse. Necessity is the mother of invention.

Other notable ancient toilets include a flush toilet discovered in Bahrain, and dated to about 1000 BC, and a water closet in a Chinese tomb from around 100 BC, which the Chinese news agency Xinhua proudly claimed to be "the earliest of its kind ever discovered in the world." The Romans employed rows of communal toilet "benches" that emptied into channels continually flushed by running water, and exported their sanitary engineering all over the Empire.

With the fall of Rome European toilet technology entered its own Dark Age. Castles and larger residences had crude privies or "necessaries," such as the garderobe—a hole in the floor of part of the castle situated over a ditch or river—however most people made do with chamber pots. By the Middle Ages a system was in place whereby the contents of a house's chamber pots were collected by "night-soil men" and carted off to huge cesspits. Most people though simply threw their waste matter out of the window into the open sewers that ran through the middle of each street. The stage was set for the invention, or reinvention, of the flush toilet.

An early attempt was made by Thomas Brightfield of London, in 1449, but the man who is generally considered to be the father of the flush toilet was John Harrington, godson of Elizabeth I. In 1596 Harrington designed "a privy in perfection" for his royal godmother, which included an overhead cistern that supplied water to wash out the bowl. A lever operated a valve to release the water. Only two of these water closets were ever installed—one for the Queen and one at Harrington's Bath home—but the ingenious device quickly fell out of favor with Elizabeth when Harrington published a pamphlet entitled *The Metamorphosis of Ajax*. The title was a pun on the slang term for toilet, "jake," but the Queen was not amused. Harrington and his water closet became the butt of widespread ridicule and the flush toilet did not reappear for nearly two centuries.

Elizabeth also complained of the water closet's offensive smell, highlighting a fundamental flaw in Harrington's design: the pan connected directly to the soil trap or cesspit via a straight soil pipe, and was separated only by a trapdoor-style valve. Unpleasant odors from the cesspit therefore wafted continuously up into the water closet. This problem was not solved until 1775, when British watchmaker Alexander Cummings finally patented the S-bend, commonly known as the "stink-trap." By making the soil pipe that drained the pan curve upward before feeding into the cesspit or sewer, and filling it with water, Cummings interposed a water barrier that kept out odors.

Despite Cummings' invention the toilet still had many drawbacks. Most toilets were made of wood and metal, which tended to get wet, dirty, and smelly. Cisterns depended on leaky valve mechanisms and there was still no public sewer system to transport the waste. The Victorian age eventually brought some signs of improvement, when public health scares led to the installation of sewers all over the country. Porcelain manufacturer Thomas Twyford incorporated the designs of a sanitary engineer named J.G. Jennings to make the first one piece, all-china toilet in 1885. The old valve systems

The first toilet paper was unbleached manila hemp paper made in 1857 by Joseph Gayetty, whose name was watermarked on each sheet. It sold at fifty cents for 500 sheets and was known as Gayetty's Medicated Paper—"an article for the toilet and for the prevention of piles."

came to be replaced by cisterns that operated on the siphon-principle, where pulling the chain or lever sets in motion a siphon that delivers a set amount of water for the flush.

Development of the so-called siphonic closet is usually credited to the legendary late Victorian plumber Thomas Crapper, who is said to have installed a solid gold toilet for Queen Victoria. Sir Thomas was subsequently made famous in a book fittingly called *Flushed With Pride*. He has since become the subject of heated debate, however, with some people now claiming that he never even existed. In fact, Crapper did exist and probably did install toilets in some royal residences, but he made no serious improvements to toilet design. Yet another of the many Crapper legends is that the word "crap" derives from slang employed by American servicemen passing through Britain during World War I who saw the name "Crapper" printed on toilets and took it home with them. This may be true, but the word has also been traced back to the Dutch word *krappe*, meaning a fish of unpalatable flavor.

The toilet has continued to evolve gradually since Crapper's time. Developments from the early 1900s include flushometer valves, backflow

preventers, and tanks that rested directly on top of the toilet. In more recent times designers have focused on making the toilet more water efficient by using motorized pumps to create a "jet flush." One contemporary design uses a device, similar to a waste disposal unit, to liquefy waste before disposing of it.

TOILET PAPER

The use of toilet paper dates back to sixth-century China, but in most parts of the world paper was a rare commodity until the 17th or 18th centuries. Before this people used a variety of devices for the purpose. In ancient Rome public toilets were equipped with a sponge on a stick, which sat in a bucket of brine; the rich used wool. Cotton, wool, and even lace continued to be popular with the wealthy classes, but poorer people used whatever came to hand—corn cobs were a favorite in colonial America.

The American Joseph Gayetty invented paper specifically intended for use in the toilet in 1857, but most people preferred to use torn-up newspapers and catalogs. In America the Sears catalog was the most popular choice, as it was printed on absorbent paper until the 1930s. Gayetty's paper came as a stack of individual sheets, but in the 1880s the Scott brothers began selling toilet paper on a roll. Originally sold in unmarked brown paper packaging, it was later marketed as a luxury item with the brand name Waldorf Tissue and became a bathroom staple.

Today's stylish Alessi toilet brushes are plastic and use synthetic bristles. The first toilet brushes were made from wood and used hair from animals including horses, oxen, badgers, and even squirrels. Tufts of hair were stuffed into holes drilled into the back of the brush.

Shower

YOU CAN SPRAY THAT AGAIN

A viable shower needs three things: a constant supply of running water that will last the length of the shower, heat, and some way of raising the flow of water to at least head height. Needless to say, the first showers were naturally occurring waterfalls, which provided two of the necessary elements. Several ancient civilizations were noted for their plumbing prowess, including the Indus Valley civilization and the Romans, but perhaps they judged artificial recreation of the waterfall to be an inefficient use of the available water, since they seem to have preferred the bath. It was the ancient Greeks who first used clever plumbing to spray water onto bathers. Such sophisticated plumbing was not seen again until Victorian times.

Until the mid 19th century water for bathing had to be heated and then put into a tub. This meant that while the water was hot it was in limited supply. The earliest domestic showers appeared around the beginning of the 19th century and overcame this problem by recycling water, but this meant that work had to be done to raise the water from the tub to head height. In the 12-ft (3.6-m) high English Regency Shower a pump used water from the tub at the base and raised it, through a pipe painted to look like a bamboo cane, up to a hidden tank at the top. The user was enclosed in a cage of poles, also painted to look like bamboo, and wore a conical oilskin as an early form of shower cap. Needless to say this device was not widely available.

Smaller contraptions appeared on both sides of the Atlantic over the following decades. Often the bather would sit on a stool so that the water did not have to be raised as high, which was important because the bather had to operate the pump manually. The innovative Virginia Stool Shower, for example, had a revolving stool that could be set to different heights, a hand-operated pump to raise the water, and last but not least a foot pedal to work a scrubbing brush for the bather's back. A British model used a bicycle-driven pump, so that bathers had to pedal as they showered. Showers thus provided good exercise.

By the late 19th century, however, sophisticated plumbing meant that running water was now available from tanks situated at the tops of houses, so that showers in the modern sense became possible. The Victorians developed wonderfully elaborate shower units that blasted water at the bather from all sides and heights. The 1889 catalog of the J.L. Mott Irons Works advertised a patented combination unit with "needle, shower, descending douche, liver spray, and bidet bath."

These showers were expensive, however, and therefore exclusive and reserved for the select few. As hot water became more widely available with the development of cheap, reliable gas and immersion heaters, showers became a more affordable luxury, as long as they restricted themselves to a single showerhead. Electric pump technology is now advanced enough to provide the "power shower"— a single unit that heats water and raises it to head height, and can be fitted in any bathroom that has running water.

Mirrors

SILVER LININGS

All surfaces reflect some light, otherwise they would not be visible, but only a special type of surface reflects light in such a way that it can form a mirror. In order to do this the surface must absorb and transmit only a tiny fraction of the light that falls on it, whilst reflecting the rest in an even, regular fashion, without scattering the light rays. Light rays are scattered by a surface with irregularities larger than the wavelength of the rays—in the case of the visible light this means that a surface must have no irregularities larger than $\frac{1}{50,000}$ inch (0.0005 mm).

Very few materials have the correct combination of smoothness, low absorbency, low transparency, and high reflectivity. The earliest mirrors would have been still, flat pools of water or naturally occurring, highly polished volcanic obsidian—such mirrors have been found at Turkish sites dating back to 7500 BC. Bronze Age civilizations used disks of polished bronze and copper, often set into ivory or wood frames or handles. The Romans, on the other hand, favored silver, the neutral color of which meant that it reflected true colors, or gold, to show off their wealth. They also constructed the first full-length mirrors.

Pliny the Elder mentions the use of glass backed with silver or tin to produce a mirror, but this technology does not seem to have been practiced until the Middle Ages, perhaps because of the poor quality of glass available. Even when glass mirror manufacture did start in the glass-working centers of Nuremberg and Venice in the early 13th century, the small mirrors that were produced were often valued more as status symbols than for their quality. Nonetheless, Venetian mirrors, backed with an amalgam of lead and mercury, were easily the finest in Europe and for centuries the doges jealously guarded the secrets of the glassworkers through physical isolation on the isle of Murano and threats of death (see Eyeglasses, page 112).

Inevitably, those secrets leaked out as Venetian craftsmen were lured away by competing European powers, and by the 17th century the mirror industry was firmly established in London and Paris. In 1677 the Duke of Buckingham brought Venetian glassmakers to Lambeth to produce "looking-glasses far finer and larger than any that come from Venice" (these mirrors are now referred to as Vauxhall Plate). The Palace of Versailles (built from 1676 to 1708) derived much of its spectacular effect from its sheer profusion of mirrors, at a time when few people could afford even one glass mirror.

In 1835 German chemist Justis von Liebig devised a process for coating glass with metallic silver ("silvering"), and mirror manufacture began on an industrial scale. Today's mirrors are made by evaporating an incredibly thin layer of aluminum or silver onto glass in a vacuum—rather like spray-painting the glass with molten metal—and come in all shapes and sizes. Curved mirrors are important in the manufacture of telescopes and microscopes, and are found in everyday life in the form of cosmetic mirrors and rear-view mirrors in automobiles. Russian Emil Bloch patented the two-way mirror in the United States in 1903.

Shaving products

CUTTING-EDGE TECHNOLOGY

 Shaving first became fashionable under the ancient Romans. The Greeks had cultivated long, curling beards, but the Romans thought these were effeminate and preferred a trimmed look. During the sixth century BC, the Romans began to encourage the use of razors by soldiers for hygienic reasons. Shaving did not catch on, however, until a group of Greek barbers from Sicily moved to the Italian mainland in 454 BC. Shaving appears to have been a sporadic activity over the next two hundred years. According to the records of Pliny, the first Roman to shave daily was the great general, Scipio Africanus (256–184 BC).

FOAM: CRÈME DE LA CRÈME

Those Roman pioneers quickly discovered that beard hair is surprisingly tough, and that shaving it can be difficult and painful unless you soften the hair shaft first by soaking it in water. Complete saturation of a hair takes around three to four minutes, and unless you happen to be shaving in the bath or shower, you need some way of retaining moisture on your face.

One way of doing this is to use foam. A suspension of particles in a medium—in which the particles are gas bubbles and the medium in which they are suspended is a liquid—foam has the useful properties of holding a lot of moisture while remaining extremely viscous. It also helps to lubricate the passage of the razor across your skin. Soap has traditionally been used for this, since it can be whipped into a lather, and today's shaving foams are an extension of this.

Modern shaving foams use extremely rapid decompression of a compressed gas to expand a cream into a lather or foam. Inside an aerosol can are shaving cream and a propellant (which is a gas at normal temperatures and pressures, but compressed to form a liquid), mixed together as an emulsion. When the can is filled, room is left at the top of the can (the "head") for some of the propellant to vaporize under extremely high pressure.

A pipe from the nozzle on top of the can extends down inside the can to below the level of the liquid propellant. Depressing the nozzle opens a valve to the outside, where the pressure is much lower than inside the can. The pressure of the vapor in the head drives the liquid propellant shaving cream emulsion up the pipe. As it comes out, the propellant is no longer under pressure and vaporizes instantly, whipping the cream into a foam to apply immediately to the stubble.

Meanwhile, the space that has been freed up inside the can is filled up again as the propellant turns into vapor. This is known as a three-phase aerosol. Phase one is the liquid propellant, phase two is the vapor in the head, and phase three is the dispersed gas that the propellant becomes when it leaves the can. This sort of three-phase system maintains pressure inside the can until the entire product has been expelled.

The most commonly asked question about shaving foam is probably "How do they get it in the can in the first place?" The answer is simple: first, the cream, in an unlathered state, is added to the can

and the top is sealed tightly. Next, the propellant is injected through the nozzle at extremely high pressure, and finally, the whole unit is immersed in water to check for leaks.

Modern shaving creams themselves are composed of a cocktail of 20 or more chemicals, based on the traditional recipe of water, soap, and fat-based substances such as stearic acid or glycerol. In addition to moisturization and lubrication, shaving foam has one more helpful property. It allows you to see the parts you have not shaved.

RAZORS

Cave paintings and archeological finds show that prehistoric man was shaving at least as far back as 30,000 BC. Stone-Age cultures used sharp-edged flints, shells, shark's teeth, or volcanic obsidian glass, implements that were still in use under the medieval Aztecs and other Stone-Age cultures right up to the 20th century. Flints would quickly lose their edge and were discarded, making them the first disposable razors. Other prehistoric and ancient means of removing hair included tweezers and crude depilatory creams using ingredients such as arsenic and quicklime.

When metal smelting was discovered copper, bronze, and even gold razors came into use. These valuable metal artefacts were highly prized—

Powered shavers have come a long way since Willis Shockey's clockwork razor in 1910. Most modern electric razors use a shaving foil, where bristles project through the holes in the foil and are then cut off by rotating blades.

elaborate ancient razors have been discovered in Egyptian tombs (including the tomb of Tutankhamen) and Bronze Age Danish mound graves (complete with leather carrying cases and handles carved into horse-head motifs). The Greeks and Romans used iron razors, and the Roman *novacila* was basically the same as the cut-throat razor, universally used until the late 19th century. While most Roman men went to a barber or *tonsor* for their shave (Julius Caesar favored tweezers), Roman women used tweezers, razors, pumice stones, and depilatory creams to stay smooth. In India women used the same technique whereas Greek women preferred to singe the hair off their legs with lamps.

The cut-throat razor—a long, one-sided, straight-edged blade attached to a long handle—remained the cutting edge of shaving technology until the 18th century. In 1762, Frenchman Jean-Jacques Perret, author of *The Art of Learning to Shave Oneself*, invented a crude safety razor. It had an L-shaped wooden guard that could not prevent the shaver from cutting himself but would at least prevent the blade from sinking too deeply into the skin. It did not catch on. Further attempts at producing a successful safety razor were made in Sheffield, England, in 1828, and in the U.S. in 1880, but skin guards were impractical as razor blades had

to be continually removed for sharpening. By this time the modern razor had begun to take shape—in 1847, Englishman William Henson invented the hoe-shaped razor we use today.

A successful safety razor was finally devised almost as an afterthought to the development of a related product—the disposable razor blade. In 1895 a traveling salesman called King Camp Gillette, seeking a product that would make his fortune, was given some invaluable advice by William Painter, inventor of the disposable crimped beer bottle cap. The most profitable product, Painter advised, was one with built-in obsolescence—something that consumers would willingly purchase over and over again. Gillette hit upon the perfect product while shaving one morning—a razor blade that was simply disposed of and replaced, instead of being constantly resharpened. "I stood before that mirror in a trance of joy," he later wrote.

Gillette realized that his disposable blades would have to be cheap but of high quality if they were to succeed, but in 1895 the technology to make steel blades cheap, thin, hard, and sharp was not available. He was turned away or discouraged by one expert after another, until, in 1901, Massachusetts Institute of Technology professor William Nickerson agreed to

Today an amusing curio, the cut-throat razor was the last word in shaving technology for hundreds of years. This example, a platinum steel razor from 1856, was made towards the end of the cut-throat's dominance of the market, when today's familiar hoe-shaped razor was beginning to gain ground.

collaborate on the project. Razor blades of the time were forged, but Nickerson and Gillette devised a method of pressing the blades out of thin sheets of steel. They also designed a safety razor to hold them, increasing the convenience and value of the product.

In 1903 the first batch of 51 razors and 168 blades were ready—Gillette gave most of them away to help publicize the product by word of mouth. His marketing ability soon began to yield results. By 1904 he had sold 90,000 razors and 123,000 blades, by 1906 he was selling 300,000 razors a year. Perhaps his greatest marketing coup was securing a contract to supply the United States Army during World War I. By the end of the war the Gillette razor was known throughout the developed world. Rival company Wilkinson Sword, keen to keep up with Gillette, invented a new market for its products with the launch of an influential 1915 advertising campaign convincing women that underarm hair was unsightly, unhygienic, and unfeminine.

By the 1930s Gillette had more serious competition in the shape of the electric razor. The first powered razor was invented by Willis Shockey in 1910, and used clockwork to drive its blades, but it had only limited success. In 1923 Jacob Schick, a Lieutenant Colonel in the United States Army and

the successful manufacturer of a magazine-loading repeater razor, based on the principle of the repeater rifle, invented the first electric shaver. Schick was a shaving enthusiast who believed, rather eccentrically, that constant shaving could prolong a man's life to the age of 120. His first electric shaver was hampered by the unwieldy size of the smallest electric motor available. It was not until 1931 that a powerful motor small enough to fit inside a handy Bakelite casing became available—although it still had to be kick started by spinning an exposed flywheel in the handle.

After a slow start, Schick's electric razor, which freed men from having to rely on soap and water for a wet shave, was a runaway success. By 1937 he had sold over 1.5 million, but he died the same year. His brainchild was so popular, however, that by the late 1930s power outlets for electric shavers were a common feature in trains, ocean liners, airplanes, and hotels. Developments in the electric razor included the Philishave, first introduced by Philips in 1939, and the 1947 Remington Lady Shave, which was simply a repackaged version of their small 1937 men's model. Other models flooded onto the market, including the Shavemaster, the Viceroy, the Smoothmaster, the Minute Man, the Zenith, and the Aristocrat.

Losing market share, wet-shave manufacturers eventually hit back. Gillette brought out improved steel blades in 1960, and twin-bladed razors in 1971 (although the idea had been around since the 1930s). The first completely disposable razors, with cheap steel blades in even cheaper plastic casings, were introduced by Bic in the 1960s.

Dental hygiene

IT'LL BE ALL WHITE ON THE NIGHT

The original toothbrush technology was the tooth- or chewstick, a small twig or stick with a blunt end frayed into a brush of sorts. Chewsticks have been found in Egyptian tombs dating back to 3000 BC, and are still in use in many parts of the world today. The earliest known toothpaste also dates back to ancient Egypt—a 4,000-year old recipe included powdered pumice stone and strong vinegar. The Romans used similar recipes and suffered similar results—the pumice wore down tooth enamel and hastened tooth decay. Another ingredient of Roman toothpaste was urine. Rich Roman matrons used imported Portuguese urine, reputed to be the strongest in the Empire. Ammonia in the urine may well have helped to fight decay, and ammonia compounds are still found in some modern toothpastes today.

Day-to-day dental care failed to improve much in Europe during the Dark Ages. For most people the point of a knife, used as a toothpick, marked the limit of their dental hygiene. The Persians, however, developed new forms of toothpaste with ingredients

ranging from burnt horn and oyster shells to honey and powdered flintstone. Similar concoctions threatened the teeth of medieval Europeans. A popular method of whitening involved filing teeth and coating them with strong nitric acid. This ate away the outer, discolored layers of enamel and produced a temporary whiteness, but drastically shortened the working life of a person's teeth.

TOOTHBRUSH

Toothbrushes were first used by the Chinese in around the late 11th century. They shaved or plucked stiff bristles from the backs of Siberian hogs, raised in cold climates to increase their bristle production, and fixed them to handles of bamboo or wood. Hog-bristle toothbrushes arrived in Europe near the end of the 15th century but many people found them too stiff and abrasive on the gums. Some stuck with toothpicks (gold or silver ones were a mark of distinction), while others preferred softer horse or badger hairbrushes. Pierre Fauchard, whose 1723 treatise *The Surgeon Dentist* is credited with starting the dental profession, recommended the use of natural sponge.

Modern electric toothbrushes have elevated the science of tooth cleaning to new levels. They spin fast enough to perform as many strokes in a few seconds as a manually powered toothbrush can manage in several minutes, while also plunging up and down to reach awkward spots.

FLOSS

In 1815 a New Orleans dentist named Levi Spear Parmly started to promote the use of silken thread for the flossing of teeth (although there is evidence from archeological remains that the practice dates from prehistoric times). Silk dental floss was later mass-produced by the Codman and Shurtleft Company of Massachusetts in 1882, however, wartime shortages of silk prompted the introduction of nylon floss in the 1940s.

Until the 19th century toothpaste continued to do as much harm as good, thanks to abrasive ingredients such as brick dust, powdered china, and ground cuttlefish, but in 1824 a dentist named Peabody first suggested adding soap. In the 1850s chalk was added, and in 1873 Colgate started making aromatic "dentifrice." Colgate came in a jar, but in 1891, in London, the first toothpaste in a collapsible tube appeared—Dr. Ziener's Alexandra Dentifrice. The first American toothpaste in a tube, Dr. Sheffield's Creme Dentifrice, appeared the following year. Almost all toothpaste was supplied this way until the pump dispenser was introduced in 1984.

Mass production of hog-bristle toothbrushes started in England around the late 19th century, and for many decades hog bristles continued to be the material of choice for toothbrushes. In 1937, 1.5 million pounds (680,000 kg) of hog bristles were imported into the United States. Then, in 1938, Du Pont chemists introduced a new synthetic material called nylon, and used it to make "Exton bristles." The first toothbrush to incorporate the new bristles was Dr. West's Miracle Tuft Toothbrush, but unfortunately early Exton bristles were extremely stiff and the public avoided it. Not until the 1950s were softer nylon bristles introduced.

Toothbrushes and electricity were first combined as long ago as 1880, with the release of Dr. Scott's Electric Toothbrush, but it seems likely that this was an electrified, rather than an electric-powered toothbrush—according to the manufacturer it was "permanently charged with electromagnetic current." (It was believed at the time that mild electric currents had therapeutic properties, and there was hence a vogue for such devices.) The first electric-powered toothbrush did not appear until 1939, in Switzerland, and only went on sale in America in 1960, when it was released as the Broxodent.

TOOTHPASTE

During the postwar period toothpaste developed into its modern form. Soap was replaced with more effective, less distasteful synthetic detergent agents such as sodium lauryl sulphate and sodium ricinoleate, and fluoride was added for the first time. The tooth-preserving effects of fluoride had been noticed as far back as 1802, when doctors around Naples in southern Italy noticed that while local residents suffered from fewer cavities than normal, their teeth were mottled with yellow-brown spots. The mottling was traced to the presence of high levels of fluoride in the soil and water, and by 1840 dentists in both Italy and France were making up lozenges of honey and fluoride to help combat tooth decay.

Fluoride is now added to most toothpaste—the American Dental Association estimates that it can reduce tooth decay by up to 30 percent. Hence the original Procter & Gamble tag line, "Look, Mom—no cavities!" Fluoride can also be taken in tablet form or as a solution "painted" directly onto the teeth or used as a mouthwash.

In the early 1900s a Colorado dentist, Fred McKay, noticed a similar pattern of tooth mottling and cavity protection in his patients, and by 1928 laboratory tests had confirmed that the presence of fluoride was the cause of both. After the success of experiments in Newburgh, New York in 1945, where fluoride was added to local drinking water, pharmaceutical giant Proctor & Gamble developed a means of adding it to toothpaste, resulting in the 1956 release of Crest "with Fluoristan!"

Since the introduction of fluoride there has been only one major development in toothpaste technology—the addition of stripes. Many brands of toothpaste now emerge from the tube or pump dispenser with three colored stripes, prompting universal cries of "how?" The three different colored pastes are made separately and then piped to a three-chambered nozzle that keeps them separate as they are pumped into the tube. This is the crucial part of the operation: as they are pumped into the bottom of the tube at high pressure and incredibly quickly (the machine fills 250 tubes per minute), the bottom of the tube is immediately sealed. The contents of the tube are just soft enough to be squeezed out of the nozzle, but are packed in so tightly that it is difficult for them to mix (although if you mangle the tube hard enough you can mash them together). Since the three pastes meet in the center, where the nozzle is, squeezing makes them come out in equal amounts.

Dentures

LONG IN THE TOOTH

False teeth were first made in ancient Egypt in around 2600 BC, but the finest denture-makers of the ancient world were the Etruscans, a pre-Roman civilization in Italy, circa 700 BC. Etruscan dentures were skillfully crafted from ivory or bone—favorite denture materials right until the late 19th century—with bridgework of gold wiring to hold them in place. Such skillful dentistry was not seen again for the next 2,500 years.

Denture craft went steadily downhill from here. The Etruscans passed on some of their secrets to the Romans, but after the fall of the Empire dentistry became a haphazard and crude affair. By medieval times the focus was on extraction rather than replacement—Queen Elizabeth I simply blocked the gaps in her teeth with pieces of cloth.

Where dentures were available they were hand-carved from bone or ivory (from both elephant tusks and hippopotamus teeth). Such materials, however, would discolor, rot, and cause bad breath. George Washington would soak his ivory dentures (he never had any wooden ones) in port overnight to try and improve their taste and odor. Richer people favored dentures fashioned from silver, gold, mother-of-pearl or agate—the famous American patriot Paul Revere, who took part in the Boston Tea Party, was an ivory and gold denture craftsman. A popular though grisly alternative was to reuse human teeth. These were either extracted from the mouths of the dead—soldiers on the battlefield were a favorite source—or from living but impoverished folk who would cash in their dental birthright for a few coins.

Whatever the material, considerable drawbacks in denture technology made life difficult for the toothless. Apart from the unsatisfactory raw materials, there were also problems in getting dentures to fit properly or to stay in place at all. If some teeth remained, false ones were fixed in place with threads of silk or gut, but if there were none left, false teeth were fixed into fake ivory "gums" or wooden plates, and simply fell out when the mouth was opened. Upper-class medieval ladies went so far as to have their gums pierced, while a drastic 17th-century solution was to fix springs to the hinges of false teeth, pressing the plates into place on the roof and floor of the mouth. If the unwary user opened his mouth too far the teeth had an alarming habit of springing out.

Ill-fitting dentures were a source of pain and oral damage to many—George Washington suffered constantly from painful, bleeding gums, infections, and mouth ulcers. Improved methods with which to measure the mouth, and the introduction of plaster-gum impressions in 1756, helped to improve the situation. In 1774, a method for making porcelain teeth was invented in France, and was in commercial use in America by the 1820s. The practice of removing teeth from dead, and, notoriously, from merely wounded soldiers on the battlefield, was, however, still widespread. Europeans and Americans wore "Waterloo" and "Civil War" dentures, and America even exported the teeth of young soldiers to Europe by the barrel-load.

Charles Goodyear's 1844 discovery of vulcanized rubber paved the way for improved denture-plate molding techniques and subsequently more comfortable rubber fittings, while at about the same time the use of ether, laughing gas (nitrous oxide), and anesthetics made tooth extraction slightly less of an ordeal.

By the time the first plastic, celluloid, was used to make dentures, it was routine for people to have all their teeth removed and replaced with false ones, a practice that continued into the mid 20th century. Today's dentures are machine-crafted from durable plastics or ceramics, and fixed in place with the help of nontoxic adhesives.

Lipstick

LIP SERVICE

Body decoration dates from prehistoric times, long before the beginning of civilization. Cave-dwelling prehistoric peoples in Europe and the Middle East used plants and minerals to create up to 17 different colors for body and face painting, and it seems likely that the first attempts to color or enhance the lips date back this far as well. Throughout history most forms of lipstick have concentrated on accentuating the natural color of the lips, so the first lip paint would probably have been red—possibly made from henna, a plant dye popular in many ancient cultures.

The use of color to enhance features was characteristic of most ancient civilizations, and the oldest cosmetic ever found in the Middle East, dating back to 4000 BC, is a lip color recovered from a Babylonian tomb, possibly belonging to a man. Right up until the 20th century, however, the use of lip paint and make-up in general was almost exclusively restricted to two groups—the rich and powerful, for whom the expense of cosmetics provided a means of displaying their wealth, and prostitutes or courtesans, with whom make-up was frequently associated.

Affluent ancient Greeks, particularly women and courtesans, used rouge on their cheeks and lips to make themselves more attractive. Unfortunately the rouge was made using cinnabar, a poisonous compound of mercury. Applying it to the lips meant that it gained easy access to the digestive system and bloodstream, so that lip paint probably had a significant bearing on the life expectancy of those using it.

For many centuries thereafter, lip paint remained the preserve of either the rich or the indecent. In Renaissance Italy noble women wore pink lip paint to demonstrate their wealth, while prostitutes were gaudier in their choice of lip color. The bright red lip paint favored by them enjoyed a brief period of popularity in 18th-century France among both men and women, but the French Revolution brought with it a new Puritanism. The link between lip coloring and prostitutes was cemented in Victorian times.

Although advances in pharmaceutical technology meant that they were no longer toxic, cosmetics, and lip paint in particular, became so unfashionable that by 1880 a leading fashion magazine commented, "… it hardly seems likely that a time will ever come again in which rouge and lip paint will be employed."

The only exception to the Victorian attitudes toward cosmetics was the stage, where make-up was an accepted part of stage craft. Here the use of lip paints in various shades was perfected and the first lipstick, devised for easy application, was invented.

In the 1910s and 1920s, the theatrical tradition was to prove pivotal. As a result of World War I, women were now enjoying greater wealth and independence than before, and increasing emancipation. Hollywood actresses, with their exaggerated make-up including full, red lips, became cultural icons. Applying lipstick in bold colors was a sign of new female confidence and independence, and Max Factor and Helena Rubinstein—Hollywood make-up artists who had created the new look—became the pioneers of mass-market cosmetics. The advent of color films in the late 1930s drastically increased the popularity of boldly colored lipsticks, and, later, the fashion experimentation of the 1960s introduced a range of new and exciting colors.

Deodorant

THE SWEET SMELL OF SUCCESS

According to historian Charles Panati "every major civilization has left a record of its attempts to produce deodorants." As far back as the ancient Sumerians of the sixth millennium BC, people have attempted to mask or dispel their bodily odors. What the ancients did not know is that many types of body odor result from the action of skin bacteria on perspiration, and that the key to successful odor prevention was decreasing the amount of sweat produced.

The ancient Egyptians managed as best they could with perfumed oils, citrus and cinnamon mixtures, and even a slow-release scent-delivery device consisting of a cone of perfumed fat which, when worn on the head, would slowly melt in the heat. The Greeks and Romans also used perfumed oils, and alcohol-based perfumes were developed in the Middle East and brought to Europe by the Crusaders in the 13th century. The manufacture of deodorant perfumes was on the curriculum of the first beauty school, set up in Moorish Spain by a Baghdad-born singer called Blackbird, in the year 840 AD.

ANTIPERSPIRANT

It was only with the development of antiperspirants, however, that body odor was successfully tackled at its source. The first commercial antiperspirant to come on the market was Mum, invented in Philadelphia in 1888. The

identity of Mum's creator has sadly been lost, but it is known that he started selling the antiperspirant through his nurse. Mum was based on a zinc compound, but most subsequent antiperspirants were based on a different drying compound, aluminum chloride, which was substituted in the 1940s after complaints of skin irritation. Scientists today are still unsure of exactly how these antiperspirants work.

Mum originally came in the form of a jar of cream that was applied with the fingers, but in 1952, inspired by the success of Bic's ballpoint pen, Mum developed and marketed a roll-on applicator. Sold in the United States as Ban, the roll-on was an overnight success. During the 1960s, antiperspirant manufacturers developed aerosol applicators and overcame the problem of "staining"—white antiperspirant residues left on clothes—by adding "volatile silicones" to their product. As concern mounted during the 1980s over the environmental effects of CFC gases used as propellants in aerosols, manufacturers responded with pump sprays and deodorant sticks.

Recent developments in the field of deodorants include the use of plant-derived microfibers to soak up perspiration, and of encapsulated body oils. These are tiny packages of oil that break down and release their fragrance in response to body heat, like microscopic versions of the system used by the Egyptians thousands of years ago.

Tissues and cotton swabs

WIPE OUT

Until the 20th century production and manufacturing costs were generally too high to make disposable products viable. This particularly applied to goods such as tissues and paper towels, whose function could be performed by cloths that could be used over and over again. An obvious exception was toilet paper, and by 1907 the Scott company was doing a roaring trade in its Waldorf line.

TISSUES

Arthur Scott had learned of a local teacher who was dispensing toilet paper to students with runny noses in order to stop them soiling the cloth towels in the bathrooms, which suggested to him that there might be a market for disposable paper towels. When the paper mill delivered a load of faulty paper that had been rolled too thickly to be used as toilet paper, Scott decided that, rather than send the faulty load back to be pulped, he would have it made into towel-size sheets. The new product was marketed under the name Sani-Towel.

By 1924 the market for disposable paper towels was firmly established and Kimberley-Clark launched a new product—the Kleenex disposable cold cream towel. Kleenex made use of an artificial fiber developed for use in hospital dressings during

World War I as a substitute for cotton, which was in short supply. Made from wood, cellucotton was five times more absorbent and much less expensive than cotton. Left with vast stocks at the end of the war, Kimberley-Clark came up with the idea of a disposable tissue that was much softer than existing paper towels, and would therefore be suitable for make-up removal.

Customer feedback showed that Kleenex was more popular as a disposable handkerchief than for its intended purpose. After market testing in 1930, Kimberley-Clark changed their advertising strategy and sales doubled. Today Kleenex is still the number one tissue brand and is sold in 150 countries.

COTTON SWABS

A Polish-American named Leo Gerstenzang invented the original brand of cotton swabs—Q-tips—in the 1920s. Alarmed that his wife was using a toothpick stuck in a small ball of cotton wool to clean the ears of their baby, Gertstenzang set about creating a safe version with a blunt-ended stick that would not splinter and cotton tips that would not come off. Ironically, Q-tips today come with strict instructions not to use them to clean out your ears. Gerstenzang's original name for his invention was "Baby Gays," but, perhaps fortunately for the modern market, he changed it in 1926 to "Q-tips," where the "Q" stands for "quality."

Hairstyling implements

HAIR TODAY, GONE TOMORROW

Hairstyling implements date back to prehistory. Back then hairpins and combs were made from bone (often the long, thin bones of fish) or ivory, and it is possible to speculate that early humans would also have used long thorns, just like modern tribal peoples do.

The art of hair styling reached its height in the ancient world with the Assyrians, who built an Empire based in northern Iraq around 1500 BC. The Assyrians favored long, elaborate hair, cut into layers and styled, using the first curling irons, into waves and ringlets. Even their beards were styled, and important women would wear fake beards for court business. The Egyptian nobility preferred to shave their heads and wear wigs, which they fastened with elaborately crafted pins. Cleopatra favored ivory hairpins, and adopted the Roman custom of storing poison in hollow pins—there is even some speculation that she may have used one to commit suicide.

Other ancient peoples in the Near East curled their hair by coating it in clay, which would then be baked hard by the Sun. The ancient Greeks preferred to use styling tongs. They considered long hair in tight, oiled curls to be a mark of sophistication and civilization, in contrast to the short, unkempt hair of the "barbarians" who surrounded them.

At first the Romans were more conservative when it came to hair, but as the Empire became

more dissolute wigs came into fashion, particularly blonde wigs made from the hair of German slaves. Wigs came to be associated with prostitutes and immorality and were banned by the Roman Catholic Church. Natural hair, on the other hand, was considered godlier, and combs became important symbols, frequently featured in stained-glass windows. Instructions were issued to priests regarding the proper use of combs, and a superstition developed that combing could restore color to graying hair.

After the Reformation wigs made a comeback, becoming the height of fashion in 18th-century France. Women sported towering structures so high that they had to sit on the floors of their carriages. The hairpin evolved into the double-pronged bobby pin at this time, and was used to flatten real hair and attach wigs. By the late 19th century people abandoned wigs in favor of their own hair and the first hairbrushes were made—bristles from wild boar were a favorite component.

In Paris in the 1870s Marcel Grateau's waving iron created a craze for the so-called marcel wave and started the fashion for regular visits to the hairdresser. The permanent wave, or perm as it became known, was invented in London in 1906. It required a combination of borax paste and heavy brass rollers weighing up to 2 pounds (0.9 kg) each, and needed six hours to set. The cold perm only came along in 1945, by which time a series of African-American inventors had revolutionized hair styling in the United States. In 1898 Lyda Newman had created the first hairbrush with synthetic bristles. In 1905 "Madame" C. J. Walker invented a process whereby hair could be straightened and built a business empire on the back of it, becoming one of the first female black millionaires. In 1928 an employee, Marjorie Joyner, invented an electric permanent wave machine, and some years later in 1946 Jessie Pope invented the thermostatically controlled curling iron, which was marketed with help from Eleanor Roosevelt.

Hair dryer

CURL UP AND DRY

Before the advent of electricity it was largely impractical to dry hair directly with heat from an artificial source, and customers at hair salons would sometimes simply sit by the window with their hair hanging out, hoping to catch a breeze. An early attempt to speed up the process was Alexandre Godefroy's gas hair dryer, invented in Paris in the late 1880s. Godefroy's device involved a bonnet connected by a tube to the heat-source—a gas stove. Similar devices were still in use in some salons in the 1930s, but customers complained about the poisonous carbon monoxide emissions.

Electricity promised to provide a clean, convenient source of energy for hair drying,

although the first appliances employed for this end were vacuum cleaners. Versatility was a major selling point in the marketing of early electric appliances, so manufacturers were eager to point out that while one end of the vacuum cleaner sucked in dirt, the other end could be drying hair. As late as 1929 the Air-Way Sanitary System proudly boasted an attachment that fitted over the cleaner's exhaust, while an earlier model, the Pneumatic Cleaner, promised "a current of pure, fresh air" from its exhaust—possibly a rash claim in the days before micro-particle filters.

The first electric hair dryer appeared in Germany as early as 1899, but a truly practical model depended on the development of a "universal motor"—an electric motor that was lightweight and compact enough to fit in a hand-held device while being powerful enough to run a fan at high speeds. Engineers in Racine, Wisconsin, developed a universal motor for the electric blender (see page 21), but its first commercial use was in the 1920 "Race" and "Cyclone" model hair dryers. The

Germans developed their own versions, using a universal motor to drive a fan that blew air over heat-generating niochrome wire on a mica or asbestos board.

These early hair dryers were large, cumbersome, and strictly functional, with visible components and wooden handles. With their metal casings they were also hazardous. The introduction of Bakelite led to safer, attractive new designs, with streamlined molded casings. In fact the hair dryer was the first domestic electric appliance to be made from Bakelite, a revolutionary early plastic. Now that it was a fashion item the hair dryer became extremely popular, and more advanced models offered temperature settings and progressively more compact designs, as new technology enabled the motor to fit inside the fan.

A peculiar 1951 Sears, Roebuck model recalled Godefroy's 19th-century design. It featured a hose connecting the air and heat source to a pink plastic bonnet. Related hood-type hair dryers for salons appeared in the late 1950s.

Plastic strip/Band-Aid®

STICKY BUSINESS

Until the development of "germ theory" in the late 19th century physicians were generally ignorant of the need to keep dirt, and therefore bacteria, out of cuts and wounds. Even after the discovery of bacteria there was considerable resistance from the medical community to the principles of antiseptic practice. Among the many unhygienic features of routine medical care was the use of pressed sawdust

(waste material collected from sawmill floors) as surgical dressings.

The eminent British surgeon Joseph Lister campaigned against such unhygienic medical practices. Attending a talk given by Lister at the 1876 Philadelphia Medical Congress were Joseph Lawrence, who went on to create the mouthwash Listerine, and a Brooklyn pharmacist named Robert

Johnson. Inspired by Lister's theories, Johnson teamed up with his two brothers, James and Edward, to develop an antiseptic alternative to sawdust dressings. Forming the company Johnson & Johnson (it is unclear why the third brother's name was left out) they developed sterile prepackaged surgical dressings of cotton and gauze. As the years went on they added new products to their line, including Johnson's Baby Powder in 1893, and a zinc oxide adhesive surgical tape in 1899 (although the first adhesive plaster had been made as far back as 1838 by Robert Shoemaker).

Johnson & Johnson's most successful product, the Band-Aid®, was invented in 1920 by an employee named Earle Dickson. Dickson's wife Josephine was accident-prone in the kitchen and he frequently put together makeshift dressings for her cuts and burns by fixing small squares of company gauze onto her wounds with strips of company tape. Fed up with making each dressing individually, he stuck a series of gauze pads down the center of a roll of adhesive tape, and used a strip of crinoline on top to keep the tape from sticking to itself. When Josephine wanted a new dressing all she had to do was cut one off the roll.

Dickson mentioned his idea to a colleague, who encouraged him to approach the management. The response was lukewarm until Dickson demonstrated how easily he could apply his new form of dressing to himself. Production began the following year, but the handmade bandages were inconveniently sized, in sections 2.5 inches (6.5 cm) wide and 18 inches (46 cm) long (injured customers were supposed to cut off sections as required). Sales were poor until the company hit on a brilliant marketing campaign, supplying free Band-Aids (a name suggested by employee W. Johnson Kenyon) to boy scouts and butchers all over the United States. When mechanized production and a range of sizes were introduced in 1924, sales increased dramatically.

Subsequent improvements to the Band-Aid included the addition, in 1928, of aeration holes to allow wounds to breathe. A red tear-string to help open the packaging was added in 1940. Band-Aid became known as "plastic strip" in 1958, when they were first made out of vinyl.

Sticking plaster has come a long way since Earle Dickson's makeshift original Band-Aid. Now consumers have the choice of waterproof or breathable plastic strips, while clear plastic plasters make emergency repairs less conspicuous than ever.

Dickson was made a vice-president of the company and sat on the board until shortly before his death in 1961. By that time Johnson & Johnson were selling over $30 million worth of Band-Aids a year. The company estimates that it has now sold more than 120 billion Band-Aids.

Feminine hygiene

A GIRL'S BEST FRIEND

Until the 20th century women had to improvise ways of soaking up menstrual blood. Using, washing, and reusing cloth pads or recycled rags were probably the most obvious methods, but there is some evidence that disposable tampons have been improvised throughout history. The ancient Egyptians used softened papyrus or pellets of shredded linen with gum arabic, while the fifth-century BC Greek physician Hippocrates described how Greek women would use lint wrapped around a small piece of wood. Elsewhere, women have used the most convenient local materials—wool in ancient Rome, paper in Japan, vegetable fibers in Indonesia, and rolls of grass in equatorial Africa.

SANITARY NAPKINS

In 1920 Kimberley-Clark, faced with mountains of surplus cellucotton—a cotton substitute developed for bandages during World War I—launched the Kotex brand, using cellucotton to manufacture disposable sanitary napkins. Kimberley-Clark were so fearful of negative public reaction to such an unmentionable product that they started a separate company, the Cellucotton Products Company, to make and sell Kotex. Their fears proved to be well-founded, because shops refused to display the product and newspapers and magazines refused to carry advertising for it. Eventually, however, resistance was overcome, sales took off, and Kimberley-Clark realized that they had tapped into a lucrative market in intimate feminine hygiene.

According to social historian Susan Strasser, disposable sanitary napkins became one of the ultimate symbols of the shift to the convenience-driven, disposable, consumer society we are today. The selling points of disposable sanitary towels—"cleanliness and convenience"—were the rallying call and justification for a massive transformation in consumer values.

At first Kimberley-Clark were the only players in the field but that changed when the market research of pioneering businesswoman and engineer Lillian Gilbreth, inventor of the pedal trash can, encouraged Johnson & Johnson to enter the market with Modess. An unusually frank survey by Gilbreth found that Kotex were often considered uncomfortable. One respondent said that the "harsh" materials used in Kotex meant that "fat women cannot wear them."

TAMPONS

Many women found that sanitary napkins, whatever the brand, were bulky and inconvenient. In 1929 such complaints from female friends and patients led Dr. Earle Haas, who had already invented a flexible ring for contraceptive diaphragms, to devise a new feminine-hygiene product. Inspired by the efficacy of surgical cotton to stanch bleeding, Haas set to work in his basement and came up with a pressed-cotton tampon, complete with a removal cord and double-tubed applicator. The London newspaper *The Sunday Times* later voted him one of the top 1,000 "makers of the 20th century."

In 1931 Haas filed for a patent for what he called his "catamenial device" (from a Greek word for

"monthly"), and sold the rights to a Denver-based group that started the Tampax Sales Corporation. Its president, Gertrude Tenderich, made the first Tampax tampons at home. Like the earlier Kotex sanitary napkins, Tampax met with strong resistance from shopkeepers and the media. Drugstore owners refused to stock the product until there was a demand, and magazines refused to carry the advertisements that would create the demand. One early salesman would start his pitch by asking for a glass of water, into which he would then dunk a tampon to demonstrate its absorbency.

From these humble beginnings Tampax grew into Tampax Incorporated (now Tambrands) and, through the canny use of mass-market advertising campaigns, were soon exporting tampons all over the world. The first advertisement, in July 1936, used euphemisms and coy phrasing—"permits daintiness at all times"—attributes that have always been the hallmark of feminine-hygiene marketing. In 1921 Kotex warned shopkeepers that, "women of refinement dislike to ask for so intimate an article by its full descriptive name," and boasted, "Kotex advertising to women is so restrained in tone that women's intuition tells them what Kotex is!" Much more recently Kimberley-Clark designed a range of tampons to look like lipstick so that women could carry them without embarrassment.

A colored scanning electron micrograph of the under-surface of the outer layer of a sanitary napkin. The surface is designed to absorb fluid into the napkin without allowing it to flow in the opposite direction.

Tampax achieved its greatest success during World War II, when it was able to convince the United States government to license it as a priority product on the basis that tampons used less cotton than sanitary towels. By the end of the war Tampax was a worldwide brand name, but it soon encountered competition from other tampon makers. Nonetheless, Tampax still maintains more than 50 percent of a market worth a healthy $1 billion per year in the United States alone.

Tampon sales continue to grow despite scares over dioxin levels and toxic shock syndrome (TSS), a condition caused by a rapid acceleration of bacteria in the artificial fibers in the tampon and can result in sickness and, occasionally, death.

Overpricing and unfair taxation are also major issues. In the United States and Canada, for instance, tampons do not qualify for tax exemptions, because they are not classed as "necessities," unlike condoms and even lip balm. The average woman can expect to spend around $3,000 on tampons in her menstruating lifetime.

Pricing gripes notwithstanding, many believe the tampon to be a landmark invention. In a 1986 *Consumer Reports* survey of more than 100,000 revolutionary products and ideas, tampons were ranked as one of the 50 most significant innovations of the 20th century.

B E D R O O M *

* sleep tight, don't let the bedbugs bite...

Beds

Piles of leaves, grass, ferns, or animal skins probably formed the first beds, but sleeping on the ground left people prey to drafts and creatures. Raised structures of wood or earth were an obvious solution, but for several thousand years beds remained the preserve of the rich. The earliest known bedrooms are from the royal palaces of ancient Sumer, circa 3500 BC, and contain only one bed, reserved for the head of the household. In ancient Egypt, pharaohs like Tutankhamen slept on beds of ebony and gold, while the common people slept on heaps of palm fronds. Egyptians of all classes, however, employed mosquito netting to protect themselves from nighttime pests. The word "canopy" is derived from the Greek *konops*, for "mosquito."

Egyptian and Sumerian beds were hard, with solid bolsters as pillows, primarily designed to preserve elaborate hairdos. The Greeks and Romans were among the first to use mattresses and string their bed frames with rope or leather to make a sleeping surface. The Romans in particular developed sophisticated beds and bedding—the richest Romans had ornate metal bedframes and mattresses stuffed with down. The norm, however, was a simple pallet stuffed with straw.

Bed technology was not to improve in the West for another 1,500 years. The very wealthy continued to use beds as status symbols—Elizabeth I of England and Louis XIV of France were both renowned for holding court from their massive, stately beds. Elaborate canopies and hangings originally developed in imitation of the ornate royal tents used in war and sport crowded homes of medieval Europe. Beds were made of wood and were held together with rope strung as tightly as possible. Inevitably the bed would become rickety or saggy as the rope stretched and loosened and would have to be tightened, giving rise to the phrase "sleep tight."

Even the most affluent people had to make do with mattresses stuffed with organic material which would eventually become infested with mold and vermin. Poorer people coped as best they could by taking the stuffing out during the day to dry and air it before restuffing the bed in the evening (this may be where the phrase "making the bed" originates). In 16th-century France a popular alternative was an early air or "wind" bed, made by inflating a waxed canvas bag.

As metalworking technology advanced, iron bedframes and steel springs for mattresses came into use. Conical springs that would compress vertically without slipping sideways were used to make the first viable "sprung mattresses" in the mid 19th century. Cotton, horsehair, feathers, or down were popular stuffing materials, and would be selected according to the individual's budget. At first, however, springs were expensive and construction by hand was difficult. It was not until the early 20th century that the complicated "innerspring" designs popular today caught on. After World War II, with the development of latex, foam became the favored packing material. No longer needed for mattresses, the downy feathers of the eider duck were used to stuff quilts, giving rise to the eiderdown or, to use the French term for down, the *duvet*.

Futons and waterbeds

SLEEPING IN STYLE

FUTONS

The Japanese word *futon* translates variously as "bedroll," "bedding," or "place to rest," depending on the source. In Japan it refers to the whole system of bedding, including the *shikibuton*, or thin, flexible, cotton-filled mattress, and the *kakebuton*, or cotton-stuffed duvet-like covering (the two are essentially the same). These can be easily rolled up and stowed away during the day to save space and preserve the uncluttered minimalist style of the Japanese home. At night they are brought out and laid on the *tatami*, a two-inch thick woven reed matting that forms the floor of traditional homes. Japanese futons are returned to the "futonier" on an annual basis, so that the cotton can be taken out, washed, and restuffed.

North Americans abroad had admired the futon since the late 19th century, but it was not until the 1960s that they became popular in the United States and Canada, as beatniks, bohemians, and people attracted by alternative cultures began to make their own or acquire them through friends. North American adaptations such as extra layers of padding, zip-on upholstery covers, and use of a foam center made the futon thicker and bulkier. The invention of the convertible frame in 1978, by Boston craftsman William Brouwer, led to the sudden explosion of futon-making from a cottage industry to a billion-dollar business.

Today, there are even cat and dog futons available for household pets.

WATERBEDS

The first waterbeds date back 3,600 years to when the ancient Persians used sun-warmed, water-filled goatskins as mattresses. Difficulties in making the mattresses sufficiently waterproof and durable meant that they were not much heard of again until the mid-19th century. In addition, unless properly insulated and heated, waterbeds can absorb all of a sleeper's body heat with dangerous consequences.

In 1853, Dr. William Hooper of Portsmouth, England, patented a modern waterbed. Hooper had established that waterbeds provided an excellent pressure-reduced surface which helped in the treatment of a number of medical conditions, most notably pressure sores in bedridden patients. His waterbed was a simple water-filled mattress made from rubber, much like an enormous hot water bottle. He found that it was also effective in treating burn injuries, arthritis and rheumatism and at least one was in use in London's St. Bartholomew's Hospital by the end of the 19th century.

In the 1960s American Charles Hall made use of the durable, insulating properties of the new material PVC (polyvinyl chloride), or, more plainly, vinyl, to improve on the earlier rubber models and give waterbeds a new lease of life. Even today, proponents of waterbeds argue for their benefits to health—they cannot absorb dust or bacteria and so can be recommended for asthma and allergy sufferers.

Waterbeds enjoyed a revival during the 1960s, and although they fell out of fashion by the late 1970s, millions of devotees around the world still admire them for their evenly-distributed support for human bodies.

Clocks and alarm clocks

TIME MACHINES

The earliest methods used to measure the passage of time involved the motion of the celestial bodies, particularly the sun. The position and length of a shadow cast by a stick was probably the first of these, and is still used today by some nomadic tribes. These basic sundials were developed by early civilizations such as the Egyptians, who used huge stone obelisks as pointers, or *gnomons*. In the northern hemisphere the shadow of a sundial's gnomon moves in what we know call a clockwise arc, accounting for both the design of clock faces and the direction of movement of the hands. At night the passage of time could be measured by the progress of the moon or the stars.

The sundial was perfected by the Chaldeans, who, in around 320 BC, introduced to ancient Greece the *hemispherium*—sophisticated sundials made from blocks of stone with semicircular depressions. The Chaldeans were the first to divide the day into 24 hours. At about the same time in ancient China the day was divided into 100 units, and was measured differently from the West until the 19th century.

Almost as old as the sundial is the water clock, where the passage of time is measured by water running into or out of a vessel. The earliest form was probably the sinking bowl, where a bowl with a hole in the bottom is placed in a larger vessel that is filled with water. As the bowl fills it slowly sinks, and the time can be read off marks on the side of the bowl. The other type of water clock involves water running out of a filled vessel—the Greeks called this a *clepsydras*, or "water thief." An early example was found in the tomb of the pharaoh Amenhotep I, dating back to 1500 BC. Similar water clocks were still in use in some parts of North Africa in the 20th century.

Water clocks became very sophisticated under the Greeks, who fashioned elaborate versions, including the first town clock, involving multiple vessels, hands, bells, and even water-powered whistling birds. In 270 BC Ctesibius of Alexandria made a water-powered alarm clock, but the first alarm clock may have been an adaptation of the candle clock, where regular marks on a candle count out the hours. A pin stuck in at the desired level will fall out and make a sound when the candle burns down.

Water clocks and sundials were the standard means of measuring time in Europe until the late Middle Ages. Monks used water-powered alarm clocks to tell them when to pray, while most church towers were marked with simple sundials. Many were inscribed with mottoes such as *carpe diem* or *tempus fugit*. These traditional methods had drawbacks, however. Sundials told only the local time, which would vary with longitude and season (although some more sophisticated dials were marked to take account of the season). Water clocks told only relative, rather than absolute, time and were difficult to regulate because water runs out faster when the vessel is full than when empty. Both methods were at the mercy of the weather, since sundials needed sunlight and water clocks would freeze in the winter (monks used hourglasses in winter, as did sailors at sea).

The Chinese were the first to use mechanical clocks. In 1090 BC the astronomer Su Sung built an enormous clock using water and mechanical power, which featured revolving spheres, rings, and disks, and little figures that would hit bells. Similar technology was in use in Europe by the late 13th century—in Britain, for instance, one was installed at Dunstable Priory in 1283. Mechanical clocks require a power source to drive the mechanism but until springs were introduced gravity was the only source of power used, in the form of weights that were raised by hand and then slowly dropped. This meant that clocks needed to be hung on walls and could not be moved around.

Most early mechanical clocks were used in church towers and at first they had no hands—only bells. The word "clock" derives from the German *Glocke*, meaning "bell." One of the first tower clocks was installed in France in Strasbourg Cathedral in 1352, while the first British clock tower was at Salisbury Cathedral, in 1386. Later clocks were fitted with a single hand—the minute hand was not introduced until 1577. Springs were first used to power clock mechanisms in the mid 1400s and the first portable clock was made in 1504 by Peter Henlein of Nuremberg.

At first mechanical clocks were very unreliable and not good at keeping time accurately. They had

A Japanese woman winding up a wall clock, circa 1700. With a clock of this type it would have been necessary to reset the weights twice a day, at dawn and dusk, to make sure the clock kept the correct time throughout the day and night.

to be reset by reference to sundials. In 1581, however, Galileo used his pulse to time the pendulum movement of a lamp hanging from the ceiling of a church, and noticed that it had a regular interval, no matter how short the arc of its swing. Although Galileo himself never built a pendulum clock, this discovery was to be the basis for more accurate timekeeping. In 1657 the first such clock was built to a design by Dutch physicist Christiaan Huygens, and in the following years technological advances came thick and fast, to the point where mechanical clocks could keep time accurate to within a few hundredths of a second per day.

As clocks improved, the shortcomings of the sundial became more apparent. But people in rural communities were slow to adopt the new technology and mistrustful of those who advocated it. A memorial in a village near Chester, in England, records the satirical reaction to a clockmaker's claim that his wares were more accurate than the traditional method: "Here's the cottage of Peter, that cunning old fox, Who kept the Sun right by the time of his clocks."

The accuracy of clockwork mechanisms was not surpassed (for public use) until 1967, when the Swiss Horological Electrical Center invented the quartz watch. To keep time accurately, quartz

watches operate on the principle that a quartz crystal subjected to an electrical current vibrates at a rate of 8,000 cycles per second. The scientific community uses an even more precise standard—the cesium atomic clock, where the vibration of an atom of cesium is used to keep time. A second is now defined as the length of time it takes for a cesium atom to vibrate 9,192,631,770 times. Cesium clocks are accurate to within 1/1,000,000 of a second per year.

Venetian blinds

SLAT MACHINE

Although curtains were first recorded in Western culture in 1509 they did not become common until the 18th century. Before this, windows were shaded with shutters or panels of oiled cloth in frames, known as fenestrals. Early blinds probably derived from fenestrals. William Bayley patented a cloth blind in 1692, and in 1750 the first spring-loaded roller blind, also known as a "spring curtain," was invented. The origins of the Venetian blind are unclear. According to some sources the name is derived from the connection with Italianate windows, a practice pioneered by British designer Edward Beran, who enclosed wooden slats in an adjustable frame in 1769. Angled wooden slats would have been familiar from medieval times, when louvers were common features of church bell towers.

Often used in the home to add a touch of class, Venetian blinds are also popular in commercial and institutional settings because of their technical superiority over ordinary curtains—they are generally considered to be more durable, easier to operate, and cheaper.

Other sources, however, claim the name derives from the Venetians themselves, in particular Venetian slaves captured by the medieval Persians, from whom, it is said, they learned the design. The Venetians subsequently introduced the new craft on their eventual return to Europe. This theory is borne out by the fact that the French for Venetian blinds is *persiennes*.

Venetian blinds first came to America as early as 1761 (before Beran is said to have invented them), when they were installed at St. Peter's Church in Philadelphia. They are shown in contemporary pictures hanging in the Independence Hall in Philadelphia at the time of the signing of the Declaration of Independence and at the Constitutional Convention in 1787.

Radio and clockwork radios

OUT OF THIN AIR

Radio waves are a form of electromagnetic radiation, like visible light, which can be used to transmit sound or other information over long distances at the speed of light. The existence of such waves was first suggested by British physicist James Clerk-Maxwell in 1873, but not demonstrated until 1888 when the German scientist Heinrich Hertz generated a burst of radio waves by passing a spark between two metal balls.

In 1894 a young Irish-Italian, Guglielmo Marconi, used a spark-generator similar to Hertz's to send a radio signal across a room. The next year he was able to send signals over several miles. In 1896 he packed up what he called his "Black Box" and set off for England to make his fortune. Undaunted by the attentions of suspicious customs officials, who promptly broke his apparatus, Marconi successfully demonstrated his invention to the authorities and won a patent. In 1897 he set up the Marconi Wireless Telegraph Company. By 1898 the British Navy were using Marconi technology in maneuvers, and in 1899 Marconi transmitted the first radio message across the English Channel. By 1901 transatlantic radio communication was possible.

At this stage radio was used to send coded messages in a similar fashion to the telegraph, but in 1905 a Canadian inventor, Reginald Fessenden, invented a device that allowed continuous speech to be broadcast. On Christmas Eve 1906 he sent out the first voice broadcast over the North Atlantic—it was picked up by sailors on board banana boats belonging to the United Fruit Company, which had developed crystal receiver sets for its fleet. These simple devices, which used a quartz crystal to detect and isolate the message-carrying signals, made radio available to amateur enthusiasts, but it was the development of the electronic valve by Lee de Forest, in 1906, that eventually made simple, reliable radios available to the public.

De Forest, who became known as the "father of radio" after winning a 15-year patent battle, the longest in radio history, broadcast opera from New York as early as 1910. Regular entertainment transmission did not begin until 1920, however, when Frank Conrad, a Pittsburgh enthusiast who had been transmitting music from his garage, started radio station KDKA, broadcasting for an hour every evening.

By this time radio sets based on valve technology were available to the general public. An early example, the 1922 Operadio, weighed in at a hefty 22 pounds (10 kg). As sales grew so did the audience, and by the late 1920s the Dodge Victory Hour—a coordinated nationwide broadcast by NBC—was able to draw an audience of more than 35 million people. During the Depression, shows such as "Amos and Andy" regularly drew audiences of more than 40 million.

The invention of the transistor in 1947 led to the miniaturization of electronic components, and it

became possible to produce tiny transistor radios that could be taken anywhere. The limiting factor for radio availability became the power source—batteries ran down and were unavailable or too expensive for people in poorer areas of the world. In 1995 British inventor Trevor Bayliss successfully developed a gearing system that allowed a wind-up spring to release its energy slowly enough to generate long-lasting electricity sufficient to power a radio—40 minutes of power from just 20 seconds' winding. Bayliss' clockwork radio has been a particular success in South Africa, where, with the help of former President Nelson Mandela, he set up a company to manufacture the device.

Wristwatch

TIME IN MOTION

The invention of the mainspring by Peter Henlein of Nuremberg in the early 16th century paved the way for the first portable clocks. Henlein's first creations were housed in drum-shaped cases and were designed to be hung from a belt or girdle. Later he made "pomander" clocks—globes filled with perfume that also told the time. Among the leading users of early portable clocks were the town watchmen who patrolled 16th-century European towns with clocks slung about their necks, calling out the hours. As a result, portable clocks became associated with watchmen, a word that was later contracted to "watch."

Most watches were made for the luxury market, leading to the creation of ornate designs encrusted with gems. The first recorded watch to be worn on the arm was presented as a gift to Elizabeth I in 1571. It was "an armlet of gold, all fairly encrusted with rubies and diamonds and having the closing thereof a small clock."

In 1675 Robert Hooke and Christiaan Huygens independently developed the balance or hairspring, a device that allowed accurate, reliable watches to be made small enough to fit into a pocket. Attached to a chain or ribbon, these fob or pocket watches soon caught on. The technology now existed for a viable wristwatch but it took a while for fashion to catch up. It was not until 1790 that the first record of a wristwatch appeared, in the form of a "watch to be fixed to a bracelet," made by Jacquet Droz and Paul Leschot of Geneva. Switzerland by this time was the center of world watchmaking, exporting more than 60,000 watches per year.

Wristwatches were considered effeminate and did not catch on for more than a century. Many of the advances we now associate with wristwatches, such as self-winding mechanisms and stopwatches, were originally developed for the fob watch. But the wristwatch offered practical advantages that were hard for the military to ignore. In 1880 the German Navy issued wristwatches to all its officers, and they were also widely used by British officers in the Boer War and later World War I.

Rugged-looking design features such as metal grids and chunky leather straps made wristwatches more appealing to men.

Wristwatches also benefited from their association with explorers and pioneers. In 1907, when wristwatches were still extremely rare, the famous jeweler Louis Cartier was commissioned to make one by powered flight pioneer Alberto Santos-Dumont. Aviators Amelia Earhart and Charles Lindbergh both sported wristwatches during their famous flights. In 1927, London typist Mercedes Gleitz wore a Rolex Oyster, the first waterproof wristwatch, during a swim across the English Channel. This trend continues to this day, with wristwatch manufacturers proudly advertising the use of their watches for all kinds of unlikely occasions, ranging from around-the-world yachting to outer-space excursions!

World War II cemented the popularity of wristwatches, but the basic design changed little until the introduction the Beta 21—the first quartz timepiece, developed in Switzerland in 1967. Fearing that quartz watches would undermine their traditional clockwork product, however, the Swiss were slow to capitalize on their invention. Japanese companies quickly took the lead in the market, followed by the Americans, who in 1971, developed the Pulsar—the first digital watch, which had an LED display and no moving parts. Liquid-crystal displays were developed not long after, and now 87 percent of wristwatches are digital. Today more than 60 million wristwatches are sold each year in the U.S., and the digital technology revolution is redefining their role as it becomes possible to integrate computing power, telecommunications, photography, and entertainment into a single unit.

Bikini

SWIMWEAR WITH IMPACT

Bikini-like outfits are known from murals and mosaics to have existed in ancient times, when they were worn by female athletes and dancers as practical garments that facilitated free movement during sports activities. Sicilian mosaics of the fourth century AD, for instance, show a woman wearing a strikingly modern-looking strapless bikini while "working out" with what look like handheld weights.

Swimwear was first used in the West in the 18th century when bathing became fashionable. Victorian bathing suits for women were hardly any skimpier than normal clothes, but as time went on they got smaller and lighter. By 1870 the all-in-one suit had appeared, and by the 1930s backless versions with narrow shoulder straps gave way to two-piece suits.

The bikini itself was created by a Paris couturier in July 1946, and was named after the Bikini Atoll in the Pacific—where the United States had just tested an atomic bomb amidst a flurry of worldwide

media attention—on the basis that it would create as much of a stir. The details of its creation, however, are in dispute. According to some sources it was the brainchild of designer Jacques Heim, but according to others the designer Louis Réard. One story is that Heim created a daringly skimpy swimsuit and named it the Atome, and that Réard created an even skimpier version and called it the Bikini. When Micheline Bernardi modeled the new suit on a Paris catwalk on July 5 1946, just four days after the atomic test, it duly created a worldwide sensation.

Stockings

THE NYLON REVOLUTION

Stockings evolved partly from a Roman garment of the first century AD, called an *udo* (the plural of which is *udones*), a type of sock designed to protect the feet inside rough boots. Over time *udones* became longer, extending up the leg to cover the knee, and became part of the official dress prescribed to the clergy by the Catholic Church.

During the same period the Germanic tribes of northern Europe wore loose, trouserlike garments called *heuse*, which later became hose. Hose and *udones* evolved into broadly similar figure-hugging leg coverings, which in ninth-century Europe became known as *chausses*, and later netherstockings—eventually shortened to stockings. An alternative name, from as early as the 11th century, was "skin-tights," reflecting the fashion for increasingly figure-hugging designs.

Women are believed to have started wearing stockings in the sixth or seventh century, but as women's legs were generally not visible in contemporary art and it was considered immoral to write about them, there is little record of their use. It was not until 1306 that a picture of a woman putting on stockings first appeared. By this time Chaucer had already recorded a fashion for brightly colored stockings—his Wife of Bath wears stockings of "fine skarlet redde."

In 1589 the Reverend William Lee invented a machine that could knit stockings and they started to become more widely available. For several centuries silk was the favored fabric, but during the 1930s chemists at DuPont, in particular Wallace Hume Carothers and Julian Hill, created a new synthetic fiber they claimed was "as strong as steel, as fine as a spider's web." They dubbed the new product nylon, and today it is the second most used synthetic fiber in the developed world. The coinage of "nylon" is disputed; some say the "ny" stands for New York but more credible is the opinion that "nyl" comes from vinyl and "on" comes from rayon.

At first nylon was used for fishing lines and toothbrush bristles (see page 70), but in 1939 DuPont exhibited nylon stockings at the World's Fair. Word of mouth about the virtues of nylon,

which was said to be unbreakable, and nylon stockings, which were said to be indestructible, combined with heavy pubic relations from DuPont to generate a state of nationwide hysteria. The chemical giant carefully coordinated the release of the first stockings so that none would go on sale before "Nylon Day," May 15, 1940.

The consumer frenzy that followed was unprecedented. More than 4 million pairs of "nylons'" were sold in just a few hours and a depression hit the Japanese silk market. At least 36 million pairs were sold in the first year, 64 million, according to some sources. The outbreak of war led to nylon rationing as it was requisitioned for the manufacture of parachutes and tents, and near riots greeted the reintroduction of nylon stockings after the war.

Nylons were sold as individual stockings that had to be held up with a garter belt until 1959, when Glen Raven Mills of North Carolina introduced the first nylon panty hose. This innovation did not catch on until 1965, when fashion's boldest statement, the miniskirt, was launched and garter belts became impractical.

Brassiere

SUPPORTING ACT

In Egypt and Crete most men and women were scantily clad in loin clothes or skirts that hung from the waist or just below the breasts. Minoan murals show some women wearing an early bra-type device designed to emphasize the bust by pushing their breasts up and clear of their clothes. Ancient Greek and Roman women sometimes favored the opposite esthetic and strapped their bosom down with strips of cloth to give a flat-chested appearance, a fashion revived more than 2,000 years later by the flappers of the 1920s.

Flappers were breaking with a fashion tradition that had persisted since 16th-century Europe, when "wasp waists" first came into vogue (initially, for both men and women). Corsets or bodices with drawstrings and whalebone or metal stays not only "cinched" waists but also emphasized their narrowness by accentuating the hips and bosom. In the late 18th century "falsies" first appeared in the form of so-called bust improvers of wool, cotton, or wax, which were inserted into the bust area of a bodice or corset.

Mounting Victorian concern over the health risks of tight corsets created a market for a less restrictive form of bosom enhancer. American Mary Phelps Jacob (later known as Caresse Crosby) is usually credited with the invention of the brassiere in 1913, and while it is true that hers was the first successful version there were several earlier attempts. In 1875 George Frost and George Phelps patented Union Under-Flannel—ladies' underwear that had no stays or drawstrings. In 1889 corset-maker Herminie Cadolle sold a bra-like garment called the Bien-Etre

("Well-Being"), and in 1893 Marie Tucek patented the "breast supporter." This had all the features of the brassiere, including separate pockets for each breast, over-the-shoulder straps, and a hook-and-eye fastener, but Tucek never marketed it and ceded her place in underwear history to Jacob.

In 1913 Mary Phelps Jacob was a young debutante preparing to attend a party in a sheer gown she had just purchased. Concerned that a traditional corset, with its bulky stays, would ruin the line of the new dress, she enlisted the help of her French maid and devised a makeshift substitute by sewing together two handkerchiefs and some ribbon. The simple new garment was popular with friends, prompting Jacob to patent her "backless brassiere" in 1914. Her attempts to market it failed and she soon sold out to the Warner Brothers Corset Company.

A notable popular myth gives an alternative version of the birth of the brassiere, attributing its invention to the suspiciously named Otto Titzlinger. Needless to say, this is a complete fiction that has entered the public imagination thanks to the writer Wallace Reyburn, author of *Flushed With Pride*—the book partly responsible for the myth that Thomas Crapper invented the toilet. In his subsequent book *Bust-Up: The Uplifting Tale of Otto Titzlinger*, Reyburn recounts how the eponymous hero invents the bra with the help of his trusty sidekick, Hans Delving, for the benefit of one Lois Lung.

The brassiere gained ascendancy in the world of ladies' undergarments with remarkable rapidity, quickly toppling the corset. It was helped by the onset of World War I, when women were called upon to stop buying corsets as a patriotic gesture because the metal used to make stays was needed for the war effort. As women switched to bras more than 28,000 tons of metal were freed up.

After the war advances in brassiere technology made them even more popular despite the vogue for flat chests. Elastic fibers were introduced in the 1920s, followed by strapless bras and the adoption of the standardized cup-size system in the 1930s.

During the 1930s and 1940s fashion favored an ever-increasing bust size, a trend that reached its peak in the 1950s with the invention by Howard Hughes of a special cantilevered contraption for the well-endowed starlet, Jane Russell. The bra burning of the Women's Liberation movement in the 1960s and 1970s briefly threatened the popularity of the bra, but Ida Rosenthal was unfazed. Her response was simple: "…after age 35 a woman hasn't got the figure to wear no support. Time's on my side."

Velcro®

VELVET HOOKS

Conceived as a rival to the zipper, Velcro was the brainchild of Swiss mountaineer George de Mestral. During an Alpine hike in the summer of 1948 de Mestral was fascinated by the irritating burrs produced by cocklebur bushes, which clung to his clothes and his dog, and were extremely difficult to remove. Studying them under a microscope, he observed that the burrs were covered in thousands

of tiny hooks that were caught on the tiny cotton loops of his clothing.

De Mestral determined to create a synthetic equivalent that would make a simple but effective fastener. Approaching textile experts he was rebuffed by all except a weaver from Lyon, France, who painstakingly produced two cotton strips—one with tiny hooks, the other with tiny loops or eyes. De Mestral called it "locking tape."

Technical difficulties, however, meant that viable locking tape was not patented until 1955. Duplicating the hand-woven original with machines proved difficult, and the fragile cotton hooks and eyes quickly broke down after repeated opening and closing. Using nylon solved this problem, particularly after de Mestral discovered that infrared treatment could produce almost indestructible nylon. He christened the new material Velcro, taking the "vel" from velvet and the "cro" from the French *crochet* (little hook). By the late 1950s, 60 million yards (55 million m) of Velcro were being produced every year.

Safety pin

A PATENT CLASSIC

In prehistoric times, humans used simple pins, made from thorns, splinters of wood, or fish bones, and later from metal, to fasten their clothes together. Such pins had an obvious disadvantage, however, in that they could easily fall out. Improved, U-shaped versions appeared in Bronze-Age Europe in the second millennium BC. By the sixth century BC the Romans had developed the *fibula*—a U-shaped pin with a cradle at the end of one arm, a point on the other arm, and a coil at the bend, providing tension to press the point into the cradle and hold the pin closed. It was very similar to today's safety pin.

Somehow knowledge of the *fibula* was lost, however, and by Victorian times buttons, laces, snaps, and hook-and-eye arrangements had largely replaced the once ubiquitous pin. Pins were still used, however, for items such as shawls and diapers, and still posed age-old problems such as falling out and stabbing the wearer. In 1842 Thomas Woodward of New York was granted a patent for a "shielded shawl and diaper pin" that was almost exactly like today's safety pin. It had a cup at one tip to hold the point and shield it: "It will not become loosened by the motion of the wearer and... cannot be caused to puncture the person." Unfortunately it had one crucial

Prior to Walter Hunt's 1849 version, with its integral springy coil, the "dressing pin" was the bane of dressmakers, diaper-changing mothers, and babies alike, coming open all too easily to stab fingers and flesh with a loose point.

drawback—it was hinged at the bend, which meant that the tension to hold it closed had to come from fabric bunched between the two arms. Too little fabric and the pin would come open, too much and it would bend out of shape.

The solution to these problems was provided by the "dress-pin," patented in 1849 by Walter Hunt. Hunt was a prolific New York inventor whose previous efforts included a repeating rifle, artificial stone, an ice plow, an early bicycle, and the first practical sewing machine which he did not patent for fear that it would put seamstresses out of business. A draftsman to whom he owed $15 (for the illustrations to some of his many patents) proposed that Hunt should assign to him the rights to whatever he could invent using an old piece of wire. In return the debt would be forgiven and Hunt would be paid $400.

After three hours of twisting, Hunt came up with a self-sprung safety pin, where the wire itself was coiled at the bend to make a spring that would provide tension to hold the point against a cradle or shield. There was no hinge joint or pivot that would wear out or work loose. It could be used, said Hunt in a patent considered a classic by inventors ever since, "without danger of bending... or wounding the fingers."

Contact lenses

UP CLOSE AND PERSONAL

Leonardo da Vinci was the first to suggest correcting defective vision back in the 15th century by placing a lens in direct contact with the eye. Da Vinci's version involved a tube of glass filled with water and sealed at one end. The open end would be placed against the eye so that it was bathed in water, which would refract light, acting as a corrective lens. French philosopher René Descartes proposed a slightly modified version of da Vinci's lens in 1632, involving a water-filled glass tube ¼ inch (5 mm) long with a lens from a microscope at one end. In 1801 Thomas Young successfully used Descartes' design to correct his own vision.

Da Vinci and Descartes had suggested water-filled tubes because they knew that the glass-blowing and glass-grinding techniques of the day could never make a lens smooth enough to be tolerated by the sensitive eyeball, but of course their designs had to be held in place, meaning that they were hardly an advance on spectacles. A 17th-century French attempt to fit a small glass lens onto the eye with a layer of gelatin underneath for comfort failed because the lens kept falling out.

In 1827 English astronomer Sir John Herschel suggested a solution—a lens that was ground to conform exactly to the surface of the eye—but a practical version was not produced until 1888, when Swiss physician Adolph Fick and Parisian Edouard

Although no accurate conclusions have yet been drawn, studies are being performed worldwide to examine the effects of oxygen permeable lenses to slow the progression of myopia.

Kalt independently reported the use of a contact lens to correct vision. Fick's lenses successfully corrected astigmatism but must have been an ordeal to wear. They were large, measuring more than ½ inch (1 cm) across, and were designed to fit over the entire eyeball, rather than just the cornea (the layer that covers the pupil and iris).

In 1929 a Hungarian physician named Josef Dallos developed a technique for taking molds from people's eyes, so that lenses could be made to fit more exactly. It was not until the development of plastic lenses, however, that contact lenses caught on. In 1936 German firm I.G. Farben introduced Plexiglass lenses, and in the same year New York optometrist William Feinbloom introduced plastic lenses to America. Proper corneal lenses were developed in the 1940s but many people were still put off by the discomfort of hard lenses.

Development of the soft contact lens is variously attributed to Kevin Tuohy in 1948, and Otto Wichterle and Drahoslav Lim in 1960. Soft lenses finally became commercially available in the United States in 1971. Since then advances in plastics technology have made it possible to wear tinted lenses (introduced in 1980), lenses that can be worn for extended periods (1981), bifocal lenses (1982), disposable lenses (1987), and even ultraviolet shielding lenses (1996).

Eyeglasses

EYES CAN SEE CLEARLY NOW

 Eyeglasses are lenses of glass or plastic held in a frame and placed in front of the eyes. As the lens refracts light rays they compensate for defects in the eye's own lenses. Eyeglasses were invented in Italy during the 1280s, in either Florence or Pisa, probably by Salvino Armato. A Florentine optical scientist and skilled glassworker, he ground lenses into a convex shape to help correct his long-sightedness.

When a person is long-sighted the lens of the eye weakens and light rays passing through it, instead of being focused on the retina, converge on a point behind the retina. A convex lens helps to correct this defect by doing some of the work for the eye, focusing light rays before they reach the eye's own lens.

Armato's invention was well received, and was recorded in the words of an early 14th-century friar, Father Giordano da Pisa, in a sermon he gave in Florence in 1306—although Armato himself was not mentioned by name:

"It is not twenty years since there was discovered the art of making spectacles which help you see well, and which is one of the best and most necessary in the world. I myself saw the man who discovered and practiced it and I talked with him."

These early eyeglasses were the result of a long tradition in Islamic countries of experimentation with lenses and their abilities to refract light. This knowledge was passed on to European scholars during the Renaissance. Roger Bacon (1214–1292), for instance, is known to have experimented with convex corrective lenses, possibly before the Italian invention of eyeglasses.

Before this time, those who developed far-sightedness in old age, or were born with it, were doomed to cope as best they could. Convex-lens eyeglasses had the potential to revolutionize the lives of those involved in close work, such as tailors or scribes, and would become even more important with the invention of printing and popularity of books and newspapers. Lenses quickly caught on, and within 20 years the center of the new industry of eyeglass manufacture had shifted to Venice. Here the glassworks were moved to the island of Murano and the master glass craftsmen guarded their secrets jealously—workers who left the island were threatened with death!

Drastic union rules notwithstanding, eyeglass technology soon spread across Europe, although eyeglasses were still relatively expensive and their use was mainly restricted to the educated, noble, and wealthier classes.

At this time eyeglasses were uncomfortable to wear, and almost exclusively took the form of pince-nez—where the frames stayed in place by "pinching" the nose—and were heavy, with thick glass and frames of horn, bone, ivory, or tortoiseshell. Arms to loop over the ear and hold the eyeglasses in place were not invented until 1727, so people used leather or cord straps, fixed the eyeglasses onto sticks, or simply wore them on the bridge of the nose and avoided moving suddenly or breathing heavily.

As technology advanced eyeglasses improved and became more widely available. Concave lenses to

correct myopia (near-sightedness) were first made in the 15th century, and Benjamin Franklin invented bifocals in the 1760s. As eyeglasses became more popular, however, they lost their image as a status symbol, and by Victorian times they had become unfashionable. Ladies would avoid wearing them in public, a state of affairs that has persisted almost up to the present day. The introduction of plastic lenses and frames made eyeglasses lighter and more durable and gave manufacturers and designers greater scope, but only in the last few years have eyeglasses again become fashionable.

Sunglasses

THROUGH A GLASS, DARKLY

The first sunglasses were made by the Inuit tribes of the Arctic Circle in the 18th century. They used pieces of whalebone or wood with narrow horizontal slits across the center to prevent snow-blindness by protecting their eyes from the glare of sunlight reflected off snow. Inuit sunglasses date back thousands of years, and may even be much older, given that humans first adapted to life in Arctic areas tens of thousands of years ago.

During the Ming dynasty (1368–1644) the Chinese employed colored or smoked rock crystal (quartz) as dark glasses—types of quartz included *cha ching*, "tea crystal," and *mo ching*, "black crystal." These devices were not primarily used as sunglasses, however, but as a means of hiding the eyes of judges as they sat in court—according to Chinese tradition, the judge's expression as he evaluated evidence was to remain inscrutable until the end of the trial. When glass spectacles arrived from Europe in around 1430 these too were adapted for judges by smoking the glass to darken it.

Smoked glass was also used to create dark lenses in Europe until technology made tinted or colored lenses widely available in the 18th century. Eyeglass designer James Ayscough used some of the first tinted lenses in 1752. He recommended the use of green- or blue-tinted lenses because he felt that transparent glass caused a dangerous glare that might damage the eyesight.

Sunglasses only became popular after they were adopted by the military, in particular by the United States Air Force, which commissioned the optical specialists Bausch & Lomb to create high-performance sunglasses that could protect the eyes of their fighter pilots from the glare of sunlight at high altitudes. Company researchers developed a tint that would cut out the brightest part of the spectrum, and fashioned frames that extended downward to protect aviators' eyes when they glanced down at their instruments. They called the new glasses Ray-Bans.

American physicist and inventor Edwin Land contributed a further advance in sunglass technology. In 1929 he used a cellophane-like plastic to make a polarizing filter. Normal sunlight

is made up of light waves oriented in several different planes. A polarizing filter only transmits light waves oriented in one plane, absorbing and cutting out the others and thus dramatically reducing glare. In 1937 Land founded the Polaroid Corporation to produce, among other things, the first Polaroid sunglasses.

After World War II sunglasses became an essential fashion accessory for Hollywood stars and the international jet set. With the help of heavy advertising campaigns by the likes of Foster Grant, the association between shades and chic became firmly cemented in the eyes of the public and sunglass manufacturing became big business.

Zipper

THE FAST TRACK

In 1893 an American mechanical engineer called Whitcomb Judson, patented a device he called a "clasp-locker," the forerunner of the modern zipper. At the time, boots were done up with fiddly button-hooked shoelaces or long rows of buttons, and the story goes that Judson was inspired to create a simpler alternative when a friend complained of the sore back caused by bending over to do up his boots.

The clasp-locker had a row of hook-and-eye fasteners that were fastened or unfastened by a slide. It operated in much the same way as a modern zipper, which uses the principle of the inclined plane or wedge. A wedge is a simple tool that redirects a small force to produce a stronger one. In the case of a zipper, wedges inside the slide redirect a small effort (pulling the slide up or down) into a strong force that can push together or force apart a row of interlocking teeth in a way that is almost impossible to reproduce manually (try closing the two sides of a zip without using the slide).

Judson exhibited his invention at the Chicago World's Fair in 1893 but the device's complicated appearance and poor reliability—it had a tendency to jam or come open—failed to win many fans. Undaunted, he set up the Universal Fastener company and succeeded in selling 20 clasp-lockers to the United States Postal Service for use on mailbags. They were soon discarded when they kept jamming. Despite Judson's continual efforts to improve his design, Universal Fasteners, which later became the Automatic Hook and Eye Company, had little success.

In 1917 an employee of Automatic Hook and Eye, Swedish-American engineer Gideon Sundbach, was granted a patent for a significantly improved version—the "hookless" or "separable fastener" (later known as the Talon slide fastener). Sundbach's advanced version used interlocking metal teeth instead of hooks and was much more practical and reliable.

The new slide fastener was given a big boost when it was adopted by the United States military

during World War I, and was also used on boots, money belts, and tobacco pouches. It was slower to catch on for clothing, however, as the metal teeth would rust and cause discoloration when they got wet—fasteners had to be unsewed from garments before they could be laundered. People also found the unfamiliar device difficult to operate, and a book of instructions accompanied each fastener!

Waterproofing and improvements in reliability increased the appeal of the slide fastener, and in 1921 the B.F. Goodrich footwear company ordered 170,000 for its new Mystik galoshes. These were soon renamed Zippers, after the noise the fastener made. In the following decades zippers were widely incorporated into clothing, and promoted as a simple solution for children's clothes ("Mommy, look! One zip and I'm all dressed!" was the tag line for one campaign). They replaced button fasteners on men's trousers and were even used on spacesuits. In clothing for women only side zippers were used, front zippers being considered immoral.

Today the average American buys 12 new zippers every year, most of them manufactured by the YKK company, founded in Japan in 1934 as Yoshida Kogyo Kabushililaisha. In 1914, Automatic Hook and Eye produced a few hundred feet of zippers each day. Today, YKK have 206 factories in 52 countries, making everything from the brass for the zippers to the dyed fabric that surrounds them, and they produce 1,200 miles (1,900 km) of zipper every day in their Macon, Georgia, factory alone.

Buttons

KEEPING IT TOGETHER

Buttons were invented 3,500 years before buttonholes, having first appeared as decorative disks fixed to clothing for ornamentation. The oldest examples date back to the Indus Valley civilization of the third millennium BC, when seashells were shaped into circles or triangles and sewn onto garments. Other cultures made buttons out of bone, horn, pottery, wood, or metal—they were often intricately carved but were not used as fasteners. Clothes were fastened by means of cloth ties, pins of bone, horn or metal, or cords.

The Greeks and Romans used buttons as ornamentation too, but also fixed loops to the fringes of garments so that buttons could be passed through them. Such advanced technology was beyond the inhabitants of Dark-Age Europe, who favored simple, loose-fitting robes and swathes of cloth. Buckles, brooches, belts, and pins were sufficient for such fashions.

In the Middle Ages, however, tighter clothes that molded more closely to the body came into fashion among the rich and powerful. Achieving this look required many pins, which had a tendency to fall out or get misplaced, while repeated pinning damaged the fine, delicate fabrics that had come into favor.

Buttonholes, cut into the fabric and then reinforced with stitched edges, just like today, began to appear in clothes in the 13th and 14th centuries.

Buttons were an expensive luxury and therefore became a way of showing off. Courtiers and noblemen and women competed to display the most ostentatious buttons, made of ivory, glass, precious metals, and gems. They were carved, inlaid, stamped, and even painted with miniature scenes. Clothes were designed with long rows of close-set buttons on every surface, and there were craftsmen who specialized exclusively in buttons.

In 1520 the French King Francis I met his English rival Henry VIII at the Field of the Cloth of Gold near Calais. Each man strove to outdo the other with displays of wealth and sophistication. King Henry's extravagant buttons were modeled on his rings, while Francis wore a black velvet suit covered in 13,400 golden buttons. Later the 17th-century French monarch, Louis XIV, would outfit entire regiments in uniforms equipped with silver-coated buttons.

Contemporary illustrations and paintings show that from around the 15th century buttons were sewn onto the right-hand side of men's garments and the left side of women's. One theory is that buttons were attached in this manner to suit the people who did them up (who were mainly right-handed). Men of all classes did up their own clothes while at war or when traveling, while the only women of the period who could afford buttons would have had maids to dress them.

Disapproving of ostentatious displays of excessive buttoning, 17th-century Puritans condemned the button as sinful. They preferred the simpler, cheaper, and less showy hook-and-eye fastener. During the 18th century, however, the mass production of metal buttons, which were pressed from sheets in industrial fashion, made them cheaper and more widely available. In the 1840s vulcanized rubber was tried as an even cheaper alternative to metal, but did not catch on. Eventually celluloid was developed as a cheap synthetic substitute for ivory, and plastic buttons became widespread. The most recent innovation is the Velcro button, designed for elderly people whose arthritis makes awkward traditional buttons difficult to deal with.

Air conditioning

BLOWING HOT AND COLD

Several ancient civilizations tackled the perennial problem of how to cool down air in order to ease domestic discomfort. The ancient Egyptians exploited the principle of evaporative cooling (see Refrigerator, page 16) to produce ice, which could then be used to cool dwellings. In ancient Babylon, in around 2000 BC, wealthy noblemen would air-condition their homes at night by spraying water on to exposed surfaces—as the water evaporated it absorbed heat from the house, cooling it. Ancient Indians employed the same principles by hanging wet grass mats on the windward sides of their houses.

Roman emperors and Persian caliphs, such as Al-Mahdi of eighth-century Baghdad, used imported ice or snow, fanned by slaves, to cool their palaces. Similar methods were still in use in the late 19th century, when theaters would cool air by passing it through pipes packed with ice.

The main drive for more efficient and reliable methods of controlling the humidity and temperature of air came from industry, particularly the textile industry, which needed to maintain levels of humidity in mills to condition the yarn. As early as 1719 a silk mill in Derwent, England, installed a system for heating and ventilation. Other early air-conditioning systems included one fitted at the House of Commons in London in 1838, and, in 1844, one of the first uses of mechanical refrigeration, by physician John Gorrie, who used it to cool air for a hospital in Florida. By the late 19th century textile manufacturers were using sprays and steam to "condition the air" in their mills, and it was textile engineer, Stuart Cramer, who coined the term "air conditioning" in 1906.

By this time a young Cornell graduate, Willis Haviland Carrier, had already invented the first modern air conditioner, which controlled both temperature and humidity and filtered and circulated the air. He came up with the system for a Brooklyn printing plant in 1902. Like textiles, printing was an industry plagued by fluctuating air humidity and temperature. Heat and moisture caused paper to expand and contract—not much, but enough to throw carefully aligned colors and fonts out of register.

Carrier developed his system after receiving a flash of inspiration while waiting for a train on a cold, foggy platform. While considering the relationship between temperature and humidity he formulated principles that he later called his "Rational Psychrometric Formulae." His theory enabled him to dry and cool air at the same time to the desired level, and it has formed the basis of all air-conditioning systems since.

In 1915 Carrier formed the Carrier Engineering Corporation in order to develop his technology further, and his invention started to gain success in nonindustrial applications. The air conditioning installed in department stores and cinemas, such as the Hudson Department Store in Detroit (1924) and New York's Rivoli Theater (1925) proved to be hugely popular in its own right. Cinemas found that their air conditioning was often a bigger draw than the movies themselves.

In 1928 Carrier produced its first domestic air-conditioning unit—the Weathermaker—and air conditioning was soon installed in railroad carriages (1931), automobiles (1939), and buses (1940). By 1995 the Carrier Corporation boasted healthy annual sales of $5 billion.

Air conditioning has come a long way since ancient times, when overheated potentates stuffed the walls of their summer palaces with ice. Today, the focus is on efficiency and low energy use, but air conditioners still operate on the principles devised by Carrier in 1901.

Condom

DRESS FOR SAFE SEX

Since ancient times birth control has been considered the responsibility of the female, a view still held by many men today, and a variety of indignities and dangers were visited on women as a result. Ancient Chinese women were given abortifacients of mercury while ancient Egyptian women were told to use spermicide made from honey and crocodile dung. Condoms were developed solely to protect the wearer from sexually transmitted diseases.

The first sheaths were used by the Romans and possibly the ancient Egyptians, and were made out of oiled animal intestines or bladders. They did not reappear until the mid 16th century when the Italian anatomist Gabriel Fallopius designed a sheath of medicated linen to fit over the glans—the head of the penis—and tuck under the foreskin. Full-length sheaths for circumcised men soon followed; they were secured at the base with a pink ribbon.

The prophylactic sheath was reinvented a century later when King Charles II of England, a noted philanderer, commissioned the court doctor, Lord Condom, to come up with a means of protecting his royal member from syphilis. Once again the intestines of

Just a few of the many flavors of condom available for the discerning palate. Less popular flavors include curry and chile.

animals, in this case sheep, were pressed into service. Much to the noble doctor's chagrin his name was soon irreversibly associated with his invention.

Despite royal endorsement, condoms were widely unpopular. As unsatisfied Roman men had discovered 1,700 years earlier, condoms were fundamentally inadequate and unsatisfactory. Even the thinnest sheaths available deadened sensation while a poor understanding of the principles of hygiene meant condoms were often reused, and as a result failed to prevent disease. As a 16th-century Frenchman remarked, condoms were "armor against love, gossamer against infection."

The first rubber condoms appeared around 1870, but were little better. Men were instructed to wash the thick rubber sheaths after sexual relations and simply reuse them until they fell apart. The basic shortcomings of condom design were finally tackled in the 1930s with the introduction of latex rubber, which could be made extremely thin without sacrificing strength. "Prevents nervous strain," declared the first packets of Durex, "the strongest, thinnest, and silkiest protectives in the world."

S T U D Y *

* innovations in the way we work

Light bulb

LET THERE BE LIGHT

Thomas Edison is usually credited with inventing the light bulb but he was actually nearly 60 years late. The first known incandescent light was the invention of Warren De La Rue, in 1820. De La Rue passed an electrical current through a platinum coil inside a tube from which the air had been pumped, and produced light. His invention had all the essential elements of the modern light bulb. It had a metal filament that conducted electricity, but with some resistance, causing electrical energy to be converted into heat. The platinum heated up until it glowed with an intense light, but because of its high melting point it remained intact. Air had been pumped out of the tube to create a vacuum so that the hot platinum would not oxidize (i.e., burn through).

Unfortunately platinum was too expensive to be practical, and over the next five decades inventors across the world searched for a cost-effective material that could survive at high temperatures. In 1879 Edison was granted a patent for a bulb with a filament of carbon, derived from cotton fibers. Carbon was a natural choice because it is the element with the highest melting point—6,510° F (3,599° C). Unfortunately Edison wasn't the first man to think of it. English inventor Joseph Swan had been granted a similar patent in Britain the year before (furthermore, an American court later judged that Edison's "invention" was based on the work of a man named William Sawyer). Swan sued Edison and won, and eventually the American was forced to make Swan a partner in the British arm of his electric company.

It was this electric company that secured Edison's place in the history books. He may not have invented the light bulb, but he did introduce it to the real world by supplying the energy that made them glow. In 1882, Edison's Pearl Street Power Station in New York supplied electricity to 3,144 electric lamps in 203 Manhattan households and businesses. These initial customers struggled with bulbs that had a lifespan of just 150 hours, although this was a considerable improvement on the 13.5-hour life of Edison's original patented bulb. By 1886 Edison's bulbs, using carbon filaments derived from bamboo, lasted for 1,200 hours (modern bulbs last for around 1,500–2,000 hours), and although business was slow at first (by 1889 he had just 710 customers) it eventually took off. By 1910 more than 3 million people in the United States had electric lighting.

By this time technological advances had replaced carbon with tungsten, a tough metal with a high melting point (6,170° F/3,410° C). Tungsten-filament light bulbs are still the norm today, but they are far from perfect. Tungsten filaments suffer from sublimation, that is, metal atoms evaporate off the filament. Eventually the inside of the bulb becomes coated with a thin black film and the filament wears so thin that it breaks. Modern bulbs are no more efficient than early models: in a typical light bulb just 5 percent of the electrical energy is converted into visible light; the rest is lost as heat. Alternative technologies such as fluorescent bulbs and halogen are much more efficient.

Neon and fluorescent lights

GAS WORKS

A light bulb works on the principle of incandescence, using electricity to heat a filament until it glows. A neon light, in contrast, uses electricity to produce light directly, energizing atoms of gas or vapor so that they give off light (known as an electric discharge or vapor light). The principle of the electric discharge light was first observed in 1675 by French astronomer Jean Picard, who noticed that a mercury barometer tube gave off a faint glow if shaken. What he did not understand was that shaking the tube produced static electricity, which charged atoms of mercury vapor in the tube so that they emitted light.

By the 19th century electricity was better understood and experiments with different types of electric lighting were carried out. In 1855 German glassblower Heinrich Geissler produced the first example of what we now call a neon light, by filling a glass tube with gas and applying an electric charge to it. Subsequent experiments with different gases showed that they give off visible light of various colors. Mercury vapor gives off blue light, carbon dioxide white, helium gold, and neon red.

Neon, a name derived from the Greek neos, "new," was discovered in 1898 by British chemists William Ramsay and Morris Travers, who distilled it from liquid air. It gives off a faint red glow at room temperature and an even brighter one if an electric current is applied. In 1910 Frenchman George Claude exhibited the first neon tube in Paris, and two years later he created the first neon advertising sign for Paris' Palace Hairdresser.

In 1923 his company was commissioned by the Packard auto dealership of Los Angeles to produce the first neon sign in North America, for the then considerable sum of $24,000. The neon tubes spelling out "Packard" had a great impact and were dubbed "liquid fire" by an admiring public.

FLUORESCENT LIGHTING

A phenomenon related to electric discharge light is fluorescence, where light emitted by one source energizes the atoms of another, so that they give off a different type of light. When an electric charge is applied to mercury vapor, for instance, it gives off invisible ultraviolet light in addition to visible light. This ultraviolet light can be used to energize another light source in order to generate visible light. In fluorescent lighting ultraviolet light from mercury vapor is used to make a thin phosphorescent coating on the inside of a glass tube to give off visible light.

The first such light was made as early as 1859 by Antoine-Henri Becquerel, but was not developed in the United States until 1934. Fluorescent lights (also known as strip lighting) convert very little of their electrical energy into heat, making them much more energy-efficient than light bulbs. As a result they are also cheaper to operate, and soon caught on for commercial and public uses. Today, neon and fluorescent lights are available in over 150 different colors.

Anglepoise® lamp

DOUBLE-JOINTED

The Anglepoise lamp was created in 1932 by British designer George Cawardine. A skilled engineer who had worked for many years on suspension systems for cars (including a design that U.S. car manufacturer General Motors was alleged to have pirated), Cawardine's original concept was for an apparatus of springs and hinged arms that could move in three planes and hold its position. At first this was simply an abstract concept and Cawardine had no particular application in mind, but in 1931, possibly inspired by a 1927 lamp designed by the Frenchman Edouard-Wilfred Buquet, which used balanced masses to control its movement, he patented an initial lamp design that he named the Equipoise.

The following year, in collaboration with the spring manufacturing firm Terry's of Redditch, England, Cawardine attempted to patent an improved version of his "Elastic Equipoising Lamp." The patent office argued that "equipoise" was a word in general usage and could therefore not be trademarked, so Cawardine came up with "Anglepoise" as an alternative.

A company memo defined the properties of an "Anglepoising" spring like this: "Correct Anglepoising springs are characterised by the feature that the force exerted by them is always proportional to their length, and the length of an Anglepoising spring is considered to be the distance separating the centers of the pins by which they are anchored to the machine."

At first Terry's produced Anglepoise lamps for industrial applications but it quickly became obvious that there was a domestic market for a smaller version. This was the classic model 1227, which remains virtually unchanged to this day. Widely recognized as an outstanding example of great design through the application of rigorously functional principles, the Anglepoise was recently voted the all-time favorite lamp by top European design magazine, *Design Week*.

Cawardine's aim in creating the Anglepoise lamp was to design a mechanism with the flexibility, control, and precision of the human arm. The key elements of the lamp were the "Anglepoising" springs—they had to be very tightly wound and were extremely difficult to make.

Plugs and switches

When electricity was first introduced into homes in the 1880s it was used only to power light bulbs. The wiring installed in houses was minimal and generally featured only one outlet for electrical power, namely the wall- or ceiling-mounted socket into which the light bulb was screwed. In the early

believed to have made sockets with on-off switches as early as 1888, but it was a prolific American inventor, Harvey Hubbell of Connecticut, who devised two important inventions that we still use today. In 1896 he patented a "pull socket" for electric lights, in which a chain or cord attached to the light

The first plug was a hand-built wood and metal prototype to be attached to a "boxing" machine in a penny arcade. Today's plugs retain essentially the same features, although in many countries, like Britain for instance, a third "earth" pin is present as a safety feature.

days of electricity, the supply operated only for a few hours a day so electric lights were simply left on at all times. Other devices that ran on electricity either had screw sockets that could be screwed into the light fitting, which was inconvenient, or had to be attached directly to the wiring of the house. This rather basic system soon became outmoded because people wanted to turn their lights on and off, and few had the skills or inclination to wrestle with complicated wiring every time they wanted to use an appliance.

An English inventor named David Salomons is

fitting could be used to turn it on and off. Today's switches operate in much the same way. In 1904, Hubbell patented a "separable attachment plug," the forerunner of today's two- and three-pin plugs.

Hubbell was inspired to create the plug when he saw a janitor struggling to detach and then reattach the awkward wires of an electrically powered arcade machine in order to clean behind it. Experimenting with metal and wood (as an insulator), he created a makeshift plug-and-socket arrangement for the janitor. This would only have to be wired up once, and would be simple to operate thereafter.

Pens and pencils

THE WRITE STUFF

The Egyptians were using reeds and the hollow joints of bamboo as writing implements as early as 4000 BC. Ancient Greek "styli" are known from 1296 BC, and the Chinese used camel and rat hair brushes in the first millennium BC.

Quill pens came into use in Europe from the sixth century AD, and were not surpassed for quality or convenience until the mid-19th century. At the peak of use 30 million quills were imported to Great Britain annually. The wing feathers of large birds were preferred, usually goose, but also swan and turkey, while crow feathers produced quill pens that were ideal for fine drawing.

Metal pens were known in ancient times—a bronze pen from the ruins of Pompeii now lies in the Naples Museum—but were little used until the 1800s. In 1803 steel tube pens, with edges that met at a central slit and sides cut away like a quill, were sold in London. As with a quill, these were dipped in ink so that a small amount would be drawn up the central slit by capillary action. In 1828 John Mitchell started manufacturing machine-made steel pens in Birmingham, which soon became the center of a thriving pen industry. After World War I, the center of production shifted to Camden, New Jersey.

ROLL ON: THE BALLPOINT

In just 60 years, the ballpoint pen has become the most popular writing implement of all time.

Bic®, the world's leading manufacturer of ballpoints, sells over 14 million pens daily, in 150 countries around the globe. Yet this astonishing success story had inauspicious beginnings.

In 1888 a patent was granted to the American John Loud, for a new writing implement—a ballpoint pen. Loud's invention was a crude device designed for scrawling marks on the sides of rough packing cases. But the principle of the ballpoint fired the imagination of pen designers.

Other pens of the day delivered ink to a fixed writing point, and although by the end of the 19th century pen design had reached a high level of proficiency, there were several major limitations. Pens wrote in one direction only and depended on fluid, water-based inks, which were prone to leaking and smudging. The ink ran out quickly, necessitating constant dipping or filling from a separate, bulky source, and small particles frequently blocked the nibs, which also dried out quickly, so that the pen would not write first time.

The ballpoint pen would overcome all of these problems, providing millions with a cheap, disposable and, above all, convenient writing implement. But it would take a while, and it was not until 1938 that Laszlo Biro, a Hungarian living in Argentina, perfected a successful design. Biro's pen depended on two key elements: the ballpoint and a special ink.

A ballpoint has a precision-ground ball bearing held in a housing that leaves an exposed writing face. Ink is delivered from the reservoir to the sides of the bearing via four to six shallow grooves. These distribute the ink evenly, allowing the pen to write

equally well in all directions. In many ways this ink is the crucial component. It must remain liquid in the pen so that it writes first go, but not leak out of the pen or smudge once on the paper. Early ballpoint pens used ink composed of dye in oleic acid, mixed with special oils and resins to keep the mixture fluid. But they did not dry properly, smudging and transferring between pages, and fading quickly in the light. Biro improved on these early inks, and his pen design was superior, but ballpoints were still messy and far from perfect.

Enter Baron Marcel Bich (1914–1994), a high-school dropout from France who started with little except foresight and a keen determination to succeed. Together with a friend, Edouard Buffard, he moved into an empty factory near Paris in 1945 and set himself up in the pen business. Technical advances made during the war allowed ball bearings to be ground to extraordinary precision, and opened up the new field of plastics. Bich invested heavily in the new technologies, and in 1947 he received an order for plastic bodies for the early European ballpoints. He wasn't impressed. In his own words, the early pens were "… a terrible mess. They stain the clothes and don't write." Bich knew he could do better, and spotted a lucrative market opening. Here was a product that everyone needed, could be cheaply mass produced, and had to be frequently replaced.

After two years of design work, Bich launched his plastic-bodied ballpoint pen with a shortened,

Unlike the disposable BIC Classic®, the Orbic Eagle was aimed at the luxury pen market. The case was permanent and only the inner unit was replaced.

easy-to-remember version of his own name—Bic®—along with an aggressive marketing campaign. By 1951 he was selling 21 million pens a year, and double that a year later (mostly in France). In 1959 he invaded the United States with a catchy slogan, "Writes First Time, Every Time"®, and an affordable price tag—29 cents. Forty years later that pen, now known as the Classic Stic®, has become the bestselling pen of all time.

Modern ballpoints vary in complexity and price, sometimes consisting of as few as ten components. Compared to water-based inks, ballpoint pen ink is extremely expensive, but a little goes a long way—even the cheapest ballpoint ink lasts 20 times longer than the equivalent amount of ink in a fountain pen.

INK: IN THE BLACK

The earliest materials used for making marks were probably blood or plant juices. The earliest reported date for ink is 2697 BC. This ancient ink was composed of carbon black (essentially soot) in lamp oil, mixed with gelatin from donkey bones, probably to disguise the odor of the oil. A similar recipe of carbon black, water, and gum or glue was used right up until the Middle Ages. It served well enough, but users had to mix their own, which was a messy business.

Around 1100 AD it was discovered that iron salts dissolved in a tannin-rich substance derived from nutgalls (a form of plant tumor that grows on the

trunks of oak trees) would form a precipitate that made good ink, although it did tend to aggregate into small clumps, blocking the nibs of quills and pens. It also faded from black to brown in sunlight, accounting for the washed out look of many venerable documents.

Nutgall extract was basically tannic acid, and if the scribe got the mix of his ink wrong it could end up overly acidic. Not only would this dissolve the quill he was writing with, it might eventually eat through the parchment of processed sheepskin he was writing on!

In the 1860s, synthetic dyes were developed, and modern water-based inks (as opposed to ballpoint inks) are based on these. A variety of additives are also used, including humectants (substances that retain moisture) to give instant starting, fungicides and algicides to prevent contamination, and corrosion inhibitors to protect pens.

A 1900s advertisement showing early Waterman fine silver filigree and black, chased hard rubber eye-dropper models with chased, gold-filled bands.

FOUNTAIN PENS

Fountain pens were known in Paris as early as the 17th century, but the first practical one was made by L.E. Waterman of New York, in 1884. The Waterman company was later bought by Marcel Bich in order to gain a foothold in the United States for his ballpoints.

A fountain pen uses a capillary channel to draw ink from a reservoir to the nib. The reservoir can consist of refillable capillary tubes (which require no moving parts), or lever, plunge, or squeeze bladders,

but the most popular form today is the disposable cartridge. A fine channel, known as the feed, leads to the nib, which is often preceded by a number of vanes or ribs that provide an interim collecting and storage capacity to absorb excess flow and even out the delivery of ink. Nibs are sometimes made of exotic elements such as platinum-group metals like ruthenium.

FELT-TIP PENS AND PENCILS

The first successful felt-tip pen was made in Japan, in 1964. Felt-tips use points made of a porous material (usually synthetic polymers) that holds ink like a sponge. The reservoirs are either cartridges or long, parallel fibers arranged to form capillary channels.

The Aztecs were using graphite to write and draw before Cortes landed in 1519. In Europe, commercial lead pencil manufacture depended on a single source of graphite, discovered in England's Lake District in 1564. This lode, which was worked until 1833, contained the purest deposit of graphite ever known. Initially the graphite was simply cut into blocks or sticks, and later on these sticks were wrapped in rope (and eventually wood—cedar from western North America is the favored source today) to form a pencil.

It was apparent that a means of diluting the graphite was needed before it ran out. In 1795 Conte in France and Hardmuth in Austria independently invented a way to use diluted graphite dust to make pencil leads. The dust was

mixed with water and other substances to make a paste, which could be extruded and baked to give very thin rods.

Other landmarks in the history of pencils include: the first pencil made in the United States, in 1812 (until then, they had all come from Europe); the first patent for an integral pencil eraser—granted in 1858 to Hyman Lipman of New York; and the first mechanical pencils—invented in 1822 by Mordan and Hawkins of the United States, and first successfully manufactured by Alonzo Cross some 40 years later in 1868.

Liquid paper

THE GREAT COVER UP

The original liquid paper was simply white paint (tempera with a water base) dabbed on with a watercolor brush to cover typing mistakes. Its inventor was a Dallas secretary named Bette Nesmith Graham, who found that the mistakes caused by her occasionally erratic typing were hard to correct in any other way—using an ordinary eraser on errors made with the carbon-film ribbons of electric typewriters simply caused smudging and made matters worse.

A keen artist, Graham hit on the idea that she could use an artist's method of simply painting over any mistakes. At home she mixed up a batch of white paint to match the color of the paper she used at work, and brought in a small bottle and a brush the next day. A neighboring secretary asked if she could have some, and Graham

For the first 12 years Bette Graham made and sold liquid paper from her kitchen and garage. Her dedication was repaid when the product became ubiquitous in offices throughout the land. She had intially offered the product to IBM but was turned down.

supplied it in a small bottle marked "Mistake Out." Soon the other secretaries in the typing pool were clamoring for their own Mistake Out, and Graham realized she was on to something. In 1956 she started the Mistake Out Company, later changing its name to Liquid Paper.

Working from home, mixing and blending batches by hand, and bottling with the help of her son Michael Nesmith (who later found fame as a member of The Monkees rock group), Graham slowly built up the business. By 1968 she was able to move to a proper factory and automate the process, and by 1976 the Liquid Paper Company was selling 25 million bottles a year. In 1979 she sold the company to Gillette for $47 million. She died the following year, but not before setting up two charitable foundations to help working women.

Paperclip

FORM FITS FUNCTION

As paper and the practice of storing documents became more widespread, more and more people encountered the frustration of attempting to secure loose leaves of paper. One of the earliest solutions was to use a penknife to cut matching slits in the papers, thread a string or ribbon through them, and tie them together. By using wax to stick down the ribbon the fastening was secured and no substitutions could be made.

Tying with ribbons was laborious, however, and an early alternative was to pin pages together with a straight pin. The mechanization of pin manufacture in the 19th century made pins widely available, and pinning became the standard method of attaching papers. Pins also had their drawbacks, however—clerks frequently pricked their fingers, pins would fall out of papers or papers would fall off pins, and making holes in the corners of pages quickly made them ragged and worn.

The paperclip was an elegant solution to these problems, employing a principle known as Hooke's Law to hold papers together. Hooke's Law describes the way in which elastic materials, such as steel, will resist attempts to deform them. The more tension that is applied to them, the harder they resist (but only up to a limit, at which point they lose elasticity, as anyone who has tried to hold together too many sheets with one paperclip will testify). With the invention of highly elastic stainless steel wire and the ability to produce and work it in industrial quantities, it became possible to make a clip that would hold papers together with a springlike tension.

The paperclip's invention is usually attributed to the Norwegian Johan Vaaler, who came up with a design for a paperclip in 1899 but was unable to patent it in Norway because of the lack of proper patent laws. Instead he obtained his patent in Germany, and an American patent followed in 1901. National pride in this fastening led the Norwegians to adopt the paperclip as a symbol of protest against the Nazi occupation of their country in World War II, when they were forbidden to wear badges or pins of their King.

Unfortunately it seems that Vaaler did not invent either the first or best paperclip. His 1901 patent shows a variety of possible paperclip shapes, including triangular, rectangular, and rounded designs, but none are of the classic "loop-within-a-loop" design that is today regarded as the quintessential paperclip. This design, known as the Gem, was just one of several that were already in widespread circulation by the time that Vaaler patented his versions.

A patent filed in 1896, by the American Matthew Schooley, shows similar clips to Vaaler's and explicitly states: "I am aware that prior to my invention paperclips have been made somewhat similar to mine." The first description of the classic Gem paperclip, meanwhile, is in a patent for a paperclip-making machine, issued to William Middlebrook of Connecticut in 1899. Middlebrook probably did not patent the actual clip design because he had not invented it. Instead it is thought to have first been manufactured by Gem Limited of

Britain, and may have been around for some time.

In fact no one has ever patented the Gem, which is a shame for someone because about 20 billion of them are produced every year, though in some cases minor improvements have been made to the original design. In 1934, for instance, Henry Lankenau of New Jersey patented a Gem with square ends and a V-shaped tongue. This version is known as the Gothic Gem, while the traditional oval shape is called the Roman Gem. Other improvements included serrated or crinkled wire for better grip (1921) and having one tongue bent slightly out of plane for easier application (also Lankenau's idea).

Stapler

RIVETING STUFF

Staples are U-shaped pieces of wire used to fasten things together. In their original incarnation they were large and heavy, with sharp, nail-like ends, and were intended to be driven into wooden walls or posts with a hammer to secure barbed wire, signs, hooks, and so on.

In the 19th century the market for books and magazines was growing fast and, in order to keep up with demand, publishers were looking for quick ways to bind their wares together. Traditional stitching methods were replaced with machines that could stitch with metal wire, but these machines were large and complicated, and took a long time to adjust for each book or magazine. Cutting the wire into short lengths and bending it into individual U-shaped staples made for greater flexibility.

There is some disagreement over who can claim to be the first person to have done this. The American Samuel Slocum patented a device for driving pins into paper in 1841, but this was not really a true stapler. The McGill Single Stroke Staple Press was invented in 1866 and a similar device from the Novelty Manufacturing Company dates from the same year. The man who usually gets the credit, however, is British bookbinder Charles Gould, who built a wire stitcher in 1868. His device cut the wire, bent it, and then drove it into a stack of papers to create a binding. On the other side of the paper was a base plate that would turn the ends of the staple inward, creating a "stitch." Subsequent staplers were either similar, or used staples that were precut and shaped, but still had to be hand-fed into the stapler one at a time, making the devices laborious and inconvenient.

In 1894 the first stapler with a supply chamber for a line of loose staples was introduced. Staples were packed onto a wooden core and would tend to come apart as they were loaded, jamming the machine. Until around 1910 the stapler was known as a fastener, or "Hotchkiss," after an early manufacturer.

In 1896 Thomas Briggs founded the Boston Wire Stitcher Company, which later became Bostitch. His first stapler was similar to Gould's device, but he soon saw a gap in the market for lightweight, easy-to-use staplers for the office. In 1923 Briggs came up

with a method for gluing strips of staples together for easy loading, and the stapler started to gain in popularity. By the 1930s staplers had assumed their modern appearance with the application of an Art Deco streamlined design, and in the late 1930s Swingline introduced the top-loading method.

A feature of staplers that many people wonder about is the rotating base plate. Normally the grooves on the plate turn the prongs of the staple inward, but by rotating the plate they can be made to turn outward. This creates a much looser stitch, and is a feature incorporated for cases where papers only need to be attached temporarily, for example if a covering letter is attached to a form that needs to be returned. The outward-facing staple is easily removed without incurring broken fingernails, pierced fingers, or the need for a special staple-removing device.

Self-adhesive tape

CLEAR WINNER

Started in 1902 as a mining concern, the Minnesota Mining and Manufacturing Company soon switched to the manufacture of sandpaper. In the course of developing methods to make sand or grit stick to its paper backing, the company, now almost exclusively known by its contraction, 3M, had acquired considerable expertise in the field of applying adhesives to paper.

In 1923 a young 3M lab technician, Richard Drew, was delivering a batch of new "Wetordry" sandpaper to an automobile workshop in St. Paul, Minnesota, and overheard some workers complaining about the difficulty they were having in applying the two-tone paint jobs then popular. Achieving the sharp lines between two colors required the use of paper masking, and, with no other alternatives available at the time, the paper had to be stuck down with glue. When they came to remove it, workers found that they had to scrape it off, damaging the paint underneath. Drew determined to come up with a product to solve this problem.

It took Drew two years to find the right combination of paper and adhesive, but in 1925 he produced the first batch of effective masking tape for 3M, made of two-inch wide tan paper backed with pressure-sensitive adhesive. At first the adhesive was only applied to the paper in two narrow strips along either edge, because it was thought this would make it easier to remove without damaging paint. Unfortunately it was too easy to remove and the minimal binding area meant that it would peel off under the weight of the paper it was supposed to be fixing in place. According to company legend, a dissatisfied customer told one of the 3M salesmen to "take this tape back to your Scotch bosses and tell them to put more adhesive on it." (The Scots, or Scotch, as they are sometimes called in North America, were proverbial in common folklore for being stingy

or mean.) 3M complied with this slur and a famous brand was born. The name, of course, survives to this day.

In 1927 DuPont patented a waterproof version of cellophane, a transparent plastic made from plant cellulose. Cellophane seemed an obvious candidate for a waterproof version of Scotch® tape that Drew was attempting to create for wet applications. By 1930 he had succeeded in creating Scotch Cellophane Tape, by which time the Great Depression had begun. The new tape seemed to meet the needs of the era and was immediately pressed into service in a wide range of commercial and domestic applications that its inventors had never imagined. Scotch tape was used to repair everything from books and toys to clothes and cracked eggs. The first self-adhesive tape reached Britain in 1934, and the most famous British brand, Sellotape, was launched in 1937.

Though popular the new tape was far from perfect—it was difficult to find the end and hard to tear without splitting diagonally, it yellowed and peeled with age, and even oozed adhesive. In 1935 3M created the first tape dispenser, with serrated "teeth" to help tear the tape evenly and then hold the end in place. In 1961 3M came up with Scotch Brand Magic Tape, which kept its color and adhesiveness for far longer.

Post-it® Notes

STUCK ON YOU

Post-it® Notes, like Scotch® tape, were brought to you by 3M, and grew out of its expertise in combining paper and adhesive. The glue came first, originally developed by 3M research scientist Spencer Silver in 1968. Searching for a super-sticky version of the acrylic adhesives used on many 3M tapes, Silver managed to create the exact opposite, a high-quality but low-tack "unglue." It was made up of tiny, virtually indestructible acrylic spheres, each no wider than a paper fiber. Whilst individually sticky they made only intermittent contact with surfaces and therefore proved to be a weak bonding agent—strong enough to hold papers together but weak enough to allow them to be pulled easily apart. Because of their hardiness, however, they could be stuck and restuck over and over again, and Silver realized that he was on to something.

Unfortunately he wasn't sure what. At seminars to other 3M personnel he suggested using the new glue as a spray, or for sticky bulletin boards on which notices could be temporarily posted, the latter tantalizingly close to the eventual application. Most 3M executives were unimpressed, but attending one of Silver's seminars was a young product development researcher, Art Fry. A keen member of his local church choir, Fry would use makeshift bookmarks of scraps of paper to flag the day's songs in his hymnal. Although this was a time-honored solution to the problem of marking places in a book,

dating back to advent of cheap paper in the Middle Ages, it was an unsatisfactory one. Fry was frequently frustrated when his scraps of paper slipped out of view or fell out altogether, and while musing on the problem in church one day he had a brainwave: Silver's "unglue" would make the perfect adhesive for a "temporary permanent bookmark."

Fry soon created prototype "post-its" and they proved popular with his colleagues, finding applications beyond simply book marking. Some of the best qualities of the new Post-it Notes arose by accident. Fry did not want the projecting tops of each bookmark to stick to one another, so he only coated half of one side with adhesive. This meant that when used as temporary memos/notes on documents they could be easily lifted to see what was written underneath, and became much easier to remove and reuse than a label would have been.

The marketing department was not so convinced—why would people pay for temporary bookmarks when scrap paper was available for free? Initial test marketing seemed to prove them right, but some key executives had faith in the project and further marketing convinced them to release Post-it Notes in 1980. In a classic example of an innovative new product creating its own market, office workers everywhere soon found that Post-its were indispensable. Now they are come in several colors and sizes, including poster-size Post-its and narrow, vertical ones for Japanese script. Post-it Notes are even available on your computer desktop, in the form of Stickies®.

Rulers

MADE TO MEASURE

In ancient times man used the proportions of the body as the basis for measurements. One of the earliest units of measurement, used in ancient Babylon and Egypt and mentioned in the Bible, was the cubit, which was defined as the length from a man's elbow to the tip of his extended middle finger. A similar measure was the foot, based on the length of the average male foot. This meant that anyone could use his or her arm or foot as a basic ruler, without having to worry about carrying around a precisely measured stick, which might get misplaced or broken.

The obvious drawback to this crude system was that no two arms or feet were exactly the same length, and could differ by several inches (a word that derives from the Roman *unciae*, or "twelfth part" of a foot). Such variations were of limited importance when measurements were made for the benefit of small-scale projects, like building a mud hut or pacing out your own fields for instance, but could, however, have serious consequences for larger issues like designing and building the pyramids or trading with other countries. The more advanced civilizations would very likely have equipped their master craftsmen and builders with yardsticks and rulers of set lengths, from which copies could be made to distribute to other workers.

Today most rulers and tape measures are marked with both metric and imperial measurements, but few people can readily convert between the two. Even when the metric system was first introduced in France in 1793, it caused such widespread public confusion that 19 years later it was withdrawn for 25 years.

In the West the collapse of the Roman Empire meant that a lot of advanced technical knowledge was lost, and the work of standardizing measurements had to start again. The yard, for example, was a unit of measurement originally set by the length of a sash or girdle worn by Saxon lords and kings about their waists, the word deriving from "gird." In 950 AD, however, the Anglo-Saxon king Edgar decreed that the length of a yard should be set by reference to a rod kept at Winchester.

In the 13th century Edward I had a master yardstick for the entire kingdom set in iron, known as the Iron Ulna. Master builders of the time carried their own rulers and yardsticks with them from job to job. Medieval town halls, gateways, or guilds often had a yardstick fixed to the wall to provide the local standard reference point. Recognizing that the Iron Ulna was hardly an accessible reference point for the common people, in 1324 Edward II decreed that "3 barleycorns, round and dry to make an inch" was an acceptable substitute.

Later master yardsticks included a brass bar set with gold buttons made in 1760 and a platinum rod exactly a meter long that was cast as the standard for the new French metric system in 1799. Copies of these were later sent to the United States to help establish prototypical measurements.

Away from the centers of science, commerce, and industry, however, many ordinary people continued to rely on age-old methods, using the proportions of their body to measure out distances. An inch was the length of the forefinger from the tip to the first joint, and a yard the distance from the tip of a man's nose to the end of his outstretched arm. Only when technological and industrial advances made cheap, reliable rulers widely available in the 18th and 19th centuries, did the old ways finally die out completely.

Calculator

NUMBER CRUNCHER

The first calculating device was the abacus, a framed set of rods with beads or counters that slide along the rods. Each rod represents a multiple of ten, starting with units, then tens, then hundreds, and so on. The first abaci are believed to have been developed by the ancient Babylonians around 3000 BC, but some of the earliest known examples are fourth-century BC Roman counting boards, trays of sand with small stones, or *calculi*, as counters. Abaci appeared in China by the second century BC, and were also used by the Aztecs, who called them *quipu*. They are still used in some parts of the world today, and an adept user can perform calculations faster than many people can use an electronic calculator.

The first person known to have designed a calculating machine is Leonardo da Vinci (1452–1519). According to notes now in the collection of the National Museum of Spain, da Vinci had proposed a machine that used interlocking gears to perform arithmetic, and a model of his calculator was later made. In 1623 German inventor Wilhelm Schickard built two prototypes of a mechanical calculator, but neither seem to have survived, and it fell to a 19-year-old 17th-century French mathematician, Blaise Pascal, to build the first operative calculating machine in 1642.

Pascal built his calculator to help his father, a tax collector. His machine was a metal box about 20 inches by 4 inches (50 cm x 10 cm), containing a set of eight dials similar to those on an old telephone, with digits marked around their edges. The machine could add and subtract. Numbers were put in by turning the dials, which operated a series of interlocking cogwheels (similar to da Vinci's design) that generated the result, which appeared in a small window. Around 50 of these devices still survive so they were obviously manufactured for sale, but although they were highly accurate they do not seem to have proved popular.

In 1649 Gottfried Liebniz of Germany made a calculator that could also divide and multiply, and his design was widely copied. Improved versions continued to appear. In 1820 Frenchman Thomas de Colmar built a machine that used a stepped-drum mechanism, and this became the first mass-produced calculator. A version called the Arithmometer was still being manufactured as late as 1920. In 1905 Swedish inventor Willgodt Odhner invented the next generation of mechanical calculator, using a pin-wheel mechanism that formed the basis of a Russian model, the Felix, as late as 1972.

The development of the computer during World War II sounded the death knell for mechanical calculators. Much faster electronic versions appeared in the 1950s, although mechanical calculators were still on sale well into the 1960s. The first pocket calculator, Texas Instruments' 1971 Pocketronic, could add, subtract, multiply, and divide, but weighed more than 2 pounds (0.9 kg). It marked one of the first applications of the new microprocessor technology that would revolutionize computing.

Ribbon and tinsel

DECK THE HALLS

Ribbons are probably among the earliest ornaments invented by humans, though such fragile artifacts leave little mark on the archeological record. They were also extensively used to decorate sacred or symbolic artifacts and places by many different civilizations, including ancient Egyptian, Chinese, and South American cultures.

As fashion accessories, ribbons are seen to come in and out of style through history. During the 18th century lavish adornment with silk ribbons was popular vogue amongst European nobility and for a short time in England it even became illegal for anyone except the aristocracy to sport them. Soon, however, mechanized looms meant that elaborate and intricately patterned ribbons became cheap and plentiful, and they were no longer the height of fashion. In Victorian times they came back into vogue, but by the end of the 19th century the esthetic was generally more restrained and minimal and ribbons were restricted to baby's clothes and special occasions.

As decorations, ribbons featured heavily in German Christmas traditions, which were relics of earlier pagan customs. The association of fir trees with Christmas dates back to the seventh century, and by the late Middle Ages Germans routinely decorated their trees with a variety of symbols and

Decorating valuables with ribbons extends back to ancient times, but only recently have gifts wrapped in paper and ribbons become a feature of celebrations. Up until the Victorian era, gifts generally consisted of little more than fruit or carved knick-knacks.

treats—paper roses, apples, sugar wafers, gingerbread, candles, and ribbons. Traditional colors for decorations were white and red, symbolizing innocence and knowledge and linking the Christmas tree to the biblical Tree of Knowledge.

Tinsel itself was a natural extension of ribbon, but a popular folk tale gives a different account of its origins. A poor widow is said to have labored long into the night to decorate the family tree so that her children would be impressed, but during the night spiders covered it in cobwebs. The Christ child saw the cobwebs and changed them to silver, and so tinsel was born.

Divine origins notwithstanding, tinsel was first made in Germany around 1610, and spread across the Christian world with the custom of the Christmas tree. Real silver was used, extruded from a special machine that could stretch it into wafer-thin strips. Silver tarnished quickly, however, and a substitute alloy of tin and lead was tried in its place. Unfortunately, this proved too heavy and it broke under its own weight. Only real silver was strong enough for the purpose, so tinsel remained the preserve of the wealthy right up until the 20th century. In the 1920s it became possible to produce large quantities of aluminum cheaply, providing a viable substitute for silver tinsel that was widely affordable.

Scissors

CHOP CHOP

Scissors, which require two attached but opposing blades, would have been difficult to make out of stone or animal teeth, the materials employed for prehistoric knives, but are easily constructed as a single-piece instrument using metal. The first metal to be worked was bronze, and the first known scissors thus date back to the Bronze Age. They are actually more like shears, consisting of two blades connected by a U-shaped handle, the natural springiness of which helped operate them. In ancient Egypt, Greece, and Rome they were often decorated and inlaid with great skill, while medieval nobility used gold or silver shears inlaid with pearls, enamel, and gems.

Pivoted scissors, also known as cross-bladed shears, were first made by the Greeks and Romans as early as the first century BC. Cross-bladed scissors make use of the principle of the lever. The pivot-point acts as a fulcrum, allowing the user to apply force on the opposite side of the fulcrum to the blades, increasing their cutting power considerably and making scissors particularly valuable to workers whose job involved constant snipping.

By the fifth century AD Isidore of Seville describes pivoted scissors as the tools of the barber and tailor, but these were more complicated to make than shears and therefore too expensive for most people—shearlike scissors continued to be common domestic tools until the late 18th century. In 1761 an English metalworker from Sheffield, Robert Hinchcliffe, began making cross-bladed scissors in cast steel, which was much stronger metal than iron, and started to produce them on an industrial scale, making them cheaper and more widely available.

A number of superstitions attach to scissors, reflecting their long history as an important and valuable domestic article. A common one is that giving scissors to a friend or loved one as a gift risks cutting the bond between you. Offering a small coin in return, traditionally sixpence in Britain, can avert this risk. In 1979, after Queen Elizabeth had cut a ribbon to open a Women's Institute center, she is reported to have handed over a sixpence along with the scissors she had just used. Another superstition is that if you drop a pair of scissors you should not pick them up yourself. If you have no choice you should either stand on them first or warm them before using them.

Modern scissors tend to be plain and functional, but ancient versions were often highly ornate. A typical example is a pair of Egyptian shears from the third century BC, which was decorated on each handle with inlaid metal forming opposing male and female figures.

Photocopier and laser printer

PHOTO FINISH

Printing was the first technology to produce large numbers of copies of an original document, but not everyone wanted to go through the process of publishing to produce copies of documents or drawings. Some ingenious writers built frames attached to their pens, which would replicate their hand movements to produce duplicate copies as they wrote. In 1842 the astronomer Sir John Herschel adapted a type of photographic process to help make accurate copies of his notes. He used a form of light-sensitive iron salt, called Prussian Blue, to make an early version of carbon paper, which he called cyanotype. The blue tint of the copies gave rise to the term "blueprint," and it soon became popular with architects.

By the 1930s carbon paper was widely available, providing a convenient, if messy, means of making duplicates as they were written or typed. For overworked patent clerk Chester Carlton, however, carbon paper was little help. Plagued by constant requests for copies of patents and accompanying drawings, Carlton used his physics training and ingenuity to invent a new type of copying process, based on the interaction between light and electrostatic fields, which would be cheaper and cleaner than existing photographic methods of reproduction (which called for "wet" developing). Carlton knew that some materials became conductive when exposed to light, and used this as

the basis for a process he initially called electrophotography, which he patented in 1937.

The next year Carlton and his assistant, Otto Kornei, succeeded in producing the first ever photocopy. They covered a zinc plate with sulfur, which would hold a static charge until exposed to light, and gave the sulfur a static charge by rubbing it with a handkerchief. Then Kornei wrote the date and the location of the laboratory ("10-22-38 Astoria") onto a slide. Placing the slide over the plate he shone a light on to it. Where the light could penetrate through to the sulfur it became conductive and the static charge it was holding flowed away. Where the writing on the slide masked the sulfur, the charge remained.

Then Kornei dusted the plate with powder made from the spores of a mold. The charged areas of the plate attracted the powder, so that when he blew the rest of the spores away, an image of the writing remained. To transfer the image to paper, Carlton heated a sheet of wax paper onto the plate. The wax picked up the spores, and when it cooled and the paper was peeled away, Carlton was holding the world's first photocopy. Today's photocopiers work in much the same way, except that they use an electrostatically charged rotating drum in place of the zinc-sulfur sheet, specialized ink in place of mold spores, and specialized plastics in place of wax.

Carlton needed further funding to develop a practical machine and approached over 20 of America's biggest corporations including IBM, Kodak, and General Electric, but was turned down

by all of them. Eventually he hooked up with a small photographic technology firm called Haloid. In 1949 they produced the first commercial photocopier, but it was a hopelessly complex and inefficient machine, requiring the user to perform 14 steps to make one copy.

Better machines followed and the process was renamed xerography, from the Greek *xero*, "dry," and *graphos*, "writing." The main selling point was that the new process was a dry one. Eventually Haloid changed their name to Xerox, adding the final "X" to sound more like Kodak. In 1959 Xerox finally produced a fully automated photocopier, the model 914, which was a huge success, earning them, and Carlton, hundreds of millions of dollars.

During the 1970s the rapidly advancing computer industry started to produce graphics and complex typefaces. Printing these out was beyond the teletype technology that was then in use, and researchers at the Xerox Palo Alto Research Center set about adapting the photocopier. Normally a piece of paper provides the starting image for copying, but the researchers replaced this with a high-intensity laser beam that effectively draws the image sent from the computer onto the photocopier's rotating drum. A spinning mirror is used to scatter the laser so that it can draw quickly enough. The rest of the process was the same as photocopying. The resulting machine was the Xerox Dover, the world's first laser printer.

Unfortunately Xerox laser printers were too large and too expensive, and although they had pioneered the new technology, Xerox finally lost out to other companies, notably Hewlett-Packard.

Credit card

FLEXIBLE FRIEND

The concept of credit dates back to the birth of money, when ancient Babylonians marked clay tablets with a commodity and quantity, and used the tokens as a temporary substitute for the actual merchandise. Finance became a sophisticated art in ancient Rome, with developed concepts of lending and security—the word "credit" derives from the Latin *credere*, "to believe."

Although the collapse of the Roman Empire set back the development of finance by several centuries, by medieval times commerce and trade were once again reaching a high level of sophistication. Merchants and bankers adopted financial instruments such as the bill of exchange (a promise to pay a certain amount at a later date) and the banknote (a Chinese idea), which extended the idea of credit. By the 18th century ordinary Englishmen could purchase goods on credit, and for the next 250 years traders known as tallymen ran a crude charge account system for poorer customers.

In 1914 Western Union became the first bank to offer a deferred-payment service to customers, but only to a select few, and no card was involved. That had to wait until 1950, when Diners' Club issued the first charge card and "plastic money" was born. Like

the American Express card that followed, the first Diners' Club card required payment in full within a short period of time. In 1951 New York's Franklin Bank had the idea of extending the repayment time and charging interest on the outstanding amount, and the true credit card was born.

The main early competition to Diners' Club and American Express was from the Bank of America's BankAmericard. The Bank of America started signing up other banks to their card scheme, which adopted the name Visa in 1977, while another group of banks set up what would eventually become Mastercard International. During the 1970s credit cards were a runaway success but the industry soon landed itself in hot water. Visa and Mastercard were engaged in a frenzy of card distribution, issuing cards to people without even the most cursory credit checks. Anti-fraud technology was crude at best, and a lot of money was lost through fraud and bad loans. At the same time the rival card schemes were signing up banks and merchants to mutually exclusive licensing deals, which led to customers being turned away if they had the wrong card. In the late 1970s consumer legislation and self-regulation helped tackle these problems, imposing criteria for card-issuing and agreeing to "duality" of service, so that establishments could issue and honor more than one type of card.

Mail-order catalog

WISH BOOK

The first catalogs accompanied the advent of printing itself, as printers made up catalogs to list and advertise their wares. As early as 1749 the first English printer, William Caxton, made up handbills, effectively single-sheet catalogs, listing his current publications. Agents of the printers who traveled from town to town to sell their books would use these handbills as fliers, either posting them through doors or pinning them up in public places. Customers would then come and meet the agent in the local inn, or later library, to make their purchases. The first catalog to offer products that could be purchased "remotely" is said to be a list of 15 titles offered by Venetian printer Aldus Manutius in 1498.

Aside from printers, one of the first to offer merchandise through a catalog was William Lucas, an English gardener. His catalog, published in 1667, was soon imitated by other horticulturists, and by the end of the 18th century gardeners and nurseries all over Europe were producing catalogs featuring seeds, bulbs, and plants.

The 19th century brought the development of the first nationally and internationally recognized retail names, and some of these merchants printed catalogs to advertise their wares to potential customers. In 1844 Orvis distributed a list of fishing lures and in 1846 Tiffany & Co. of New York printed a catalog of "Useful and Fancy Articles," featuring imported Chinese and European goods.

Claimants for the title of first mail-order business include Aristide Boucicaut, founder of Paris' Au Bon Marché, who produced his first catalog in 1865, and London's Army and Navy Co-operative Society, founded in 1871 to serve members of the armed forces and their families. Its 1872 catalog

offered 112 pages of items including gout remedies and hare soup, most available by mail order. The new industry was destined to make its biggest impact in the United States, however, where Aaron Montgomery Ward started an exclusively mail-order business in 1872.

Ward had gained his retail training at the pioneering department store Marshall Fields (where Harry Gordon Selfridge, who would later set up the London store, Selfridge's, learned his trade). His experience convinced him that mail order would be a more efficient and therefore profitable method of selling goods to rural families. In 1872 Ward set up his new enterprise in Chicago with just $2,400 capital. His first catalog was a single sheet, 8 x 12 inches (20 x 30 cm), with a list of goods, their prices, and instructions on how to order. By 1904 Ward was sending out three million catalogs a year.

Sears-Roebuck, the name that would eventually become synonymous with mail-order catalogs in the United States, started in 1886 as a firm selling watches to the West. In 1897 Richard Sears and his partner Alva Curtis Roebuck started printing their general catalog. By 1907 they were sending out three million a year. The catalogs of Montgomery Ward (which folded, after 128 years) and Sears (which is still going strong) became known as "wish books" to their rural customers, promising

Disproving those doomsayers who've been predicting the end of the mail-order catalog with the coming of e-commerce, more catalogs selling more things are available today than ever before.

"satisfaction guaranteed," a huge list of products that would otherwise be completely unavailable, and, thanks to the highly absorbent paper on which they were printed, a ready source of toilet paper in the days prior to the invention of tissue (see page 59).

Even earlier than Sears, however, the owner of a dry goods store on Toronto's Yonge Street had introduced the widely scattered population of Canada to the convenience of mail-order catalogs. In 1884, Timothy Eaton started the Eaton's mail-order system, which the catalog bragged covered "Canada from sea to sea" and sold everything a Canadian might need. From a thimble or a ball of string to stoves, patent medicine, hockey skates, and even houseplants, everything was guaranteed "goods satisfactory or money refunded." By 1907, when Timothy Eaton died, his two large retail stores and two factories employed more than 9,000 people and the company had offices in Europe. The catalog was discontinued in 1976 after 92 years but it is so loved by Canadians as a part of their history that a select few issues from the earliest years were republished and sell today in bookstores. Unfortunately, the T. Eaton Company was forced to declare bankruptcy in 1998 after massive changes to the face of the retailing business in Canada. After a resurrection under the Sears company, by 2002 it was still uncertain what the company's ultimate fate would be.

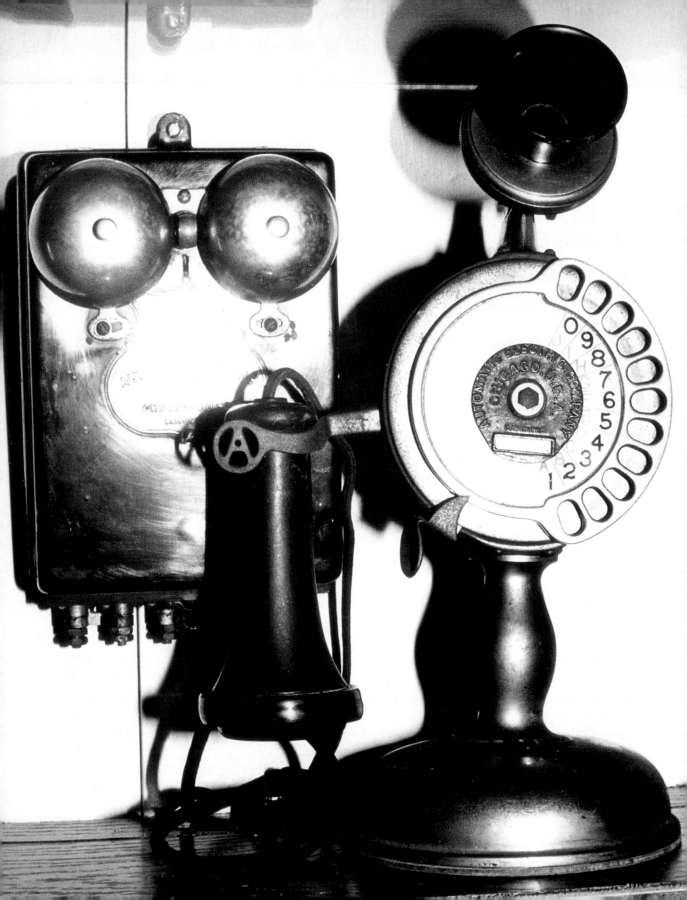

Telephone

RING MY BELL

Electricity had first been used to send messages down wires with the invention of telegraphy in the 1840s, and it was one of the inventors of the telegraph, Sir Charles Wheatstone, who coined the term "telephonic," from the Greek *tele*, "distant," and *phone*, "voice," or "sound." Wheatstone applied this term to a forerunner of the modern telephone, an invention called the "enchanted lyre," which transmitted music from one room to another.

Debate rages over who can claim credit for the first successful electrical transmission of a voice. One contender is Italian inventor Antonio Meucci, who claimed to have transmitted his voice between two rooms of his house in Cuba in 1849. Although Meucci subsequently applied for a United States patent in 1871, his claim is generally said to be unverified—only in Italy is he regarded as the first inventor of the telephone.

The first verified telephone call was made by a German teacher, Johann Phillip Reis, in 1860, using a crude device constructed from the "hollowed-out bung of a beer barrel, a sausage skin, a violin, and a knitting-needle," which he called a "Telephon." According to one expert, Reis missed out on inventing a true electric telephone by the "turn of a screw," but he failed to take his own research seriously, dismissing the device as a "philosophical toy."

The person who is generally regarded as the father of the telephone is the Scottish-American inventor Alexander Graham Bell. In the early 1870s Bell was working on a system that would improve telegraphic communication by allowing more than one message at a time to be sent down a wire. His background in elocution and speech training for the deaf, which had given him an understanding of the science and mechanics of sound, inspired his research and he applied the same principles in developing a theory for the transmission of voices. With the help of his assistant, Thomas Watson, he created a device that could turn sound waves into electronic impulses, send them down a wire and convert them back again, inventing along the way both the microphone and the loudspeaker.

On March 10, 1876, Bell spilled acid from a battery onto his pants. Picking up the mouthpiece of his new device he made the first electric telephone call in history, summoning his assistant from the next room with the immortal words, "Mr Watson, come here, I want to see you." Seven days earlier Bell and his backers had been granted a patent for "Improvements in Telegraphy," now considered to be the most valuable patent ever issued. Bell well appreciated the unique potential of his invention to make long distance communication available to everyone, explaining in a speech in 1878, "all other telegraphic machines produce signals which require to be translated by experts, and such instruments are therefore extremely limited in their application, but the telephone actually speaks, and for this reason it can be utilized for nearly every purpose for which speech is employed."

Bell had filed for it just two hours before rival researcher Elisha Gray attempted to file a patent of his own for a similar system. While Bell gave his name to the telecommunications company that was to lead the field for decades, Gray helped found its main early competitor, Western Electric. The race to exploit the commercial potential of the telephone was on.

The first permanent outdoor telephone wire was strung up in 1877. It was three miles long, and the first commercial service began that same year. In 1878 the public telephone exchange, linking 21 telephones in New Haven, Connecticut, was created so that users no longer needed direct

No matter how modern the design, or how advanced the technology, the layout of the telephone keyboard still reflects the original technology of the first number dialing telephones from more than a century ago.

lines to connect to other users. By 1879 there were too many users for operators to remember all their names, so the first telephone numbers were introduced. New Haven was also the home of the first public telephone, installed in 1880 by the Connecticut Telephone Company.

The first telephones bore little resemblance to today's phones, with separate mouth- and ear-pieces and no dials. Instead they consisted of a pair of boxes. One had a trumpet-shaped receiver and the other a hole for speaking into. Calls were placed by turning a crank, which alerted the operator. At first an internal battery powered the telephones but this proved unreliable, and in 1888 Hammond Haynes introduced a system where a central battery supplied electricity down the phone wire to all the phones on the exchange. The "French" telephone—

a phone with a single handset combining both transmitter and receiver—was originally developed as early as 1904, but not released until 1927.

Automatic dialing was invented in 1891 by Almon Brown Strowger, a Kansas City undertaker, who discovered that the operator of his local switchboard was the wife of one of his competitors. Suspecting that she was diverting all enquiries to her husband he was inspired to develop a system that could connect calls without human involvement.

Automatic dialing led to the introduction of number dials on phones. These transmitted the desired numbers to the switchboard by sending the matching number of "pips." Zero was signaled by 10 pips, and therefore followed nine on the dial. When dials gave way to keypads this arrangement was retained, which is why telephone keypads run from one to zero, while calculator keypads run the other way, from zero to nine.

By 1918 the Bell Corporation alone had installed 10 million telephones in the United States but Alexander Graham Bell was not one to rest on his laurels. Among his subsequent projects were the "photophone," an early version of the optic fiber later used to increase the volume and quality of telephone transmission, an improved version of the phonograph, an early airplane, and a metal detector, which he invented to try to locate the assassin's bullet that eventually killed President James Garfield.

Mobile phone

GLORIFIED WALKIE-TALKIES

A mobile phone is essentially a two-way radio, and has developed largely from the work of a single radio enthusiast. Al Gross grew up in Cleveland, Ohio, and developed a fascination with radio at the age of nine. As a young engineer his love of radio inspired him to create the first lightweight two-way radio, or walkie-talkie, which he patented in 1938.

The walkie-talkie, and Gross's subsequent refinements of two-way radio communication, including Citizen's Band radios and the first pagers, laid the basis for later mobile and cordless-phone technology. The use of radio waves for personal communication was generally ruled out because radio signals could be picked up by anyone and could not be kept private. Gross overcame this problem with his telephone pager, invented in 1949. It was a pocket-sized device that used special circuitry to allow it to respond only to specific radio signals.

Gross attempted to interest major telecommunications companies such as Bell in his mobile telephone technology, but was rebuffed. By the time his vision was realized in the 1980s his patents had lapsed and he never profited much from his groundbreaking inventions.

It was the Swedes who first used radio waves for a mobile phone network. In 1981 they set up a series of low-power radio transmitter-receiver stations. Individually each station could only cover a limited area, known as a cell, but each cell was linked to the other cells by a computer network. People with a "cell phone," essentially a walkie-talkie capable of communicating with the cell's radio station, could therefore call a cell phone in any other cell despite the low power of their own device.

Answering machine

In 1898, Danish engineer Valdemar Poulsen created the telegraphone, a device that could record sound by magnetizing a wire. At the time Poulsen was working for the Copenhagen Telephone Company and the telegraphone was presumably intended to record voices from a telephone, making it the first answering machine, but by inventing the first magnetic recording device he had also created the forefather of audio cassettes, video, and even computer hard drives and floppy disks.

The telegraphone consisted of a long steel wire, a recording head, and a playback head. The recording head converted sound into electromagnetic fields of varying strength. As it moved along the wire the changing field left an imprint of magnetic variation along the wire. This could then be read by the playback head to recreate the original sound. Poulsen strung the wire up in his laboratory and set the recording apparatus on a trolley, which he would push along the wire as he spoke into a microphone. The playback apparatus sat on another trolley, which Poulsen would then push along the wire to read the recording.

The telegraphone generated much excitement at the 1900 Paris Exposition, where the Emperor of Austria spoke a few words into the device to make what is believed to be the oldest surviving magnetic recording. Despite this, Poulsen struggled to find backers to fund commercial exploitation of the device. However, in 1903, with American help, he founded the American Telegraphone Company to market an much improved version that could record continuously for 30 minutes on a length of steel piano-wire moving at a speed of 84 inches (213 cm) per second. Despite these technological advances, commercial interest remained limited, and Poulsen's steel wire mechanism was later replaced with magnetically coated ribbon (or tape), invented in 1927 by the American J.A. O'Neill.

Magnetic tape formed the basis for the first commercially successful answering machine, the Model 400 PhoneMate, introduced to the United States by Casio in 1971. Earlier efforts had included Casio's 1960 Ansafone, and a rather bulky three-foot-tall machine invented by Willy Muller in 1935, which was intended to help Orthodox Jews who are not allowed to operate machinery, and therefore answer the phone, on the Sabbath.

The most popular of the early answering machines—the 1971 Casio PhoneMate— weighed 10 pounds (4.5 kg), and now sits in the Smithsonian Institution. Today's answering machines are more likely to be of the digital variety, first invented in 1983 by Dr. Kazuo Hashimoto of Japan.

Computer peripherals

I. T. ACCESSORIES

FLOPPY DISK

Originally known as the "memory disk," the floppy was invented in 1971 by a team at IBM, led by engineer Alan Shugart. The first floppies had a capacity of 100K; they were 8-inch (20-cm) wide plastic disks coated with magnetic iron oxide, the same material as audio- or videotape. The disks themselves were thin and flexible, earning them the nickname "floppy," but came in either a soft plastic envelope or a hard plastic casing, in which case they were called diskettes. In 1976, 5¼-inch (13.5-cm) disks were introduced, and in 1981 Sony produced the first 3½-inch (9-cm) diskettes, which have become the standard.

Floppy disks were originally intended to help load information onto a larger storage device, called a disk pack file, but it quickly became apparent that they provided a convenient and portable method of storing and transferring both data and programs, and they soon superseded other systems such as tapes. Disk drives work like record players: they grip the disk through the hole in its center and spin it. A head reads or records information, just as in a cassette player, through a window in the envelope or casing.

THE MOUSE AND THE "WINDOWS" INTERFACE

During World War II Douglas Engelbart had been a radar technician, and became familiar with the cathode ray tubes (essentially television screens) used to display radar information. Training in electrical engineering after the war, Engelbart realized that creative use of the cathode ray tube could create a graphical interface between computers and computer users that would be accessible to nonexperts. He set up the Augmentation Research Center at the Stanford Research Institute, and led the development of software that would eventually become a "windows"-type interface, and hardware that would enable anyone to use it.

The keyboard provided a barrier to interaction with Engelbart's graphical user interface. It was difficult to control the movement of a cursor or pointer using only arrow keys, and having to learn different codes and instructions to make the computer do things immediately excluded nonexperts. His solution, invented in 1964, was an ergonomically designed tool that took advantage of the user's natural way of doing things—the mouse. In Engelbart's 1970 patent the device is called "an X-Y position indicator for a display system," but he nicknamed it the mouse because the wire connecting it to the computer looked like a tail.

The first mouse was a wooden shell with two metal wheels. Moving the shell caused the wheels to turn; one wheel recorded vertical movement and one horizontal movement. The computer could combine the two to calculate the overall diagonal movement, and then use this to move and position the cursor or pointer on the screen. Clicking the button on the mouse then activated whatever was being pointed at, a process known as "point-and-click" operation.

The computer mouse got its first public airing in a landmark presentation in 1968, in which Engelbart and his colleagues demonstrated an interactive, networked multimedia system that was decades ahead of its time. Among the range of new technologies on show were the windows interface, and video conferencing.

GAMES CONSOLE

In 1970 Nolan Bushnell from Utah invented the first computer game, *Computer Space*. Similar to the later game *Asteroids*, *Computer Space* was too complicated for the mass market, so Bushnell came up with the much simpler *Pong*, a crude computer version of ping-pong. *Pong* was an immediate and massive arcade success. The first *Pong* machine, installed in 1971 at a bar in California, broke down on its debut after being overstuffed with quarters. In 1972 Bushnell founded Atari, which went on to create seminal arcade games such as *Breakout* (1976) and *Pole Position* (1982).

The first home video game was the little known Odyssey, released in 1972, but it was left to Atari to truly open up the domestic market. In 1975, in collaboration with Sears, Atari released a home version of *Pong*, played with a machine that plugged into the television—a brilliant stroke that made video games accessible to everyone, long before home PCs became commonplace. A plethora of ball and paddle games that could be played on TV followed, but for many years the games-console industry

All-time classic *Pac-man*, created in 1980, is still a huge favorite. In an age where games routinely feature graphics as good as the Hollywood special effects industry can produce, *Pac-man* still sells and new versions are being released.

lagged behind both arcades and home computers. Early consoles included the 1976 Fairchild Channel F, the first cartridge-system, and the 1980 Mattel Intellivision, but by this time arcade goers were playing *Space Invaders* (1978) and *Pac-man* (1980), and home users had access to the Commodore PET (1977) and the Sinclair ZX Spectrum (1980).

Games consoles only came into their own when Japanese giants Nintendo and Sega entered the market. The Nintendo Entertainment System reached the West in 1985, followed by the Sega Master System the year after. Ironically, considering their slow start, the new generation of consoles, including Sony's Playstation 2 and the Microsoft X-box, promise to become the dominant household IT appliances, allowing access to the Internet and broadband services, DVD and CD playing, and e-mail, as well as games.

KEYBOARD

The keyboard came to be the most common way of inputting information to a computer because it already existed in the form of typewriters and keypunch machines (machines that created punch cards using a keypad). The first typewriters were made as long ago as 1808, but commercial production did not start until 1877, when gun manufacturer Remington brought out a machine designed by Milwaukee typewriter pioneer Christopher Latham Sholes.

Early typewriters used "type bars," arms with the characters on the end, arranged in a circle. If two keys were struck in quick succession, their two type bars would meet in the middle and jam, particularly if they were hanging next to one another. To reduce the likelihood of this happening, Sholes designed his keyboard so that the most frequently used keys were furthest apart, resulting in today's familiar QWERTY arrangement.

Typewriters were soon combined with electricity, initially by Edison, and by the 1930s they were being used as both input devices and printers for the telegraph, producing a new type of machine called the teletype. When BINAC, the successor to ENIAC, was built in 1948, teletype and keypunches were selected as the interface for inputting data and instructions. These devices recorded information on either strips of magnetic tape or punched cards, and these then had to be fed into the machine. This was time-consuming and clumsy, but much easier than rearranging wiring and valves directly.

In the 1960s universities and businesses that made extensive use of computers introduced individual workstations, allowing several users at a time to access the computer. In order to provide a workable interface for these users the designers combined visual display units (VDUs) with keyboards derived from electric typewriters. These allowed users to type information directly into the computer without having to go through any laborious steps involving punch cards and magnetic tape. When hobbyists produced the first personal computers in the 1970s they followed previous practice and included keyboards as the main means of inputting data. Soon the keyboard and the computer were inextricably linked.

This marriage is becoming increasingly unhappy, as more and more people complain about repetitive strain injury (RSI), a painful syndrome caused by repeatedly making the same motions with your fingers. Critics of the keyboard point out that the familiar QWERTY design, also known as the Universal keyboard, is the result of 120-year-old design constraints, which deliberately gave the keyboard the most unergonomic design possible. More ergonomic versions such as the Dvorak keyboard, which groups the most commonly used letters on the "home" row where the typist's fingers rest, have failed to catch on because the QWERTY design is too well-established and because they make little difference to typing speed. In the future, however, more sophisticated technology could bring about the death of the keyboard, replacing it with speech-recognition software or personally customized input devices (e.g., chord-typing devices, such as those used by court stenographers), which are either more ergonomic or completely nonmechanical.

The long decline of the "New Industries" and the tech market has provided a perspective on the phenomenon of e-commerce. At one point e-commerce was heralded as the end of traditional retailing. Today, poorer but wiser analysts await the Next Big Thing.

Personal computer

The first man to conceive of a computer was the visionary British mathematician Charles Babbage. In 1833 Babbage was working on a design for a machine that he called the Difference Engine, an advanced form of calculator, when he came up with the idea of an entirely new type of device, the Analytical Engine. This machine would have a processing unit, or "mill," which could be programed to perform different types of calculation using principles of logic, and which could then keep its results in a memory "store." With the help of Lord Byron's daughter, Ada Lovelace, Babbage even designed a system for feeding information into the machine using punch cards, which had recently been introduced to help program mechanical looms. The Analytical Engine would "weave algebraic patterns as the loom weaves flowers and leaves."

Unfortunately for Babbage the specifications of his design were far too advanced for the engineering of the day and neither machine was ever built in his lifetime. British scientist Alan Turing later used the principles of the Analytical Engine as the theoretical basis for the Colossus computing system that helped crack the Nazis' Enigma codes in World War II.

Colossus and its American successor ENIAC depended on an electrical component called the valve, essentially a light bulb, with the same tendencies to generate heat and burn out at frequent intervals. ENIAC incorporated 18,000 valves,

weighed 30 tonnes, and was 100 feet (30 m) long. When its first commercial descendant appeared in 1950 (the Lyons Electronic Office or LEO, built for the tearoom operator J. Lyons), it was estimated that just five such devices would meet the needs of the developed world.

The discovery of semiconductors, small pieces of mineral that could replicate the function of the large electrical components, by researchers at the Bell Telephone Laboratories in 1947, paved the way for the miniaturization of computer components. In 1959 the first integrated circuits appeared, combining several components on a single piece of silicon, and in 1969 American Ted Hoff succeeded in making the ultimate integrated circuit—the microprocessor. This was a single chip carrying all the necessary components for a working computer. It was now possible to build a microcomputer, a computer small enough to fit on a desktop but powerful enough to be of real use.

The first desktop-sized microcomputer for personal use was released in 1974. Its creators, Micro Instrumentation Telemetry Systems (MITS), were immediately encouraged to release a mail-order kit version for electronics hobbyists, which they called the Altair. The runaway success of the Altair kick started the evolution of the personal computer. As dozens of home enthusiasts started to design and build their own microcomputers the technology advanced at a startling rate, and at the same time the expanding demand encouraged larger companies to get involved. An early bestseller was Tandy's 1977 microcomputer, which included a keyboard, a visual display unit similar to a

television screen, and a cassette recorder for storing/inputting data.

In 1976 Steve Jobs and Steve Wozniak created the Apple computer, and soon they were offering color graphics and user-friendly interfaces (later copied by Microsoft to produce Windows). The enormous success of Apple, which became the fastest growing company in American history, prompted IBM to get involved. In 1981 IBM introduced the PC, cementing the position of the personal computer as a permanent feature of the work environment.

E-commerce

BUSINESS OF THE FUTURE

E-commerce predates the World Wide Web by around 20 years, as it has its roots in the Electronic Data Interchange (EDI) system, started in 1968 to facilitate the first electronic interactions between businesses. At first, however, the formats used by the various computer systems involved in EDI differed widely, severely limiting the potential growth of electronically conducted business, but in 1984 ASC X12 was established as the standard format for EDI.

In 1989 the World Wide Web was proposed, giving a graphical, accessible, user-friendly face to the Internet and providing the medium through which e-commerce could reach the masses. But although the framework was now in place to allow e-commerce to take off, the technical complexity of accessing the Internet meant that the customer base was limited. Even if you could get on-line, getting hold of information or making a transaction required a high degree of IT expertise. This was to change with the development of Mosaic, the first graphical browser, in 1992, and its successor, Netscape Navigator, released on October 13, 1994. Mosaic and Netscape allowed anyone to access Web content using a simple point-and-click interface.

Working lunches have taken on a whole new meaning now that laptops and wireless communications provide online services on a plate.

Made available for free, Netscape was downloaded by millions, giving e-commerce both its medium and its customer base.

The overnight success of Netscape started the Internet gold rush, filling the media with predictions of the death of traditional retail and the

dawn of a new age of commerce. A few notable success stories fueled the hype: in 1998 Amazon.com broke the $1 billion annual sales mark, while AOL generated $1.2 billion sales in just 10 weeks over the United States holiday period. In 1999 the music-swapping site Napster became the biggest thing on the Web, and though it generated no revenue it proved that there was a potentially huge market for e-music.

Inevitably, however, the bubble eventually burst. Headlined by the spectacular crash of online fashion retailer Boo.com, which burnt through $120 million in only six months, the Internet gold rush fizzled out. Even though e-commerce is still going strong and growing all the time, most analysts now view it as just one option alongside the more traditional retail media such as mail order and actual shopping.

Rubber eraser

WIPE OUT

Rubber was first introduced to Europe from South America in 1736, by French explorer Charles Marie de la Condamine. The native South Americans had used it to make balls for sports and as an adhesive, but the Europeans soon found other uses for it. By 1770 the eminent British scientist Joseph Priestley noted, "I have seen a substance excellently adapted to the purpose of wiping from paper the mark of black lead pencil." The substance in question was rubber, cut into small cubes known as *peaux de nègres*.

Like most other organic substances, rubber was susceptible to rot, until Charles Goodyear's 1844 discovery of the process of vulcanization: mixing rubber with sulfur and heating it. Vulcanization cures rubber and makes it stable and long-lasting. Erasers (or rubbers, as they were known in Britain for their ability to "rub out" pencil marks) became more widely available, and in 1858 American Hyman Lipman was granted a patent for an integral pencil and eraser. In the pencil industry this type of eraser is known as a "plug." Lipman's patent was later dismissed on the basis that he had simply combined two existing products without inventing a new application. According to one source, however, he had already sold the patent for $100,000, so he may not have been unduly upset.

Today erasers are rarely made from real rubber. Most are either synthetic rubber with added pumice grit, or vinyl.

These erasers are probably made of vinyl, requiring little processing other than cutting into shape. Synthetic rubber erasers, on the other hand, go through a process of blending, extrusion, vulcanization, and tumbling (to round off their corners).

G E N E R A L
H O U S E H O L D *

* everyday items explained

Matches

STRIKE A LIGHT

The Romans were the first to harness chemical energy to help create fire: they used sticks dipped in sulfur, a flammable element, which could be lit against a glowing ember to provide an instant torch or flaming brand. The first true match, however, which could start a fire from nothing, was the creation of English scientist Robert Boyle. In 1680 Boyle coated a piece of paper with the newly discovered element phosphorous and tipped a splinter of wood with sulfur. When he drew the splinter through the coated paper it caught fire. Phosphorous was rare and expensive at this time, however, and Boyle's invention remained a little-known curio.

In 1805 French chemist Jean Chancel tipped splints of cedar with a mixture of potassium chlorate, sugar, and gum and dipped them into a small bottle of sulfuric acid. When the splint was withdrawn it would burst into flames. Chancel's matches were introduced to Britain in 1815 as "Prometheans," and were later sold by a trader called Heurtner from a shop in London named The Lighthouse, where they were advertised with the inscription: "To save your knuckles, time, and trouble, use Heurtner's Euperion." The Euperion was a box of 50 Prometheans with a small bottle of acid, and was more familiarly known as the "Hugh Perry."

The match as we know it was accidentally invented by English pharmacist John Walker. Noticing that a stick he was using to stir a mixture of antimony sulfide, potassium chlorate, sulfur, and gum had become coated at one end, he tried to clean it by scraping it on the floor. It promptly burst into flames. Soon Walker was making 3-inch (7.5-cm) matches tipped with his special mix and selling them as "Congreves," also known as "sulfuretted peroxide strikables," but he failed to patent his invention or make much money out of it. This was left to a London businessman, Samuel Jones, who changed the name of the product to Lucifers.

Lucifers were very popular, bringing about a dramatic increase in tobacco consumption, but far from ideal. They were ignited by being drawn through a fold of sandpaper, during which process the head would often come off or split up, spitting globes of fire onto clothes and carpets. For a while they were banned by law in France and Germany.

The addition of white phosphorous to the mixture led to better matches but introduced the problem of widespread poisoning. White phosphorous is toxic and causes necrosis of the bone, particularly the jaw, producing a syndrome widely known as "phossy jaw" among match factory workers and those who used the matches. Another problem with Lucifers was their tendency to ignite too easily, which caused frequent accidents and fires. The invention of the safety match by Swedish chemistry professor Gustaf Pasch in 1844, led to the creation of a huge Swedish match industry, which was for many years the world's largest.

In 1892 an American lawyer, Joseph Pusey, invented the matchbook. The inspiration came to him in much the same way as it had to the creator of the bra (see page 106). Preparing for a ball one

night, Pusey was exasperated that his bulky box of matches was spoiling the line of his evening clothes, and came up with the idea of a book of paper matches. The idea was not an instant success, and did not catch on until 1897, when the Mendelsohn Opera Company ordered a batch of matchbooks printed with their name as an advertising gimmick.

After this, Pusey was able to sell his patent to the Diamond Match Company, makers of a rival type of paper matchbook. Matchbooks were later used during World War II to carry propaganda to occupied countries and even instructions to the resistance—the Diamond Match Co. printed one with instructions on how to derail trains.

Fire extinguisher

BLOW OUT

Fire has long been a threat to life and property. House fires were far more common in earlier centuries when cooking, lighting, and heating all depended on naked flames and houses were constructed from flammable materials. In medieval times the height of domestic fire-fighting technology was a bucket or a blanket—more affluent households were expected to keep a large barrel of water by the front door.

The earliest fire extinguishers were glass "fire grenades"—globes or bottles of blown glass that were filled with a fire-smothering fluid (often saltwater or carbon tetrachloride). They were deliberately made with thin walls so that they would explode when thrown at the base of a fire, scattering their contents. Fire grenades were found everywhere, in houses, schools, factories, trains, and hotels, and were common until

the early 20th century when fire extinguishers took over. Now they are sought-after antiques.

Numerous fire-extinguisher patents were issued in the 19th and early 20th centuries, as inventors sought more effective ways to offer domestic fire protection. Early patents include those issued to Alanson Crane, in 1863, and Thomas J. Martin, in 1872. Like the fire grenade, the extinguisher works on the principle that a fire deprived of its oxygen supply will go out. Early versions included metal tubes containing bicarbonate of soda and acid: inverting the tube would mix the two together, generating a cloud of carbon dioxide. Foam extinguishers generated a foam of carbon dioxide bubbles. Later models used compressed liquid carbon dioxide, carbon tetrachloride for electrical fires, or compressed nitrogen.

Need to operate a fire extinguisher? Remember this handy acronym: PASS. Pull the pin. Aim low at the base of the fire. Squeeze the handle. Sweep from side to side.

Fire and smoke detectors

SAFETY FIRSTS

The first fire alarms exploited the emerging technology of electricity by connecting heat sensors to electrical circuits that could sound bells. In 1852 D.L. Price filed the first patent for a fire alarm. For a heat detector he used a bimetallic strip—two layers of different types of metal that expand at differing rates when heated. Since one layer expands faster than the other, heating causes the strip to bend. In Price's fire alarm the strip was positioned in such a way that as it bent it connected to a circuit that powered a bell.

During the 1880s more elaborate systems using columns of mercury were installed in some houses. If the temperature rose, so did the mercury, eventually making contact with electrodes and again completing a circuit (mercury is a metallic element and therefore a conductor of electricity), which sounded a bell.

Smoke detectors were developed in the first half of the 20th century, but only became a common household item in the 1970s when Sears put their weight behind the product, releasing a residential model in 1974. Now over 85 percent of American households are equipped with a smoke detector.

A typical smoke alarm, with a "Test" button in the center. Remember that pressing the button only tests that the battery has not run down and the alarm is sounding properly, not that the detector itself is actually working. To test this, simply direct some smoke or steam into the detector (and cover your ears).

There are two types of commercial smoke detector—photoelectric and ionization. In the former, an optical sensor detects any break in a beam of light caused by smoke particles. Ionization detectors, on the other hand, first invented in 1941, use a small amount of a radioactive element (usually americium 241) to generate ions (charged particles) between two charged plates. As long as the ions are present they will carry a current between the two plates, completing a circuit. If smoke particles enter the detector they attract the ions and weaken the current. This is detected by a microchip, which in turn activates the alarm. Because many smoke detectors contain radioactive material it is important that they should not be disposed of as normal garbage, because they could end up contaminating watercourses near garbage dumps.

The ionization smoke detector also has a built-in failsafe because it relies on a continual flow of current to stop it from going off. If the battery fails or runs down, so does the ion current, triggering the alarm and giving a highly audible warning that you need to replace the battery.

Clothes iron

CREASE LIGHTENING

Neatly pressed clothes have been a sign of refinement and status throughout human history, and in ancient times it was already known that heat or weight could help to press creases both in and out of clothes. The Greeks employed the first known clothes irons in around 400 BC, when they used heavy heated rollers, later known as goffering irons, to press pleats into garments. The Romans used flat metal mallets to beat creases into their togas, and the Vikings used mushroom-shaped "smoothing" or "slicken" stones that were rocked back and forth (they also used whalebone plaques as ironing boards). However, since smoothing wrinkles and pressing sharp pleats involved time and hard labor, only the richest and most powerful could afford to have this done.

The clothes iron as we know it began to take shape in the Far East in the eighth century AD, with the use of the first box or slug irons. A box iron is a metal box (or pan, in its earliest incarnation) with a flat bottom and a handle on top. A heated rock or hot coal or charcoal (the "slug") is placed inside the box and heats the bottom surface. Box irons were in use in Europe by the 15th century, but by the 1700s the flat- or sad-iron was much more common. A flatiron is essentially a slab of metal with a handle, which is heated over an open fire or on a stovetop. Like the goffering irons of ancient times, the flatiron was a cumbersome tool with numerous drawbacks. It weighed up to 15 pounds (6.8 kg) and would pick up soot from the heat source. The user had to gauge

from experience when it was hot enough, but not too hot, and could only use it for a short time until it cooled, and then had to wait for it to heat up again.

A number of ingenious devices were devised to address these problems, such as irons with detachable handles, so that one could be picked up and used while others were heating up. The introduction of gas supplies to Victorian homes for lighting soon led to gas-fired irons, although these were often dangerous and shared many drawbacks with the traditional flatiron. Spirit- or paraffin-powered irons also appeared in the late 19th century, but although they could be heated while in use, like gas irons, there was no way of controlling the temperature and they were still dangerous, dirty, slow, and cumbersome.

Electricity, the great selling point of which was its cleanliness and convenience, seemed made for the iron. The first patent for an electric iron was granted to Henry Seeley in the United States in 1882, but the first practical versions did not appear until 1892. The electric flatiron, which generated heat through a resistance element above the soleplate, was cheap, clean, and heated up quickly. By the mid 1920s Americans were buying 3 million electric irons a year, and in Britain 80 percent of homes equipped with electricity had one.

In 1927 the first thermostat-controlled iron appeared in America, and by 1936 the first crude steam irons appeared. Electric irons were also becoming lighter and the introduction of streamlined designs with steel cowls covering the whole iron meant that, by the 1930s, irons had already assumed the shape we know today.

Vacuum cleaner

Up until the 19th century the only way to dust household surfaces was to sweep them or, in the case of carpets, beat them—a task so laborious that it was only done once a year, during the "spring clean." Cleaning dust out of carpets during the rest of the year required complicated operations with wet tea leaves scattered over the carpet, which were then swept away. The first attempts to build a mechanical sweeping device date back to 1699, when Edmund Heming attached brushes to the wheels of a cart for sweeping the streets of London. By the early 1800s domestic carpet-sweeping devices with revolving brushes appeared, and toward the end of the century compressed air blowers were in regular use. None of these devices was particularly effective, however, and often tended simply to move dust around or make it temporarily airborne.

The idea of using suction to remove dust dates back at least as far as 1869, when Ives McGaffey of Chicago invented the first vacuum cleaner, the "Whirlwind." This device used a hand-cranked fan to generate suction, but proved to be hard work. Subsequent hand-powered devices were equally labor-intensive, including the Teeterboard of 1901, where suction power was generated by an assistant rocking back and forth on a sort of teeterboard, and the Success Hand Vacuum of 1917, which used a concertina-style pump on the handle.

Hubert Cecil Booth of London is usually credited with inventing the first motorized vacuum cleaner in 1901, although he was actually predated by two years by John Thurman of St Louis. Booth's cumbersome machine consisted of a gasoline-powered suction pump on a horse-drawn cart, which was parked outside a customer's house while a long hose attached to the pump was run in through the front door. The air was drawn through a cloth filter, which Booth had devised after experimenting by sucking the back of a sofa through a handkerchief.

Though nicknamed "Puffing Billy," and blamed for continually frightening passing horses, Booth's vacuum cleaner was a great success, gaining the royal stamp of approval when it was used on the carpets in Westminster Abbey prior to the coronation of Edward VII in 1901.

The first practical, portable domestic vacuum cleaner was the brainchild of an asthmatic Ohio department store janitor, James Murray Spangler. His 1907 design used an old electric fan to generate suction, rotating brushes to help beat dust out of carpets and one of his wife's pillow cases as a filter bag. Unable to make a success of his "electric suction-sweeper," Spangler sold the rights to a local leather-goods merchant, William Hoover, who in 1908 had the machine redesigned with a steel casing, casters to enable it to be pulled around, and attachments for those corners that were difficult to reach. Subsequent developments in vacuum-cleaner technology included the first disposable filter bags, in 1920, the upright, in 1926, and eventually, in the 1990s, James Dyson's bagless cyclone technology, which uses a supersonic whirlwind to remove dust with greater power and efficiency than ever before.

Television

The early history of television is complex, and determining whom to credit for its invention even more so.

The concept of television, that is, of transmitting moving pictures over large distances, evolved out of work that was being carried out on the early facsimile (or "fax") machine. Advances in electronics technology meant that by the mid 19th century it was possible to transmit single images down telegraph wires by converting patterns of light and shade into varying levels of electrical current. The crucial breakthrough was the work of Alexander Bain, the inventor of the first fax machine, who in 1842 demonstrated that an image could be broken down into lines for easy transmission and reproduction—a process known as scanning.

Scanning still forms the basis of television broadcasts today. The image on your TV screen is made up of hundreds of lines of colored dots, which are redrawn many times a second, changing minutely every time. A property of human vision, known as persistence of vision, means that you don't notice the tiny gaps between each frame or the redrawing of each line, instead you perceive the picture as smoothly changing and continuous.

In 1884 German scientist Paul Nipkow designed a crude mechanical camera based on the principle of scanning. It used a metal disk with a spiral of holes cut into it and a light-sensitive element (selenium) behind it. As the disk spun round each hole would record one line of the image in front of it, and the selenium would convert the changing patterns of light and shade into electrical impulses of varying voltages. The resulting electrical impulses could then be converted back into light and projected through a second rotating disk to produce a series of lines making up a picture. One rotation of the disk produced one frame, and by spinning the disk fast enough it was possible to produce enough frames to build up a moving image. Nipkow himself was never able to build a working model because of technological constraints, but the Nipkow disk, as it became known, provided the inspiration for several early television pioneers.

Best-known among these was the colorful Scottish inventor John Logie Baird. An amateur scientist strong on ideas but technically inept (he was said to have trouble changing a fuse), Baird sold shoe polish and razor blades to help fund his research, which included an attempt to make artificial diamonds and an experimental cure for hemorrhoids that left him unable to sit down for a week. In an attic in London, on November 30, 1925, Baird successfully transmitted his first television picture—an image of a dummy's head—using a system based on a Nipkow disk, which he later called a "Televisor." This was described as a "mechanical system" because it was based on moving parts.

Baird was a zealous promoter of the Televisor, and he gradually improved the technology by introducing groundbreaking innovations such as color, infrared, and stereoscopic (3-D) television, and eagerly seeking publicity. On one occasion he visited the offices of the *London Daily Express* where his

enthusiasm supposedly prompted the news editor to warn colleagues: "Watch him—he may have a razor on him!" In 1928 he scored a major coup by transmitting the first television image across the Atlantic, and in 1929 he was allowed to use BBC radio transmitters to make the first regular public TV broadcasts in the world. A few thousand purchasers of Baird's mechanical TV sets were able to see images in black and orange on a tiny screen. The images were initially made up of just 30 lines at 12 frames per second. Although Baird later improved the definition offered by his system to 240 lines, developments in electronic television, which would render mechanical television obsolete, had already arrived.

In fact these developments had begun while Baird was still a child. In 1897 German physicist Karl Braun perfected the cathode ray tube (CRT), a device that could produce images on a screen using a beam of electrons (also known as a cathode ray). The CRT remains the basis of most television sets today. In 1907, in a letter to *Nature* entitled "Distant Electric Vision," British scientist A.A. Campbell Swinton proposed a fully electronic television system, based on CRT technology for both the camera and display devices. Russian scientist Boris Rosing came up with a similar scheme. Rosing died not long after the Russian Revolution, but his student and colleague, Vladimir Zworykin, emigrated to the United States where he carried on his research.

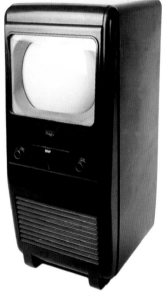

The most obvious difference from today's sets is the tiny ratio between screen area and overall size, but even this old set was an improvement on the first home television sets, which had a screen just 3 inches (7.5 cm) wide.

Although Zworykin would eventually become known as the father of modern television, he struggled for many years to perfect the technology of electronic television in his own lifetime. By 1929 he had patented both the kinescope, a television display device, and the iconoscope, a television camera, and was able to gain the backing of American media giant RCA for further research. By 1930 experimental broadcasts using a 120-line image were underway, and by 1933 a 240-line system was ready. The BBC adopted a similar system in 1936, developed by British companies EMI and Marconi, which led to the abandonment of Baird's system and the end of mechanical television.

Soon high-definition public broadcasts using electronic television were available in Britain, Germany (where they were used to broadcast the 1936 Olympics), Canada, and the United States, but competing and incompatible systems threatened to halt the new industry in its tracks. In the United States, for instance, just 400 television sets had been sold by 1941, when a 525-line system was adopted as the industry standard.

Manufacture of sets ceased when America entered the war, but the postwar years saw an expansion in TV ownership. In 1946 just 7,000 TVs were sold in the United States. By 1950 the figure rose to 10 million, and by 1953 over half of American households had a TV. It is now estimated that 98 percent of American homes contain at least one television.

Remote controls

INACTION AT A DISTANCE

The first remote controls were military devices that used radio waves to operate weapons including boats (as early as World War I), bombs, and mines from a distance. After World War II this military technology was adapted for civilian uses—the first remote control for automatic garage doors was introduced in the late 1940s. Radio technology was not suitable for television remote controls, however, as radio waves could travel through walls and might operate the neighbor's set as well. Nonetheless, managers at the Zenith Radio Corporation (later the Zenith Electronics Corporation) were convinced that television viewers hated advertisements and would pay for a remote control device that would help to avoid them.

In 1950 Zenith introduced the Lazy Bones, a remote control attached to the TV set by a cable. Pressing a button activated a motor that turned the tuning dial, changing the channel. The idea was popular, but customers complained of tripping over the cables. In 1955 the first wireless TV remote control was introduced, the Flashmatic. This was essentially a flashlight that was shone at the television, where photoreceptors at each corner of the screen picked up the signal and operated the channel changer.

Modern remote controls use infra-red light. Each button has a digital code, and when pressed the remote fires a beam of light carrying that code at the television. The beam is picked up by a photodetector on the TV, which reads the code and triggers an action.

Unfortunately the device had a major flaw and could also be triggered by sunlight, causing much daytime viewing to be interrupted.

The next development was the brainchild of Austrian born engineer Robert Adler, now acknowledged as the father of the remote control, who used ultrasound as the basis for the 1956 "Zenith Space Command." Ultrasound is sound at a frequency too high for the human ear to pick up (but audible to dogs). In the original Space Command, pressing a button generated ultrasound by activating a trigger mechanism, where a string was stretched and then released, causing a hammer to strike 2½-inch (6-cm) aluminum rods. Each rod was a slightly different length so that each emitted a distinctive ultrasound tone, and there were four of them, allowing the viewer to remotely operate four controls: channel up, channel down, sound on/off and power on/off. No batteries were required, although later versions used electronics to generate the sound.

The only drawbacks to Adler's ultrasound system were that some domestic noises, like cutlery clinking, could generate ultrasound and activate the TV, while operating the remote control would sometimes make the dog bark.

VCR

RE-RECORD NOT FADE AWAY

John Logie Baird produced the first video recordings of television images in 1928, using a simple wax disk to record the signals from one of his 30-line television transmissions. Whether he was ever able to play them back is uncertain. Practical videotaping did not appear until after World War II. The Germans had invented magnetic tape in the 1930s, developing the work of Danish scientist Vladimir Poulsen, inventor of the first magnetic recording device (see Answering Machine, page 161), to produce audio-recording machines known as Magnetophones. After the war American officials took Magnetophones back to the United States, where they were seized upon by several companies including Ampex and Bing Crosby Enterprises, a company set up by the popular crooner after he had heard a demonstration.

The Germans had used Magnetophones to record sound, helping them to produce and edit radio shows and other broadcasts. The Americans wanted to go one step further and record video signals. At this point the television industry was expanding rapidly, but was severely hampered by the need to transmit shows live, which left little opportunity for editing or time-delay broadcasting (necessary when broadcasting across time zones).

One alternative was literally to film live broadcasts by pointing a specialized movie camera at a specialized TV set, a process known as kinescoping. For several years this was the only option available to the coast-to-coast networks but it was technologically complex, gave poor quality, and was extremely expensive—by 1954 they were using up more film for kinescoping than all of the Hollywood film studios put together.

The industry was desperate for magnetic video recording, but adapting the Magnetophones was proving difficult. Far more information had to be recorded for video than for audio, and in order to fit it all on to tape the machines had to be run at prohibitively fast speeds; early versions would eat through thousands of feet of tape in just a few minutes. When a team at Ampex Corporation finally solved the problems in 1956, the resulting machine, the VR 1000, was heralded as the greatest invention in broadcasting since the television itself.

The VR 1000 was a huge, expensive machine that used enormous reels of thick tape, but it was not long before more compact versions suitable for domestic use came on the market. In the early 1960s the Telcan became the first domestic video recorder, but not until the 1970s did prepackaged video cassettes, as opposed to reels of tape, first appear.

The late 1970s saw the emergence of a short-lived challenge to the videotape's dominance. Philips and Sony—the two biggest players in the audio-visual market—brought out the LaserDisc, a video equivalent of the compact disc format that was promising to replace vinyl. The LaserDisc worked on the same principle as John Logie Baird's 1928 wax "Phonodisc," but used a laser instead of a needle to read tiny pits on the disc's surface. LaserDiscs were a commercial disaster and failed to catch on outside a hard core of enthusiasts.

Personal stereo

MUSIC TO YOUR EARS

By the late 1970s, many Japanese firms had established themselves as a strong force in the audio-equipment industry. Companies such as Sony had a reputation for low cost, high-performance products, and were celebrated for their flair for miniaturization. Perhaps the greatest success that Sony would enjoy was the invention of an entirely new product—the personal stereo, commonly known by its Sony trade name, the Walkman.

The Walkman was the brainchild of Sony founder Masura Ibuka, who wanted to find some way of listening to music while traveling, but without bothering other people. In early 1979 he presented his product-development team with a challenge—could they, in the space of just a few months (to coincide with the upcoming summer vacations), develop a portable stereo unit with a set of lightweight but high-quality headphones?

In order to save time and ensure that the product would be reliable from the start, Sony decided to adapt an existing tape cassette player, the Pressman. It was also decided that the device should be playback only, with no record function, despite warnings from many that no one would buy a playback-only machine. One of the greatest difficulties was finding a name. Walkman was chosen for a number of reasons, including the product's roots in the Pressman and the popularity of the comic-strip character Superman at the time.

The first Walkman, the model TPS-L2, was ready for launch on July 1, 1979, and included features such as a second headphone jack, so that a companion could listen in, and a talk button, enabling the volume to be cut off while carrying on a conversation. More revolutionary was the quality of sound produced by the tiny headphones, and the enhanced power output that Sony had managed to extract from ordinary batteries. A group of music journalists were given a special preview—they were bussed to a city park and let loose with a Walkman each. The initial response, however, was cool, and by the end of July just 1,000 of the original 30,000 production run had been sold. But word of mouth soon began to spread, and by the end of another month the entire run was sold out.

It was originally intended that the Walkman should have different names in overseas markets—"Soundabout" in the United States, "Stowaway" in the United Kingdom, and "Freestyle" in Sweden—but the Japanese title was quickly adopted in foreign markets thanks to tourists and travelers. The machine itself was slower to catch on abroad—in the United States, for instance, a hefty $200 price tag meant that the Walkman was considered an expensive novelty item.

In 1981 the Walkman II was introduced to overseas markets, and proved to be a huge success. With 50 percent fewer moving parts, it was 25 percent smaller and a lot cheaper. Within ten years of its launch more than 50 million had been sold, and by 1995 over 150 million. More than 300 different models have been produced to date, and, according to some commentators, the Walkman was largely responsible for cementing the place of the cassette tape as a serious audio format.

Binoculars

SEEING DOUBLE

Binoculars are essentially two telescopes mounted together, one for each eye. By sending a different picture to each eye they provide stereoscopic (three-dimensional) views. Telescopes were probably first made in the 16th century but their inventors left no concrete records. Not until 1608 did Dutch spectacle-maker Hans Lippershey apply for the first patent for a telescope. He had noticed that when he viewed a distant church steeple through two of his spectacle lenses it appeared magnified. By housing the two lenses in a tube he created a simple telescope, which he called a "looker."

When the Dutch authorities tested Lippershey's invention they found that squinting through a single lens soon gave them eyestrain and headaches, and requested that he build a binocular version using quartz crystal lenses (the glass available at the time was of poor quality) to give them a stereoscopic view. Authorities differ on whether Lippershey successfully met this request, but it is known that his patent application was eventually refused on the grounds that others had made telescopes earlier (although he was appointed telescope maker to the State of Zeeland).

Another early telescope pioneer was Galileo, who in 1609 trained a telescope on the heavens and revolutionized the science of astronomy and prevailing conceptions about the universe. Among Galileo's writings on optics was a design for a helmet-mounted telescope for use by sailors, which, according to some sources, called for twin telescopes, that is, a helmet-mounted binocular.

Later in the 17th century Newton dramatically improved telescopes with a new design based on mirrors rather than lenses, which was not applicable to binoculars. After this binoculars were of little interest to the scientific community, but continued to be developed for leisure and military uses. The first box-shaped binoculars were designed in 1671 by the Frenchman Chérubin d'Orléans, and in 1823 binoculars were used at the opera for the first time.

During the mid 19th century some instrument makers began experimenting with a clever technique to enhance the quality of binoculars while reducing their size. In a telescope the lens that magnifies images also turns them upside down. In order to invert the image so that it is the right way up another lens has to be added, increasing the length necessary for the telescope. The need for long tubes led to the development of collapsible, or "telescoping" telescopes.

In 1854 Italian instrument maker Ignazio Porro patented a new system using prisms—angled mirrors that could both turn the image the right way round, and reflect it around corners. This meant that not only could the tubes of the twin telescopes be shorter (or rather, provide greater magnification from the same length), but also their lenses could be spaced further apart than the eyepieces the user looked through, giving enhanced stereoscopic viewing. The prismatic system was adopted by the German master-craftsman Ernst Abbe, who in 1894 combined his talents with glassmaker Otto Schott and instrument-maker Carl Zeiss to produce binoculars of a quality that is rarely surpassed today.

Umbrella

GIMME SHELTER

Well-known to most of the ancient civilizations, the umbrella's original function was to provide shade from the sun—the word itself derives from the Latin *umbra*, "shade." In ancient Persia umbrellas, made of linen, were reserved exclusively for the king, and often equipped with long side-pieces or curtains to provide complete shade and privacy. In other civilizations, including ancient Egypt, Greece, and Rome, they were the preserve of the rich and powerful. In Athens a parasol known as the *Skiadeion* sheltered an idol of Bacchus, and there was an annual Feast of the Parasols at the Acropolis.

The Chinese may have been the first to waterproof their umbrellas, originally by using oiled silk and later by using oiled paper covered in lacquer. There is also evidence that Roman women used oiled-cloth *umbraculi* (men who carried them were considered effeminate). Umbrellas of this type were still in use in Italy in the early 17th century, when they were known as *umbrellaces*. In 1604 English traveler Thomas Coryat recorded that Italian umbrellas were "made of leather [in the] form of a little canopy, and hooped in the inside with divers little wooden hoopes, that extend the umbrella into a large compasse."

Umbrellas were also popular in Spain and Portugal, but were rare in England until the late 16th century. At first they were used to provide shade but later became rain-guards. They were often coated on the outside with feathers, in imitation of a water bird's plumage, though this later gave way to oiled silk. When closed, umbrellas were carried by a ring on the top, with the handle hanging down.

As in ancient Rome, it was considered very unmanly for gentlemen to use an umbrella in rain or shine. According to 19th-century umbrella expert R.L. Chambers, "in all the large towns of the empire, a memory is preserved of the courageous [male] citizen who first carried an umbrella." In fact one of the first British men to use an umbrella was a fictional character—in Daniel Defoe's 1719 novel *Robinson Crusoe* the titular hero makes one out of skins, having previously seen the Portuguese use them in Brazil. For many years a certain type of heavy umbrella was known as a Robinson.

Umbrellas were also called Hanways, after Persian traveler Jonas Hanway, who in 1750 became the first man in London to carry one. Allowances were made for him because he was known to suffer from poor health, but any other man who dared venture out with an umbrella was liable to be publicly derided as "a mincing Frenchman." The main sources of opposition were the hackney-coach drivers, who felt that their vehicles offered the public full protection against the elements, and feared that umbrellas would deprive them of their income.

In 1852 Englishman Samuel Fox invented the steel-ribbed umbrella, in order, he claimed, to help use up a stock of metal corset-stays. Compact umbrellas were not invented until the late 20th century, although as early as 1787 a manufacturer in London's Cheapside was advertising "pocket umbrellas superior to any kind ever imported or manufactured in this kingdom."

the Outside World

"Imagination, not invention, is the supreme

master of art, as of life".

Joseph Conrad, 1857–1924

LEISURE*

***out and about and DIY**

Cameras and film

PICTURE THIS

Photography and the camera evolved from the medieval technology of the *camera obscura*, which is Latin for "dark chamber." In a *camera obscura* light is allowed into a darkened room through a small hole, projecting an image from outside onto a wall or screen. The *camera obscura* was originally used by Arab astronomers to observe the sun without looking at it directly, but was later adopted by Europeans as both an entertainment and an artist's tool. Leonardo da Vinci and Vermeer used it to project an image of their subject onto paper or canvas as a guide for drawing.

Today most mechanical (as opposed to digital) cameras operate on essentially the same principles as the *camera obscura*—the body of the camera provides a darkened chamber, into which light is admitted through a small opening (the aperture), projecting an image on to a surface (the film). The difference is that in photography the image is captured through the use of light-sensitive pigments, a breakthrough that was first achieved in the 18th century.

Early photography pioneers found that while they could briefly capture an image using light-sensitive silver nitrate, they could not fix it—when exposed to light the whole image went black. The first man to master the process of fixing was French chemist Joseph Niepce, who in 1826 took the oldest surviving photograph, a view from the attic of his house in Burgundy. Niepce went into partnership with theatrical scene-painter Louis Daguerre, and together they developed daguerrotypes, one-off photographs, usually portraits, imprinted on to metal plates, which became widely popular after their introduction in 1839.

In the same year English scientist William Fox Talbot laid the basis for modern photography by inventing a process that could take photographs with very short exposures, which could then be developed into negatives, which in turn could be used to make multiple prints. Talbot called the results *kalotypes*, but it was his friend, the astronomer Sir John Herschel, who coined the term photography (from the Greek for "writing with light").

Although increasingly popular, photography remained mainly the preserve of professionals, because of the complex, messy, and expensive processes involved in making photographic plates. In 1879 American bank clerk George Eastman invented a "dry-plate" process that made taking and developing photographs much easier. Six years later he replaced glass with gelatin-coated celluloid to create transparent, lightweight, flexible rolls of "film." At first the film was made by spreading liquid gelatin on long glass tables to dry, but later Eastman invented a process that is still used today, where liquid cellulose, known as "dope," is coated onto drums where it dries into film.

In 1888 Eastman introduced the first Kodak, a simple box camera containing a roll of film 100 exposures long. When they were all used the owner returned the entire camera to the Kodak plant for processing. In 1900 Eastman truly ushered in the age of mass photography with the Box Brownie, a simple camera that sold for $1, and used rolls of film that cost just 15 cents each.

SLR CAMERAS

Mass-market cameras such as the Box Brownie used a simple pinhole to admit light into the box and expose the film, only the crudest lens, and no viewfinder. Professional photographers were more likely to use an SLR, or single-lens-reflex camera, first designed by Thomas Sutton in 1861. In an SLR an angled mirror in front of the film deflects light coming in through the aperture up to the viewfinder, so that the user can see exactly what the exposure will look like. Activating the shutter causes the mirror to flip up out of the way.

POLAROID CAMERAS

Despite the cheapness of film and the rapid spread of developing facilities, many people continued to find it frustrating to have to wait for their pictures to be developed. In 1902 Kodak produced a Developing Machine that allowed amateur photographers to develop their own films without the need for a dark room. But true instant photography did not arrive until pioneering optics scientist Edwin Land introduced the Polaroid Land camera. He was inspired by his three-year old daughter, who wanted to know why she had to wait to see a photograph that he just taken of her.

Land, who had already invented polaroid sunglasses (see page 115) and 3-D photography, and would eventually be granted more patents than any other American except Thomas Edison, set about

Digital cameras can be linked to computers so that images can be downloaded and manipulated. Computers and digital imaging were first combined in the mid-1970s, but the equipment was expensive and complex.

producing a film that would develop itself. In 1948 he brought out the Land camera, where pictures were delivered via a peel-apart process. In 1972 the process was improved with the introduction of the SX-70, which used an entirely dry, light-activated process to produce instant color pictures. Land even invented an instant color movie system, Polavision, but this never caught on, and the Polaroid company itself recently ceased operations, unable to compete with digital photography.

DIGITAL CAMERAS

Digital photography developed from television camera technology and the space industry. Television cameras use photoelectric cells to convert light into electrical current of varying voltage, essentially the same technology that is used in a digital camera. When video recording was invented in the 1950s (see page 186), it involved converting these changes in voltage into chunks, or bits, of information that could then be recorded on to magnetic tape, so that the video information was now in digital form. The use of digital information to record photographs was further developed by NASA and the Pentagon for taking pictures of the surface of the moon and of the earth from space. In the 1990s Kodak and Apple adapted this technology for consumers and produced the first digital cameras for the mass market, the DC40 and the Apple QuickTake 100.

Flashlight

POINT AND CLICK

Electric batteries went on sale for the first time during the 1890s but low power and short lifespan restricted their usefulness, and the flashlight, like many of the earliest battery powered devices, was initially considered to be little more than a novelty. Indeed, in its original incarnation, it was a novelty item—an electric flowerpot. The brainchild of inventor Joshua Lionel Cowen, the electric flowerpot was a tube containing a battery and a bulb at one end, which was housed in a fake flowerpot and lit up a fake flower. It was not a roaring success, and in 1896 Cowen gladly sold the rights to Conrad Hubert, a Russian immigrant who ran a novelty shop in New York.

With the help of an inventive assistant named David Misell, Hubert, whose original name was Akiba Horowitz, dumped the flowerpot and flower and was left with a simple battery-operated replacement for the candle or oil lamp. Although patented as "a portable electric light," it soon became known as a flashlight because the limitations of contemporary batteries and bulbs meant that the device could only be switched on for short periods at a time, providing flashes of light. In fact until 1912 almost all flashlights were operated with a button rather than a switch, and would only light up as long as the button was pressed.

Though durable, shock-proof plastic and rubber have replaced brass and glass, the overall design of this modern flashlight remains similar to its 19th century predecessors. The batteries are stored in the handle while the light is turned on either with a switch or by twisting the body of the flashlight.

In the following years Misell invented variations of the flashlight for Hubert's American Electrical Novelty and Manufacturing Company, including the bicycle light and the stickpin light. This was a small pin with a miniature bulb, connected to a battery that was carried in a pocket, intended as a joke item (one 1903 version was topped with a porcelain clown's head) but it soon became popular as a reading light.

In the meantime, Hubert concentrated on sales, distributing free flashlights to New York policemen and collecting testimonials that he used to great effect in advertising. In 1898 he brought out his first catalog, and in 1899 a second one, illustrated with a picture of one of his flashlights illuminating the globe and bearing the legend "Let There Be Light," and featuring 25 different combinations of the battery and the bulb. He also introduced a catchy brand name, Ever Ready, which would eventually become the name of the company.

In 1906 tungsten wire filament bulbs replaced the old carbon filament bulbs (see Light bulb, page 124). Combined with improved battery technology, the new bulbs made flashlights brighter, more reliable, and longer-lasting, and they soon made the transition from novelty item to household necessity.

Tools

DIY MADE EASY

Simple tools such as knives, hammers, and axes are older than mankind, being originally invented by our early ancestors, *Homo habilis*, around 2.5 million years ago. Around 50,000 years ago the human toolkit began to expand, with the addition of fishhooks and needles, and prehistoric man gradually fashioned more tools out of stone, horn, bone, and wood. Early pickaxes, made from antlers, and shovels made from animal shoulder blades, have been found in ancient British quarries dating back to 2500 BC.

The discovery of smelting ushered in the Bronze Age and later the Iron Age, and civilizations such as the ancient Egyptians improved their tools by making metal hammers, chisels, axes, saws, lathes, and adzes. The oldest metal nails come from ancient Mesopotamia, and are about 5,500 years old, but we can assume that wooden pegs and dowels were in use long before this.

The screw was originally used as a machine for raising water. This device is known as an Archimedes Screw, although it was known to the Egyptians long before the time of Archimedes (who lived in the third century BC). Its invention is sometimes attributed to the fifth-century BC Greek scientist Archytas of Tarentum. By around the first century BC screw presses, for pressing olives and grapes, were in common use. These used screws in the same way as nuts and bolts, but neither of these devices was adopted by carpenters or builders until around the 16th century. The screwdriver did not follow until 1780. When power tools came into use in the early 20th century, workers found that bits slipped easily out of the traditional slotted screw head. In the early 1930s Henry Phillips, a businessman from Oregon, designed a screw with a new type of head, the Phillips screw. The pointed tip of the Phillips screwdriver is self-centering in the recessed cross of the Phillips head, but pops out easily when the screw is fully screwed in (an important feature for power screwdrivers).

The introduction of power tools in the early 20th century revolutionized industry, but it took longer for the home DIY enthusiast to reap the benefits, with home power tools not becoming widely available for many decades. Today's power tools are extremely versatile—their functions can be changed as easily as attaching a new head.

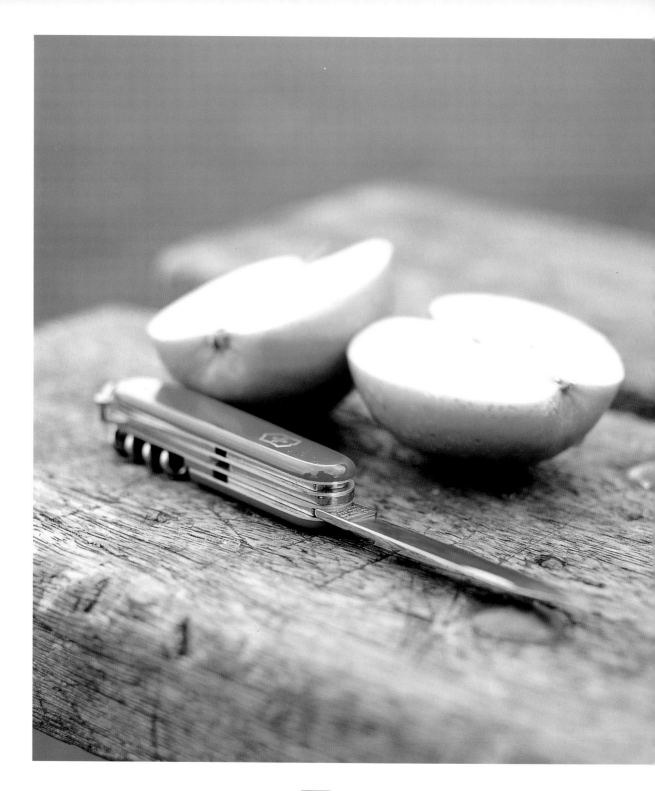

Swiss Army knife

TOOLED UP

Penknives derive their name from their original function, which was as a handy tool for writers. Before metal pens came into general use writers made do with feathers, or quills, the nibs of which quickly wore down or split. To make a new writing point the scribe simply had to cut a new nib a bit further up the quill, which is where the penknife came in. Only a small knife was needed for this task, and it became common for anyone who might be doing some writing to carry a pocket-sized folding blade.

Although the famous Swiss Army knife shares these characteristics of folding and being pocket-size, it was never a penknife in the strictest sense. It started life as a simple, single-blade, wooden-handled folding knife, issued to every soldier in the Swiss Army from 1886. In 1889 the Swiss Army started to use a new model of rifle, the disassembly of which required a screwdriver. It was decided to add this tool to the folding knife, together with a reamer or awl (a tool for making holes) and a can opener—the true Swiss Army knife (SAK) was born.

These early SAKs were actually made in Germany, in the silverware-making center of Solingen, but in 1891 Swiss silverware maker Karl Elsener started the Swiss Silverware Guild so that Switzerland could make its own army knives. As well as the ordinary pocketknives for soldiers, Elsener designed other folding knives—the different models were given names such as the Student, Cadet, or Farmer. His masterstroke, however, was an ingenious spring system that allowed more tools to be crammed into the same-size handle. Designed specifically for officers, who had to buy their own knives and therefore expected a bit more for their money, the new knife included a second blade and a corkscrew. The Officer's knife was patented in 1897 and quickly became popular with the military and civilians alike.

The famous Victorinox brand name derives from the name of Elsener's mother, Victoria. When she died in 1909 he named the knives after her, and then, in 1921, when stainless steel became available, the letters "INOX" (meaning "does not oxidize") were added. Victorinox was not the only company to make SAKs, however. In 1893 another Swiss silverware-making firm, which would later become Wenger, gained a contract to make some of the knives. Soon there was friction between the two companies, one of which was based in the French-speaking part of Switzerland, while the other was from a German-speaking canton. In 1908, to avoid offending either section of the population, the Army decided to order half of its knives from each company, and to this day both Victorinox and Wenger make authentic Swiss Army knives.

Today each company supplies 25,000 knives a year to the army, but this accounts for just one day's production, out of an annual output of 7 million. The vast majority of this goes to overseas markets, with hundreds of different models featuring tools from fish scalers to magnifying glasses. Victorinox's "SwissChamp" has 31 different features, and one model even features a specialized tool for performing emergency tracheotomies!

Bicycle

TWO WHEELS BETTER

The first bicycle was invented in 1817 by German engineer Baron Karl Dreiss von Sauerbronn. It had no pedals but otherwise closely resembled the modern bicycle, with a saddle positioned between two in-line wheels of equal size, steered by handlebars attached to the front wheels. Built out of wood and powered by the rider's own running action, the Baron's machine, nicknamed the Draisienne, was intended to help him get about the parks of Paris. Although it was a popular novelty for a while, it was poorly suited to less manicured surfaces.

In 1839 Scottish blacksmith Kirkpatrick Macmillan invented a pedal-operated version of the bicycle. The pedals hung from cranks attached directly to the axle of the rear wheel. His design was not successful and in 1861 Frenchmen Pierre and Ernest Michaux produced a version where the pedals attached directly to the hub of a large front wheel. They named their contraption the *vélocipède* (from the Latin for "fast foot"), but it quickly became known as the "boneshaker," because its wooden wheels (banded with metal) gave a very bumpy ride.

The construction of the *vélocipède* meant that with a larger front wheel the rider could travel farther, and by 1870 it had evolved into the high-wheel

Many road improvements, including better surfaces and lighting, were the result of lobbying by cyclists, while features that car drivers take for granted, such as band brakes, were first developed for the bicycle.

bicycle (the first machine actually to be called a bicycle), with a wheel diameter of up to 5 ft (1.5 m). In Britain this contraption came to be known as the Penny Farthing—an allusion to the difference in size between the front and back wheels. The high-wheel was more comfortable than the boneshaker, thanks to the shock-absorbing capacity of the long spokes and the use of rubber tires. It was the first bicycle to become widely popular and was used to set distance and speed records all over the world.

The high-wheel was also dangerous to ride and a number of safer alternatives were built, including the high-wheel tricycle and the high-wheel safety, which had the large wheel at the rear. The American inventor of the latter promoted his machine by riding it down the steps of the Capitol building in Washington, D.C. The most successful alternative was the hard-tired safety bicycle, invented in 1885, which set the pattern for the modern bicycle. The saddle sat on a diamond frame between two equal-size wheels, while the pedal drove chains attached to the rear wheel.

Lack of suspension and wheels with short spokes and hard rubber rims meant that the hard-tired safety bicycle was another boneshaker. This changed in 1887 when Irish veterinarian John Dunlop fitted

his son's bicycle with tires made from inflated rubber hoses, thus creating pneumatic tires (although the idea was not original, having first been patented in 1845). Falling manufacturing costs made the pneumatic-tired safety bike enormously popular, and many commentators have described it as a powerful agent of social change. For poor working-class riders the bicycle offered a cheap way to tour the countryside, while the sensible clothing needed for riding helped women to escape the constraints of Victorian fashion. In 1896 Susan B. Anthony proclaimed, "the bicycle has done more for the emancipation of women than anything else in the world."

Waterproof clothing

RAIN, WIND, OR SHINE

Diifferent cultures have used all sorts of different methods to try to make their garments waterproof. The ancient Egyptians used waxed or oiled cloth, the Chinese lacquered or oiled their clothes, whereas the Inuits used seal gut or skins to make hooded tops, called *parkas* in the Aleutian Islands or *anoraqs* in Greenland—names later adopted by the Scandinavians in the early 20th century as winter sports became more popular. South American Indians used latex or, as the Spanish called it, tree milk—the sap secreted by the rubber tree, *Hevea brasiliensis*—to make waterproof capes and footwear. The Spanish invaders copied them and exported the idea back to Europe.

Today's weatherproof clothing is specially engineered, using advanced membrane technology, to let the skin breathe and allow moisture out, while preventing rain and wind from getting in. Even with the best clothing technology, however, some people just plain don't like being outdoors!

Latex rubber, however, had several drawbacks as a waterproofing agent. It was unstable and broke down easily; it was sticky and picked up dirt and bugs; and it would melt in warm weather. In 1748 Frenchman François Fresneau treated latex rubber with chemicals that made it easier to use, and by painting it on to an old overcoat made an early raincoat. Unfortunately the chemical additives smelled too unpleasant for the idea to catch on.

In 1823, however, Scottish chemist Charles Macintosh discovered that rubber latex could be dissolved in naphtha, a coal-tar derivative, producing a workable formulation with no added odor. He used it to stick together two layers of cloth

and created a raincoat which he called a "macintosh." Unfortunately the new garments suffered from the same old problems. The rubber disintegrated quickly and would stiffen in cold weather, while in warm weather it would become sticky and malodorous. Not until the invention of vulcanized rubber in 1839 did the raincoat improve.

Plastic became a popular waterproof material in the 1950s, but today the most sought-after outdoor fabrics are those that combine the weatherproof features of plastic with the breathing ability of natural fibers. The best known example is Gore-Tex, invented by Wilbert Gore and introduced by his company W.L. Gore & Associates in 1989.

Athletic shoes

FOOTWEAR PHENOMENON

In 1868, not long after Charles Goodyear had invented vulcanized rubber, the first sports shoes with rubber soles went on sale in North America—for croquet players! These simple shoes, made with canvas uppers, set the pattern for sneakers for the next century. They were followed in 1876 by British shoes called plimsolls, named after the Plimsoll Line on ships that indicated the safe displacement level for merchant ships, which the join between the rubber sole and the canvas upper was said to resemble. Such shoes became known in North America as sneakers, because their rubber soles made little sound.

In 1917 American shoe company U.S. Rubber introduced the first mass-market sneakers, Keds, their name deriving from a combination of the word "kids" and the Latin root *ped*, for "foot." Like earlier sports shoes, Keds were simply constructed, with brown canvas uppers glued to black rubber soles. American sports shoes changed little over the next

decades and by the late 1950s some far-sighted sportsmen were convinced that a better shoe design would improve performance.

At the University of Oregon running coach Bill Bowerman began designing and making his own shoes to improve on the athletic shoes that were then available, most of which came from Germany (from companies such as Adidas). Meanwhile, Phil Knight, a former runner on Bowerman's track team, was completing an MBA thesis on how Japanese athletic shoes could capture the high-performance trainer market. In 1962 Knight traveled to Japan and convinced the Tiger shoe company to make him their American agent. When they agreed he hurriedly invented a name for his new company, Blue Ribbon Sports (BRS).

Back in the United States, Knight and Bowerman went into partnership and BRS did a slow but steady trade, selling its own shoes as well as Tigers. Its fortunes changed radically, however, when Bowerman came up with an innovative design to improve the traction offered by the rubber soles, which up until then were patterned on

automobile tire treads. Puttering around in his kitchen he caught sight of the waffle iron, and in a moment of inspiration pressed a piece of rubber in the machine, producing a waffle-shaped sole. Combined with other innovations, including lightweight, durable nylon uppers, wedged heels, and cushioned mid-soles, the waffle-sole gave BRS a winning product.

On the eve of the launch of the new "Moon Shoe"—the first athletic shoe to incorporate Bowerman's waffle soles—Knight dreamed up a new brand name, Nike (after the winged Greek goddess of victory), and paid designer Caroline Davidson $35 for the "Swoosh" logo (representing Nike's wings). Nike athletic shoes quickly caught on with leading sportsmen and women, and Nike improved its public profile by signing up figures such as John McEnroe and later Michael Jordan. Although Nike faced stiff competition from German company Adidas and later Reebok, who briefly outsold them in the 1980s, they were helped by Jordan and a series of effective advertising campaigns, and by 1986 Nike revenues topped the billion-dollar mark.

Barbecue

GRILL POWER

Barbecuing is the slow cooking of meat over a wood or charcoal fire. In America this method of cooking was originally used on the cattle drives in the early 19th century. The cowboys who worked the cattle were fed the cheapest cuts of beef, such as brisket, for example, a tough and stringy cut that required up to seven hours of slow cooking to be properly tenderized. Other types of meat commonly consumed included pork ribs, beef ribs, venison, and goat. In order to cook the meat at a low enough temperature and avoid burning it, it would be cooked on a wooden framework over the fire, which was called the barbecue. The word was also used to refer to a framework of sticks used for sleeping on, possibly as a result of the custom of sleeping over a smoky fire as a form of protection against biting insects.

The etymology of the word itself remains uncertain. It is believed to have come via the Spanish from a Haitian Indian word, *barbacoa*, used to describe a meat-smoking framework. An alternative source is the French phrase *barbe à queue*, meaning "from whiskers to tail," possibly referring to another meaning of the word—"to roast a whole animal over a wood or charcoal fire." A third meaning for the word was "a floor for drying coffee beans."

Today most people use charcoal briquettes for their barbecues. These were invented by Thomas Edison and Henry Ford in 1920, as a way of using up sawdust and wood scraps left over from Ford's production lines.

Kites

RIDING THE WIND

Although today we think of kites in a purely recreational context, they have been used throughout history in a surprising range of roles—religious, military, industrial, and scientific. There is evidence that the ancient Chinese were flying kites as early as 1000 BC. They used bright colors and striking designs to help ward off evil spirits, ensure good fortune, and even predict the success of the harvest.

The Chinese also used kites for military purposes: different colors and patterns of flight could be used to signal across long distances, and as kite technology became more sophisticated it even became possible to lift humans into the air to spy out the land. Needless to say, this was extremely dangerous; Marco Polo, traveling in China in the 12th century, reported that only prisoners were sent aloft, and it may be that kite-powered flight was more common in folklore than reality. A popular Japanese folk tale, for instance, tells how a samurai, exiled to a tiny island, built a kite to fly his son back to the mainland, while another tells of a thief who tied himself to a kite to steal golden roof ornaments.

Both the Chinese and the Japanese also used kites for recreation. A popular pastime was kite fighting, where the strings were coated with ground glass, broken pottery, or even blades, and the aim was to cut the strings of your competitors. At this time the Japanese name for kites was "paper hawks," and their Western name is also derived from a bird of prey.

It's not clear when Europeans first discovered kites. Archytas of Tarentum, a Greek scientist of the fifth century BC, is said to have designed and built a kite, and the Roman army used windsocks (a primitive form of kite) as regimental insignia. From at least the 12th century European children were flying a "singing kite," which produced a whistling or singing noise when the wind passed through holes in the fabric. Early explorers and traders from the Far East brought back more sophisticated kites, which were adopted by the military for signaling purposes, and by the 15th century Leonardo da Vinci was proposing that kites could be used to help build bridges across gorges or rivers. He may not have been the first to suggest industrial applications for kites; one recent theory suggests that the ancient Egyptians used them to erect huge obelisks and move heavy blocks for the construction of the pyramids.

In the 18th century scientists used kites to study the atmosphere. In 1749 Scottish meteorologist Alexander Walker fixed a series of thermometers to the string of a high-flying kite and used it to measure temperature at different altitudes. In 1752 the great American scientist Benjamin Franklin tied a key to the string of a kite and flew it into a rainstorm to demonstrate that lightning was a form of electricity. Like da Vinci, Franklin's novel application grew out of his childhood experience with kites; in one early journal he describes how a kite dragged him across a swimming pool "in a most favorable manner." Experiments like these helped scientists to develop the principles of aerodynamics that eventually led to heavier-than-air flight.

Frisbee®

DISK O'TECH

Flying disks have been used for sport and recreation since the ancient Greeks threw the first discus, but the heavy clay disks were not intended for catching and would probably take the fingers off anyone who tried. The modern recreation of tossing a Frisbee® dates back only as far as the 1940s, when students at Harvard and Yale Universities in the United States amused themselves by throwing shallow tin pie-pans from the William R. Frisbie bakery of nearby Bridgeport, which had been baking pies since 1870.

After returning from World War II, Californian Walter Frederick Morrison, whose father had invented the automotile sealed-beam headlight, was inspired by the new craze for flying saucers. He independently created his own flying disk, a saucer-shaped toy that would mimic the flight and hovering of UFOs. The first models were made of metal but Morrison later refined his product and switched to plastic, the perfect material for flying saucers. In 1957 he sold the rights to a local company, Wham-O Manufacturing, which released the toys as "Flyin' Saucers."

An expert thrower with a quality Frisbee and good wind conditions can cover a fair distance, but ultimately Frisbees generate too much drag and not enough lift. The world's farthest thrown object is the Aerobie®, a Frisbee derivative, which in 1985 was thrown 1,257 feet (383 m).

After a slow start, the plastic disks soon proved popular in Southern California and 1958 Wham-O president, Richard Knerr, toured the campuses of the East Coast distributing free samples to university students to prime the market. On reaching Harvard and Yale he was amazed to find students already using their own makeshift "frisbies," and quickly appropriated the name, trademarking it as Frisbee in 1959.

The Frisbee has over the years developed its own subculture, with a number of spin-off sports. The best known include Frisbee golf, where the players get to use specially manufactured, individually unique mini-Frisbees of different weights and ranges to play a version of golf. Also popular is Ultimate Frisbee, a version of netball, created in 1967 by enthusiast Joel Silver of New Jersey. It has caught on so well that World championships of Ultimate Frisbee have been held since 1983.

Since they were first produced in 1957, over one hundred million Frisbees have been sold around the globe.

Compass

POINTING THE WAY

Some Chinese historians claim that the compass was invented as far back as 2634 BC, but the earliest written reference dates to a Han dynasty manuscript from about 83 AD, which mentions a "south-pointing spoon." Other sources from the same period describe the use of "south-pointers" as navigational aids used by the jade collectors of Cheng (the Chinese believed that compasses were attracted to both north and south).

It is likely that knowledge of magnets was much older than this, and that directional aids made from magnetic ore such as magnetite (later called lodestone in the West) were originally used for geomancy, or "earth magic." This system of magic, also known as *feng shui*, was used to make predictions and calculate auspicious times and places. The calculations were based on the signs of the zodiac and the directions, and the first compasses took the form of spoon-shaped instruments placed on bronze "heaven-plates," on which were marked the various divisions of the heavens and the earth.

By the ninth century AD the Chinese had learnt how to magnetize iron needles by rubbing them against magnetite or heating and then cooling them in alignment with the north-south axis. By floating the needles on water or suspending them from a silken thread, a portable compass could be constructed. By the 11th century AD they were in use as navigational devices on ships, helping Chinese mariners reach the Red Sea without getting lost.

Europeans had known about magnets since the time of the ancient Greeks, but they did not learn the secrets of the compass until around the 11th century. Some historians assume that this knowledge, like most medieval and Renaissance science, was passed on by the Arabs, but in fact it probably came by way of the Silk Road, the great overland trading route from China to Europe.

A modern orienteering compass comes equipped with ruled edges and a built-in magnifying glass, together with a rotating rim that allows the orienteer to sight on a landscape feature, set the rim, turn the compass to north and read off the exact angle of the course he or she needs to take.

The European word "compass" refers to a circle, or the instrument used to draw one. Sailors navigating the northern seas, such as the North Atlantic, found that their compasses behaved erratically, pointing in different directions at different times. What they didn't know was that the North Magnetic Pole was actually different from the geographical North Pole. The former, discovered in 1831 by Sir James Clark Ross, is located on the northernmost tip of North America, in a place called Boothia. It also roams around in a 20-mile (32-km) circle, causing even more navigational headaches. Modern mariners compensate using charts and other tools, including the satellite-linked Global Positioning System, which makes the compass largely obsolete.

Fireworks

FIRE IN THE SKY

Like kites, fireworks evolved from a belief that frightening away evil spirits could ward off misfortune, in this case through the use of explosions to produce noise and light. An early way of doing this, from China's Dong Han Dynasty (206 BC–220 AD), predating the invention of gunpowder, was to roast segments of bamboo over fires: bamboo stalks are naturally partitioned, and air trapped between partitions would expand until the stalk exploded with a sharp crack.

Even before the use of these early firecrackers the Chinese knew that saltpeter (potassium nitrate), one of the ingredients of gunpowder, could be used to enhance the fires employed as signal beacons along the Great Wall of China, and later the military used similar ingredients to make bright signal flares. Gunpowder itself, a mixture of saltpeter, sulfur (also used to make fires burn hotter), and charcoal, was not invented until around 1000 AD. No one is sure why these ingredients were first combined, but one theory is that gunpowder was produced by Taoist alchemists who were experimenting with life-prolonging elixirs.

Soon the new explosive was combined with the ancient firecracker technology: bamboo stalks packed with gunpowder gave off tremendous noise and an explosion of sparks. As the powder combusted it would also have produced rapidly expanding hot gases that blasted out of the bamboo canes, driving them into the sky as the first rockets. During the Southern Song Dynasty of the 12th century firework technology was developed to a high level and fantastic displays became an important part of religious and civil celebrations.

From the Far East gunpowder and firework technology spread to India (where it may even have originated independently at the same time as in China), Persia, and eventually Europe, where the Italians became the acknowledged masters of firework manufacture. In the 15th century Florentine craftsmen built plaster figures that spewed orange and red fire from their mouths and eyes, and in the 16th century fireworks became a regular feature of royal and papal events. In England in 1533 Henry VIII ordered a lavish spectacular to mark the coronation of Anne Boleyn as his second queen. In the 17th century the use of fireworks was enshrined as part of the annual celebrations of the anniversary of the foiling of Guy Fawkes' Gunpowder Plot of 1605, a tradition that continues to this day.

In the New World, European settlers used fireworks to mark their own celebrations and to impress the natives. Captain John Smith set off the first fireworks in America in 1608, and by 1731 they were common enough for Rhode Island to institute a ban on their misuse. Fireworks were also a central feature of the first Independence Day celebrations in 1777.

At this time fireworks produced only red or orange colors, but in the 1830s Italian experts succeeded in mixing a gunpowder that would burn hot enough to ignite greenish-blue zinc compounds. Soon it was possible to produce a range of colors using different metallic compounds. Red is

produced with strontium carbonate, green with barium nitrate, gold and white with iron and aluminum and blues and purples with copper chloride. Metal salts can also be used to produce sound effects—potassium perchlorate and sodium salicylate for whistling noises, powdered titanium for ear-splitting bangs. Today's firework spectaculars no longer employ rockets but use shells, fired from mortar tubes that are sunk into the ground. The most up-to-date displays use remote-control fuses, operated by computers that can synchronize the explosions to music.

Batteries

GENERATING EXCITEMENT

A battery is a device for converting chemical energy into electrical energy. Although Italian scientist Alessandro Volta is generally credited with the invention of the battery, the world's first known battery is actually around 2,000 years old, dating back to the Parthian period of Persian history (from 250 BC to 250 AD). Known as the Baghdad Battery, this amazing ancient artifact was discovered in Khujut Rabu, just outside Baghdad. It is a clay jar with an asphalt stopper, through which protrudes an iron rod surrounded by a copper cylinder. If filled with vinegar the jar produces a current of 1.1 volts. Assuming that it was a battery, as seems likely, the Baghdad jar was probably used for electroplating, where one metal is coated with a thin layer of another metal (probably silver and gold in this case). Similar techniques are still used by craftsmen in Iraq today.

The ancient science represented by the Baghdad Battery was apparently unknown to the wider world, and it was not until the 18th century that Western scientists discovered the secrets of electricity production. In 1780 Italian anatomist Luigi Galvani discovered that a severed frog's leg could be made to twitch, thanks to electricity that was generated by touching it with a piece of metal. Volta subsequently concluded that the electricity came from the metal, and that the strongest electrical current resulted from a combination of copper and zinc. By placing a stack of alternating zinc and copper rings in a jar of saltwater, Volta created what he called a column battery, although it was more widely known as the Voltaic Pile.

Most modern batteries operate on essentially the same principles as the Voltaic Pile, although they generally use carbon instead of copper and acid as an electrolyte (usually in the form of a paste, which is more manageable than a liquid). Alkaline batteries, invented by Thomas Edison in 1914, use an alkaline electrolyte. Samuel Ruben and the Mallory Battery Company created the best-known brand of alkaline battery, Duracell, in 1964. It was such a success during the 1970s that supplies had to be rationed until manufacturing capacity caught up.

Electricity is produced inside a zinc-carbon

battery as the electrolyte slowly dissolves the zinc, releasing electrons that flow to the copper, creating a current. The reaction between the zinc and the electrolyte is a chemical one, and the rate of a chemical reaction is affected by temperature: reactions generally take place at a slower rate in lower temperatures. This means that at lower temperatures a battery will produce a lower output, or, to put it another way, will have to work harder to supply the same amount of electricity. Since the power requirements of whatever is running off the battery do not change, the battery eats through its chemical reserves faster to meet those requirements, which is why batteries run down faster in cold weather. Warming up the battery counteracts this tendency, and visitors to polar regions, for instance, try to keep their batteries as warm as possible before and during use.

Even batteries that are not in use run down as a result of natural current leakage between the battery terminals, but this reaction also slows down at low temperatures. As a result, rechargeable batteries will maintain their charge for longer if kept in the refrigerator.

Lawnmowers

ROUGH CUTS

Until the 19th century few gardens had extensive lawns of cut grass. Since the days of the ancient Greeks the vogue in most domestic gardens was for a mixture of flowers, vegetables, grass, and weeds. (It was only in Elizabethan times that the English began to regard weeds as a nuisance.) However, the increasing popularity of bowling and golf led to a growing demand for close-cropped turf, and in the early 1800s landscape designers for the great gardens of the aristocracy introduced a fashion for sweeping lawns.

The traditional methods of maintaining a lawn were either to let sheep graze on it (the method employed by George Washington to keep his estate at Mount Vernon in trim) or to cut it by hand with a scythe, although scything required that the grass be wet first. Wetting gave the grass "body," so it would not be completely flattened by the scythe. English textile engineer Edwin Budding invented an easier way of lawn mowing in 1830. Through his work at a textile mill near Stroud, in Gloucestershire, Budding had become familiar with a device that cut the nap (projecting fibers) off cloth. During the 1820s he developed the machine for use on lawns, and in 1830 he patented what is now known as a reel or cylinder mower for "cropping or shearing the vegetable surface of lawns."

Budding's reel mower had a fixed "bed" blade and a series of other blades arranged in a cylinder around a central shaft. By means of a pinion gear inside one wheel, pushing the mower causes the cylinder to turn rapidly, shearing off blades of grass that are caught between the fixed and spinning

blades. The reel mower was easy to operate and gave an even length of turf, and its shearing action was kinder on the grass than the chewing of sheep, the ripping of a scythe blade, or the shattering action of the later rotary-blade mower.

In 1841 the first horse-drawn version of the reel mower was patented, and soon estate owners were using mowers more than 42 inches (1 m) wide, drawn by horses wearing leather booties (to protect the turf). British manufacturers sold mowers to the United States until an American version was patented in 1868. By 1885 America was making 50,000 lawnmowers a year. The first power mower was a two-ton steam-driven giant, but by 1902 gasoline-engine driven mowers were commercially available, and, as they became cheaper, the gas-driven rotary-blade mower (originally patented in 1899) superseded the reel mower.

PUBLIC SPACES*

* innovations in the public realm

Locks, keys, padlocks, and key rings

SHUT IT

All locks and keys are made secure in one of two ways, with either guards or detainers. Guards, also known as wards, are fixed obstructions that allow only the correct key to be inserted into the lock. Detainers are structures that hold the bolt in place, and must be moved, usually by means of projections on the key, before the bolt can be withdrawn. These are the principles by which the first locks operated, and they still apply today.

The oldest known lock, discovered in the doorway of an apartment of the royal palace of Khorsabad, in the ancient city of Nineveh, is around 4,000 years old. It operated on the second principle of lock functioning, by means of detainers. Known as a tumbler or Egyptian lock, because of its popularity with the ancient Egyptians, this type of lock involved a stout wooden bar with a tunnel cut into it. The lock sat above the bar and falling metal or wooden pins (known as tumblers) projected down from the lock into holes in the upper surface of the bar, holding it in place. The key was piece of wood shaped like a shoehorn, with wooden or metal pegs protruding at one end. It was inserted into the tunnel and the pegs would line up with pins—by levering back the key the pins would be lifted and the pegs of the key would fit into the holes in the bar, which could then be pulled back. Similar principles are used in modern pin-tumbler cylinder locks, such as the common Yale lock.

The Egyptian lock was popular throughout the ancient world, and was in use, in almost identical form, up to the late 19th century in places as far afield as the Faroe Isles and Zanzibar. It is still used today in some parts of Africa.

The padlock appeared in Roman times when traders and travelers adapted a spring mechanism to make portable locks that would protect valuables while on the move. In this type of lock the bolt was held in place by a spring; turning the key would flatten the spring and allow the bolt to be slid back. Its not clear where spring padlocks evolved, but the technology spread along the ancient trade routes and was common from Europe to China, where padlocks were often carved into the shapes of fantastic creatures.

Keys for Egyptian locks were often large and unwieldy (the locks of Nineveh took keys up to 2 feet [60 cm] long) and were typically tied together in bunches and carried over the shoulder. The Romans, however, made small metal keys that were sometimes fixed to a ring that could be worn on a finger—the first key rings. Some key rings were even personalized with a seal.

The Romans also favored keys with intricate ends that would fit into elaborate guards, setting a fashion for lock design that lasted throughout the Middle Ages and up until the 17th century. Guard or ward locks became more and more ornate, particularly those found on chests and lock boxes. The finest 17th- and 18th-century chests often featured an ornate decoy lock, while the real one was

hidden under a panel. But while the decoration improved the actual locks did not, and most were easy to pick.

The late 17th and early 18th centuries saw great strides in lock technology. In 1778 English locksmith Robert Barron patented the double-tumbler lever lock to counter the problem of thieves taking wax impressions of key-guard locks. In this type of lock the bolt is secured in place by a small bar held by several tumblers. Turning the key in the lock first raises the tumblers so that the bar is lifted, and then moves the bolt across. In 1818 Barron's design was improved by Jeremiah Chubb, who added a detector tumbler that would jam the lock if tampered with.

In 1848 American locksmith Linus Yale adapted the ancient pin-tumbler technology of the Egyptian lock to create the cylinder lock. In this type of lock the bolt is withdrawn by turning a cylinder, which is immobilized by a series of spring-operated pins of differing lengths. Only if each pin is raised to the correct height by a key with the right arrangement of projections can the cylinder be turned. After making his name with an "infallible bank lock," Linus Yale Jr improved his father's cylinder design and in 1868 set up the Yale Lock Manufacturing Company, which remains one of the world's leading lock companies to this day.

Take a look at a Yale-type key today and you'll see a modern combination of two ancient technologies. The tongue of the key is crinkled or grooved to fit into the guard or ward of the lock, while the projections correspond to the pegs that would have been found on the world's most ancient keys.

Traffic innovations

READY, STEADY, GO

Traffic control dates back to Roman times. The Romans drove on the left and limited the number of vehicles allowed into cities; they introduced one-way streets, parking laws, and road crossings, and possibly even traffic circles. Traffic levels dropped off after Roman times but when they began to climb again in the 18th and 19th centuries road safety once more became an priority. In Britain the 1835 Highway Act made dangerous driving or riding an offence, and drunk driving became illegal in 1872. More people were killed in traffic accidents in 1875, before the introduction of the motorcar, than in 1910.

SPEED LIMITS

Speed limits were introduced to control the new steam-driven engines in 1865, but the 4-mph (6.4-kph) limit proved to be a severe handicap for drivers of automobiles when they were introduced in the 1890s. Until the law was changed in 1896 drivers had to employ someone to walk ahead of their vehicle with a red flag.

TRAFFIC LIGHTS

Traffic lights also predated the motorcar. The first signals were manually operated semaphore arms based on railway signals, with gaslit red and green lanterns. They were installed in London's Parliament Square, near the House of Commons, in 1868, but exploded on January 2, 1869, injuring the policeman who was operating them. Electric traffic lights were invented in the United States to handle increasing volumes of motor traffic. Garrett Morgan invented the first automatic electric traffic signals, again based on railway semaphore signals, in around 1918 and they were installed in his hometown of Cleveland, Ohio. Signals using red, amber, and green lights were installed for the first time in New York, in 1918, although this honor is also claimed by Detroit.

Traffic signs, like this hazard warning sign used by motorists when their car breaks down, are universally understood thanks to the international standardization conventions adopted at a conference in Paris in 1909.

ROAD SIGNS

The earliest road signs were Roman milestones and their medieval successors, some of which are still in place to this day. But road signs as we know them were largely the handiwork of early cyclists. By the 1870s cycling was becoming a popular pastime but there was considerable antipathy toward the new mode of transport from horse riders and coach drivers, and frequent tangles that invariably left the cyclist worst off. One coach guard was even said to have equipped himself with an iron ball on the end of a rope, which he would use to knock over hapless pedalers.

In 1878 the Bicyclists Touring Club was formed for the purpose of lobbying for better traffic control and road safety, and also to erect signs at particularly dangerous spots, such as sharp corners and dangerous hills, after the model of a Swiss traffic sign originally put up near a steep hill in Lausanne. In 1903 the French introduced standardized road signs and Britain adopted the same conventions in 1904. The first standard road signs included a white ring, indicating a speed limit of 10 mph (16 kph), a solid red disk, indicating "prohibition," and a red triangle, flagging dangerous spots.

ROAD MARKINGS AND CATSEYES®

Road markings were another important safety measure—a patent for a system of road markings was granted in America as early as 1894. In Britain in 1937 the Ministry of Transport set up a test to select a method of making road markings visible at night. Several types of reflective stud were installed in roads in West Yorkshire and exposed to traffic flow. The only design still working after two years was that of a young road repairer named Percy Shaw, modeled on the eyes of a cat and containing a hard-wearing reflective layer called the tapetum. In 1947 Shaw's Catseyes® were introduced around Britain.

TRAFFIC CIRCLES

Traffic circles (called roundabouts in Europe) were introduced in the 1920s to ease the flow of motor traffic at busy intersections. Although developed by an American, William Eno, traffic circles never

really caught on in the United States where even today there are only around 700. However, they are widely used throughout the United Kingdom and Europe. In 1927 the first "gyratory system" was introduced at London's Hyde Park Corner.

PARKING METERS

Even the Romans had to contend with urban traffic congestion, it seems. In 45 BC Julius Caesar introduced laws to tackle traffic congestion laying down strict regulations on the numbers of wheeled vehicles that could enter Rome. Exceptions included vehicles carrying Vestal Virgins. Congestion became an issue yet again in the late 19th century, leading to the introduction of parking laws in Paris in 1893. Americans came up with a solution that is unfortunately still in practice today, the parking meter, introduced in Oklahoma City in 1935. Invented by Carlton Cole Magee, the editor of an Oklahoma newspaper, the first parking meters proved extremely unpopular with residents of some states and regularly fell prey to destructive vigilante vandals in Texas and Alabama. The Park-O-Meter Company, set up by Magee in 1935 to manufacture his invention, is still going strong today under the name POM. In 1992 it brought out the Advanced Parking Meter, "the last word in parking control technology!"

Elevators and escalators

STAIRWAYS TO HEAVEN

Man- or animal-powered hoisting devices have been around since ancient times but were rarely used to transport human beings, since there were few buildings more than a few stories high. The world's first elevator was built for French king Louis XV in 1743, to allow him easy access to the apartment of his mistress. Known as the "Flying Chair," it was located on the exterior of the building and went from the first to the second floor. The King would embark from his balcony and signal for a team of men inside a chimney to operate a delicate arrangement of weights and pulleys that raised and lowered the device.

Over the next century steam-powered and hydraulic elevators were introduced, but they were dangerous and restricted to industrial uses. Most people preferred to walk up stairs rather than take their chances with an elevator, a state of affairs that persisted until Elisha Graves Otis invented the safety elevator in 1853. Otis was an engineer employed by a bed factory to devise an elevator system that could safely deliver goods from the basement to the top of the building. To counter the danger of a catastrophic cable-breakage Otis designed a failsafe system—a safety clamp that would engage with toothed guardrails in the shaft on either side of the elevator. Tension from the lifting-cable held the clamp in an inactive position; if the cable was severed the tension would fail and the clamp would spring out.

Abandoning plans to join the California Gold Rush, Otis built a small factory to make the freight elevators for the bed factory, but was unable to find any more orders. To generate some publicity he demonstrated his machine to a crowd at New York's Crystal Palace in 1854. In view of hundreds of breathless spectators he ascended to a great height and then ordered his assistant to cut the cable—the clamp held and Otis' business grew slowly from then on. In 1857 the first passenger safety elevator was installed in a New York department store and soon a number of hotels had their own, often with operators, plush decorations, and seating.

The safety elevator's real importance, however, was that it made the construction of tall buildings practical for the first time. Previously architects had been constrained by people's ability to climb stairs, but in 1880 the world's first steel-framed tall building, the 10-story Home Insurance Company Building in Chicago, opened for business complete with four Otis passenger elevators. In New York, the Empire State Building, completed in 1931, is serviced by 58 elevators, while the tragically ill-fated World Trade Center had 252.

In 1900 the Otis Company unveiled a new type of people-carrier, the escalator. The first escalator

The introduction of elevators to hotels meant that previously undesirable rooms on the top floors, away from the bustle and noise of the street, became sought after and more expensive. You could say that the penthouse suite owes its existence to the elevator.

was an angled conveyor belt (like a moving walkway), installed as a novelty ride at Coney Island in 1891, but in 1899 an engineer named Charles Seeberger radically altered the design to produce a moving staircase. Joining forces with the Otis Elevator Company, he named his new invention the "escalator," from a combination of "elevator" and *scala*, the Latin for "stairs." Otis presented the new device at the 1900 Paris Exposition, where it won first prize. When the first escalator was introduced to Britain in 1911, in a subway station, a man with a wooden leg was employed to ride it in order to boost passenger confidence. Nervous passengers, anxious about getting sucked into the mechanism of the newfangled contraption, could see 'Bumper' Harris, as he was known, probing that even a one-legged man had no trouble getting on and off.

Today the Otis Company is the world's leading producer of elevators and escalators, and sells 48,000 of them a year. There are over 1.2 million Otis elevators and escalators in operation throughout the world. In North America alone escalators and elevators move the equivalent of double the combined populations of the United States and Canada each day, carrying 210 billion passengers a year with an extremely low accident rate, making these the world's safest forms of transportation.

Barcodes

BARS AND STRIPES

A barcode is a sequence of black and white lines of varying thickness, used to identify an article or record information about it. The lines represent binary numbers—a thick black or white line represents a one, and a thin black or white line represents a zero (black and white have to alternate so that the code can be read by a scanner). If you look at the barcode in the illustration, you will see that a sequence of numbers is written underneath. These are the numbers encoded by the barcode, although you won't be able to translate the bars into numbers unless you know the International Article Numbering system (confusingly known as the EAN system, for short—"E" because it was originally a European system).

Take another look at that barcode and you'll notice some other features. It begins and ends with slightly longer lines, and there's probably a longer line in the middle. These are "guard lines," which allow the computer to recognize the start, finish, and middle of the code. It needs to know where the middle is so that it can count the number of black lines on each side—the left-hand side has an odd number and the right-hand side has an even number. This helps the computer to figure out whether or not the barcode is upside down, so that it can be read from any angle. If you look at the start of the number underneath the code, you'll see that it's 978—this is the three-digit code that identifies this article as a book.

To a computer, scanning from right to left, this barcode reads 0001100001, etc. To us, the numbers 978 indicate that this barcode is for a book. If it began with a number between 00 and 09, it would indicate a product on sale in the U.S. or Canada.

Barcodes were patented in 1952, after four years of work by Joseph Woodland and Bernard Silver, two graduate students at the Drexel Institute of Technology in Philadelphia. A local chain-store owner, who wanted a method of automatically reading product price and information at the checkout, approached the Drexel Institute in 1948. Silver and Woodland explored various methods, including ultraviolet ink, before coming up with barcodes, a simple method of encoding binary information so that it can be read by a scanner. The scanner fires a beam of infrared light at the barcode and reads the pulses of light that are reflected back by the white lines (black lines simply absorb the light). The binary information goes to a computer, which decodes it into a sequence of decimal numbers and checks the sequence against a database containing the price and other product information. As well as displaying the price, the computer can automatically chart stock levels and reordering requirements.

Barcodes took a while to catch on. The first commercial use was in 1966, but widespread use depended on the adoption of a standard encoding system. In 1973 George Laurer invented the Universal Product Code (later absorbed by the EAN), and in 1974 the first UPC scanner was installed in a supermarket. The first product to have a barcode was Wrigley's Gum.

ATM/Cash dispenser

CASH ON DEMAND

The world's first cash dispenser was installed at a branch of Barclay's Bank in Enfield, near London, in 1967, and worked on different principles than today's machines. Customers were issued with paper vouchers worth £10 each; these were fed into the machine, which dispensed a single note and retained the voucher. Other banks used plastic cards in place of vouchers, but the cards had no magnetic stripe—the machine was emptied and the cards manually processed and returned to the customer by mail. These early cash dispensers were "off-line" machines: they were not connected to a central computer, so there was no way of checking whether the vouchers or cards were stolen, or of processing the account transactions, until the machine was emptied.

By 1968 cash dispensers had been installed in France, Sweden, and Switzerland, and by 1969 they had reached Japan and the United States. It was in the U.S. that a company called Docutel developed the next-stage cash dispenser, the automated teller machine (ATM). In 1968 Don Wetzel, one of Docutel's vice presidents, inspired by his frustration with lines at the bank, set about developing a machine that would do more than simply dispense cash. The key difference was the use of a plastic card with a magnetic stripe to access the machine's services.

Today's ATMs allow bank customers to conduct their banking transactions from almost any ATM machine in the world, saving not only time but avoiding one-way exchanges in banks abroad where English is not commonly spoken.

Docutel's initial efforts were similar to machines that already existed in Europe—they were "off-line" machines, available only to a few customers, which issued only cash and were operated via credit cards. The first ATM was installed at a branch of Chemical Bank in Rockville Center, New York, and was followed in 1971 by the creation of a "total teller," which could take deposits, transfer money, etc. For this more advanced machine Docutel developed proper ATM cards and connected the machines to central computers to allow "on-line" operation.

The second-generation cash dispenser first appeared at a Lloyds Bank in Britain in 1972 and gradually replaced the earlier machines. The initial spread of ATMs, however, was slow—it took 16 years for installations to reach the 100,000 mark. The machines were large, complex, at times unreliable, and extremely expensive. But as technology improved and costs came down installation speeded up, reaching the 200,000 mark within just four more years.

By 1999 there were over a million ATMs around the world, mostly in Europe and the Asia-Pacific region. Modern machines have large, full-color plasma screens, in place of the older black and white or even older single-line LED readouts, and offer a range of services that are accessed via a smart card.

Vending machines

GOODS AT THE DROP OF A COIN

The world's first vending machine dispensed holy water to Egyptian worshippers in the first century AD. Invented by Heron of Alexandria, a mechanical genius and prolific inventor who also devised early versions of the fire engine, wind organ, and steam engine, the vending machine was placed outside the temple walls so that people could ritually wash themselves before entering. Dirty worshippers inserted a coin into a slot, from where it would fall into a pan. The weight of the coin pushed down the pan, opening a valve to let out the holy water. At the end of the day the machine was emptied of coins and refilled with water.

Tobacco-dispensing "honesty boxes," found in English taverns in the 17th century, operated on a similar principle. Customers dropped a penny into the slot, releasing the lock on the box lid, allowing access to the contents. Users were expected to take just enough to fill their pipes.

The modern vending machine has its roots in late 19th-century Britain. Among the earliest successful examples was a postcard vending machine invented by Percival Everitt, which was installed at London's Mansion House underground station in 1883. Machines selling other dry goods, including matches and stamps, and later cigarettes and chocolate, appeared all over Europe, in shop doorways and at railway and bus stations. Most operated on a simple "column and drawer" principle. Goods were stacked on top of one another in a column above a drawer. Inserting a coin released the lock on the drawer, which was pulled out to allow access to the item. When it was pushed back in the next item would drop into it, ready for the next user. Similar machines are still found all over the world. Vending machines arrived in the United States in 1888, when the Thomas Adams Gum Company installed a machine on a New York subway platform to dispense Tutti-Frutti gum.

Today the biggest share of the vending market belongs to drink machines, particularly hot beverage dispensers found in offices and shops around the world. In the UK, for instance, eight million cups of coffee and two million cups of tea are vended every day, using 396 billion gallons (1.5 billion l) of water a year. Research suggests that an automatic hot beverage dispenser saves the average business $142,000 a year in time spent by employees making their own tea or coffee.

Obviously vending is big business, with millions of coins pumped into millions of machines on a daily basis. But with no one on hand to supervise, vending machine owners have always had to cope with the problem of "slugs"—fake coins used to cheat the machines. Today's vending machines use a combination of ingenious hi-tech solutions to check that the coin you've put in the slot is the real deal. The first hurdle it has to pass is a conductance test, where a mild electric current is passed through the coin. Only coins within the correct range for size and metallic content pass through a start gate to the next test, where they roll down a ramp through a magnetic field. The makeup of the coin determines how much it is slowed by the magnetic field. Light sensors time the speed of the coin and measure its

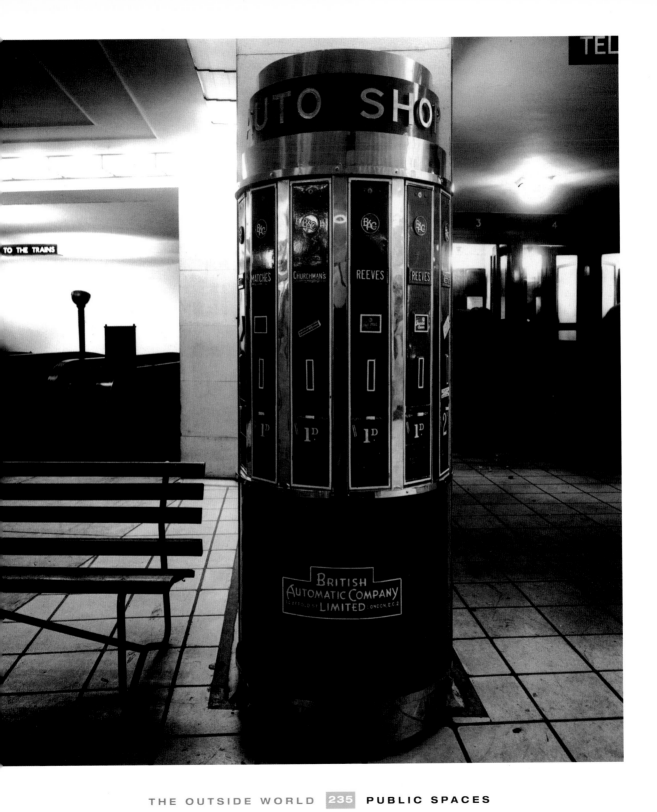

diameter, and the machine's electronic brain compares this information to known values to calculate the value of the coin. If it passes the test a gate opens and it drops into an "escrow," or temporary storage bin, until the purchase is made.

Over the years vending machines have offered an incredible range of goods, from emu jerky and pre-peeled oranges to art, poetry, and inflatable sex dolls. A machine on the Paris Metro once offered Levi's jeans – it was fitted with a sort of seat belt which strapped around the buyer's waist to determine the correct size. Machines in America offer live frogs, shrimp, and worms as fish bait, model submarines or fresh-cooked french fries.

In Japan you can buy almost anything from a vending machine, including oxygen, hot noodles, jewelry, live beetles and, famously, used panties. In fact Japan has become the true home of the vending machine, which are known there as *jidoohanbakai*. They first became popular during the Tokyo Olympics in 1964, when they were used as a solution to the problem of supplying large numbers of people despite a severe lack of space and staff. Today there are over six million *jidoohanbakai* in Japan.

Drinking fountains, watercoolers, and plastic cups

LIQUID GOLD

Many of the worst epidemics to hit urban areas in the 18th and 19th centuries were the result of contaminated water supplies and unhygienic water use. Whole neighborhoods relied on a single water source, where the supply was not protected, filtered, or decontaminated in any way. Even when water supplies improved, public drinking fountains, incorporating a faucet and a communal cup (or "sipper"), remained a common sight. Drinkers, diseased and healthy alike, shared the same cup, with inevitable consequences for public health.

Solutions to this problem evolved independently in several parts of the United States in the early 1900s. In New England in 1908, inventor and entrepreneur Hugh Moore designed a water-vending machine that would dispense small paper cups of water from a primitive water cooler at one penny a cup. Despite support from the temperance movement, Moore was dismayed to find that no one wanted to pay for a cup of water, and things looked bleak until the developing public health movement threw its weight behind one particular part of his scheme, the disposable paper cup. Changes in the law outlawed the public sipper in several states, and disposable cups were touted as a healthy alternative.

Moore changed the name of his company to the Individual Drinking Cup Company, and later to Dixie Cups. His product eventually became better known as a serving vessel for ice cream.

Meanwhile, inventor Halsey Taylor, whose father had died of typhoid contracted from a contaminated sipper, developed a sanitary new form of drinking fountain, which provided a drink without the need for a sipper. Not long after, in 1909, Californian plumber and sanitary inspector Luther Haws invented a similar device to dispense clean water in schools. To build his special faucet, Haws used spare plumbing parts, together with the ball from a brass bedstead and a self-closing rabbit ear valve. Both Taylor and Haws started their own companies to manufacture water coolers and drinking fountains. Initially they used huge, 20-pound (9-kg) blocks of ice to cool the water, but later, refrigerated water coolers using belt-driven ammonia compressors were installed in many schools. These were enormous, heavy machines that often could only be moved with a forklift, but were so well made that some still work today.

In the 1950s water dispensing units became smaller and lighter, developing into wall mounted and recessed space-saving units. In the 1960s a growing awareness of the needs of disabled people led to the introduction of lower, wheelchair accessible units. More recently, government legislation in many countries has resulted in a hybrid "bi-level" form of water cooler/drinking fountain, with faucets at two heights to meet all needs. The overall look of the water cooler has also evolved, from blockish, free-standing machines to moulded, integrated units, often used by architects and designers as design features in their own right.

Further reading

How Things Work — Volumes 1 and 2, 1978, Paladin Granada, New York and London
Panati's Extraordinary Origins of Everyday Things, Charles Panati, 1989, HarperPerennial, New York
The Evolution of Useful Things, Henry Petroski, 1994, Vintage Books, New York
The Origins of Everyday Things, Ed: Ruth Binney, 1999, Reader's Digest, New York and London
The Way Things Work, David Macaulay, 1994, Dorling Kindersley, New York and London

Useful websites

www.inventors.about.com
Inventors and inventions

www.ideafinder.com
Invention, facts, and myths

home.nycap.rr.com/useless/site_index/index.html
"Einstein's Refrigerator" site

www.didyouknow.cd
Trivia site

web.mit.edu/invent/www/archive.html
MIT's The Invention Dimension's "Inventor of the Week" archives

www.invent.org/book/book-index.html
National Inventors Hall of Fame "Index to inventors and inventions"

www.uselessknowledge.com
The discussion of imponderables

www.howstuffworks.com
Learn how things work

www.smith.edu/hsc/museum/ancient_inventions/hsclist.htm
The Smith College Museum of Ancient Inventions: See some everyday things from ancient times

Picture credits

Alessi: 27, 38, 41, 59. **Bang & Olufsen:** 182–3. **Bausch & Lomb:** 86. **Brabantia:** 50. **Cameo Photography:** 53, 61. **Canon:** 150. **Compaq Computer Corporation:** 171. **Crane Merchandising Systems:** 234. **Digital Vision:** 91. **Durex:** 122. **Dyson:** 14, 180–1. **Ebac:** 237. **Flexifoil International:** 212. **Friendly Robotics Inc.:** 221. **Glas:** 62. **Heritage Image Partnership:** 67. **London's Transport Museum:** 235. **Luxaflex:** 97. **Mainstream Photography:** 56, 68, 93, 193. **Neff:** 12–3, 15, 18. **Oakley:** 100. **Panasonic:** 19–20. **PhotoDisc:** 6, 90, 166, 197, 222, 226, 229, 231. **Rex Features:** 102–4, 106, 115, 129, 152, 156, 165, 176, 206, 217, 223, 227, 230. **Science Museum/Science & Society Picture Library:** 22, 94, 96. **Science Photo Library:** /Andrew Syred: 88, /Eye of Science: 109. **Shropshire Futons:** 89. **Sigma Group:** 236. **Smeg:** 16–7. **Swatch:** 159. **The Body Shop:** 74, 77.

Index